# MORE
# ENGINE SHEDS
## IN CAMERA

D A V I D  H U C K N A L L

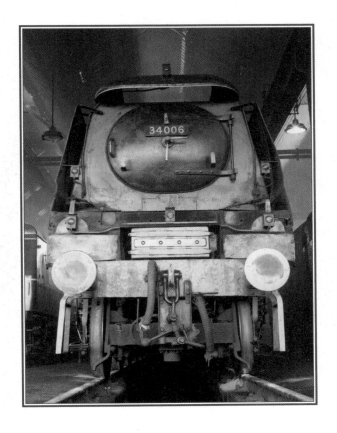

SUTTON PUBLISHING

First published in 2007 by
Sutton Publishing Limited · Phoenix Mill
Thrupp · Stroud · Gloucestershire · GL5 2BU

British Library Cataloguing in Publication Data
A catalogue record for this book is available from the British Library.

ISBN 978-07509-4585-1

*Title page photograph:* The front-end of unrebuilt 'West Country' Class No. 34006 *Bude* is shown in this unusual view taken from the inspection pit of its road inside Salisbury shed. *(George Harrison/ D.J. Hucknall Collection)*

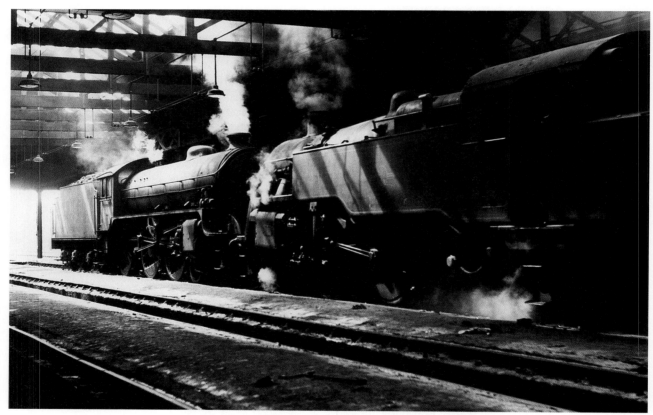

Inside St Margaret's shed on the afternoon of Saturday 13 March 1965 were BR Standard Class 4 2–6–4T No. 80054 and, 'at home', 'B1' Class No. 61191. Among other duties, 64A's 'B1's frequently worked on the 'long road' between Edinburgh and Carlisle. *(David Hucknall)*

Typeset in 10/12 pt Palatino.
Typesetting and origination by
Sutton Publishing Limited.
Printed and bound in England.

# Contents

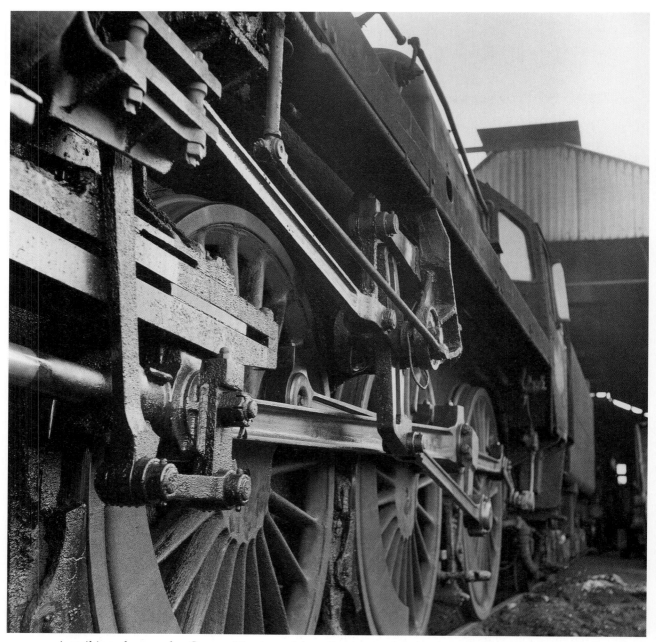

A striking close-up by George Harrison shows the accumulated grime on BR Standard Class 5 No. 73065 as it stood outside Salisbury depot on 3 April 1966. *(George Harrison/D.J. Hucknall Collection)*

# Introduction

It is over forty years since steam locomotives could be seen in regular revenue-earning service in Britain but I was delighted to discover, from information on library lending, that interest in railways in general and steam locomotive sheds in particular continues to be high. I really should not have been surprised. For well over a century, steam locomotives had pulled our goods trains, taken us on holiday and generally contributed immensely to our wealth and pleasure.

As Britain recovered from the Second World War, a problem with steam locomotives became increasingly apparent. They needed significant maintenance and they required men to clean, coal and water them. In addition to the drivers, firemen and cleaners, they also demanded fitters and boilersmiths and other competent tradesmen. It could be hard, dirty and sometimes dangerous work for relatively low wages. To supply the needs of the steam railway locomotive, sheds had been established and they were located at strategic points throughout the length and breadth of the country. They varied greatly in size. According to Charles Meacher, St Margaret's in Edinburgh, for example, had one of the largest allocations of steam locomotives in Britain (221 in the immediate post-war period) and employed 1,500 men, including 190 in the fitting and machine shops. Some, however, such as Helston, provided only the essentials of coal, water and cover).

Alec Swain, a former railwayman of considerable experience and seniority, was kind enough to write a foreword to an earlier book of mine on engine sheds (*On Shed*, Silver Link Publishing, 1993). In it he wrote: 'It should not be forgotten that many depots were long-lived and provided the livelihood and, often, the housing for many generations of railwaymen. Depots and such estates were communities in themselves and social clubs were established at the larger ones, together with allotments and other amenities. A depot of any size had its own (illegal) bookmaker – long before the betting shop – as well as a watchmaker, hairdresser, builder and decorator, etc. who used their hobby skills to provide a much-needed service to their fellow workers'.

The arrangement of this book is different to that of the previous one (*Engine Sheds in Camera*). It does not look at sheds in general and related activities in particular, instead it is divided into chapters reflecting British Railways' regional boundaries and it samples some of the sheds to be found within those. Chapter One is concerned with the Eastern/North Eastern Region and shows scenes as sheds such as York, Doncaster, and Neville Hill. Chapter Two reflects some of the activities in the London Midland Region at places such as Canklow, Crewe and Carlisle Upperby. Chapter Three covers the Scottish Region and some of the depots that I knew very well. It deals with, for example, large sheds such as Perth, St Margaret's and Kingmoor and smaller establishments such as Forres and Blair Atholl. Chapter Four (Workers and Observers) gives a brief glimpse of the men who drove and fired the engines and others who generally 'kept things going'. It also shows the photographers and enthusiasts who found sheds irresistible. Chapter Five looks at the Southern Region and features once more the excellent Salisbury work of George Harrison. Chapter Six is concerned with the Western Region, somewhat neglected in *Engine Sheds in Camera*, and highlights depots such as Old Oak Common and Plymouth Laira, among others. Because of my fascination with maps, I have also included some maps of sheds such as Penzance, Perth and St Margaret's dating from the 1930s and I am immensely grateful to Steve Turnbull who, some years ago, provided me with copies of the maps of Scottish sheds obtained from the National Library of Scotland.

# Acknowledgements

It gives me great pleasure to acknowledge those who have contributed to this book. I should like to thank Richard Casserley, Ken Fairey, John Hillmer, David Holmes, Gavin Morrison and W.A.C. (Bill) Smith. I should also like to thank Book Law Publications for permission to use two of the late Keith Pirt's photographs. Particular thanks are due to Brian Errington for his superb printing of my negatives, some of which were, frankly, poor. I should like to acknowledge my indebtedness to Peter Alvey who gave me the photographic collection of his late uncle George Harrison on which, I have, once again, drawn heavily.

Finally, I should like to acknowledge the considerable contribution of my wife Susan who, among other things, let me use some material from her 'photographic archive'.

*David Hucknall*

# Chapter One

# The Eastern & North Eastern Region

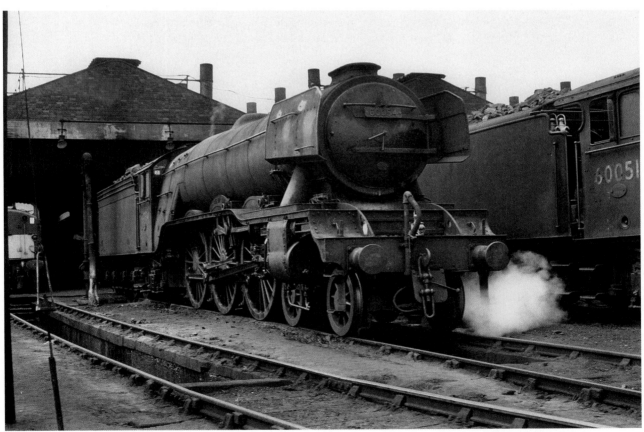

'A3' Class No. 60054 *Prince of Wales* was visiting Doncaster shed on 26 May 1963. Like No. 60051 to its left, No. 60054 saw service from numerous sheds. During its last stint at Grantham (16 June 1957–8 September 1963), its work came to the attention of C.J. Allen. In *The Railway Magazine* of December 1958, he reported that, with a load of ten coaches (350 tons), worked from Grantham to York with the 9.00 a.m. from King's Cross, 'A brilliant start was made from Grantham with 90mph at Claypole . . . Retford was passed in 28 minutes – 2¼ minutes less than the start-to-stop schedule of the diesel-hauled *Master Cutler*!' *(K.C. H. Fairey)*

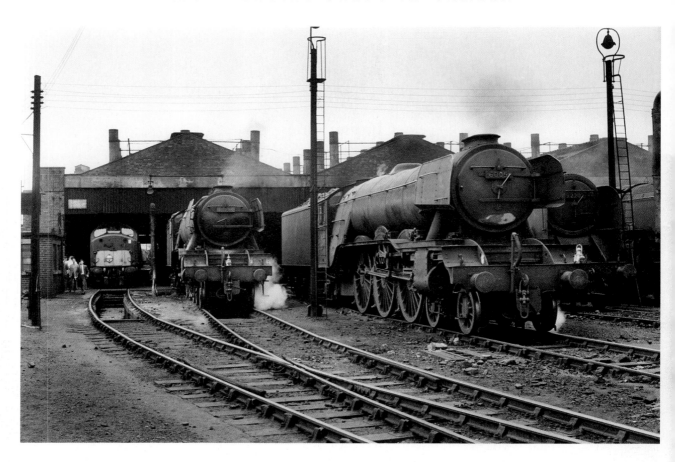

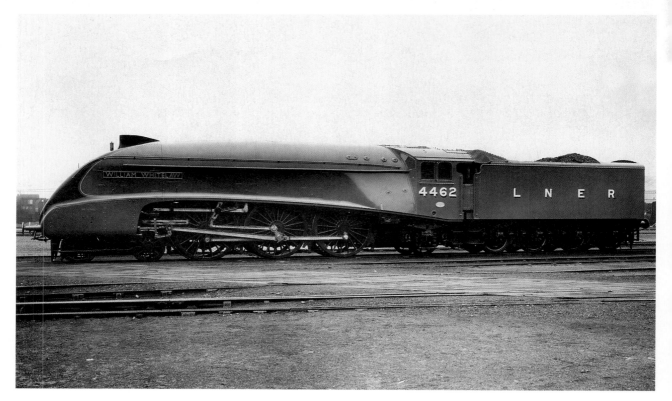

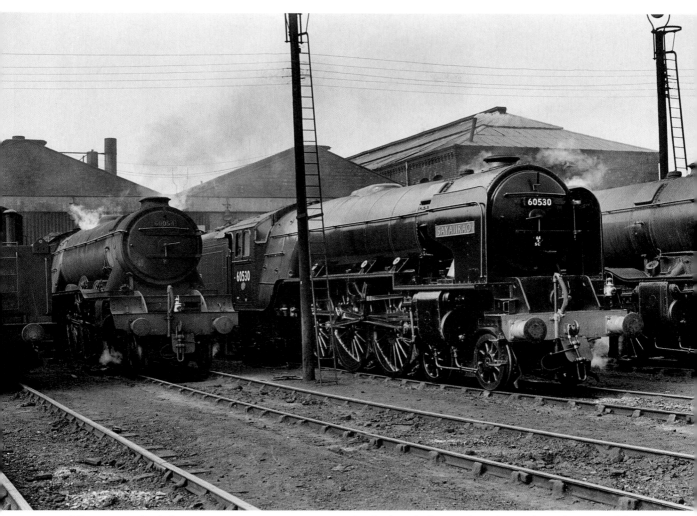

A view of Doncaster shed that we, as young trainspotters who had cycled 12 miles, always hoped we would see. Haymarket's Peppercorn 'A2' Class No. 60530 *Sayajirao*, having received a general overhaul at the 'Plant' from 7 June to 21 July 1960, was standing in the yard three days later in preparation for its return to Scotland. Its near-neighbour, 'A3' Class No. 60054 *Prince of Wales*, had itself emerged from a 'general' some four months earlier but looked surprisingly unkempt. *(K.C.H. Fairey)*

*Opposite, top:* A group of visitors to Doncaster shed, on 26 May 1963, walked past an English Electric Type 4 diesel locomotive and into the yard. There, on adjacent roads, were 'A3' Class No. 60054 *Prince of Wales* and No. 60051 *Blink Bonny*. No. 60054, a Grantham engine at the time, was, four months later, transferred to Doncaster. Between entering service at Grantham in October 1924 and its withdrawal in November 1964, No. 60054 had twenty changes of shed. Its longest period of association with any depot was its initial eighteen years (October 1924–January 1942) as a Grantham locomotive. *(K.C.H. Fairey)*

*Opposite, bottom:* Doncaster Drawing Office photograph No. 41/62 of 'A4' Class No. 4462 *William Whitelaw* was probably taken in July 1941. This coincided with a name change for the locomotive from *Great Snipe* to *William Whitelaw*. No.4462 was the first 'A4' to have the skirting removed from behind and in front of the cylinders although the front skirting (in place here) was reinstated in July 1941. *(D.J. Hucknall Collection)*

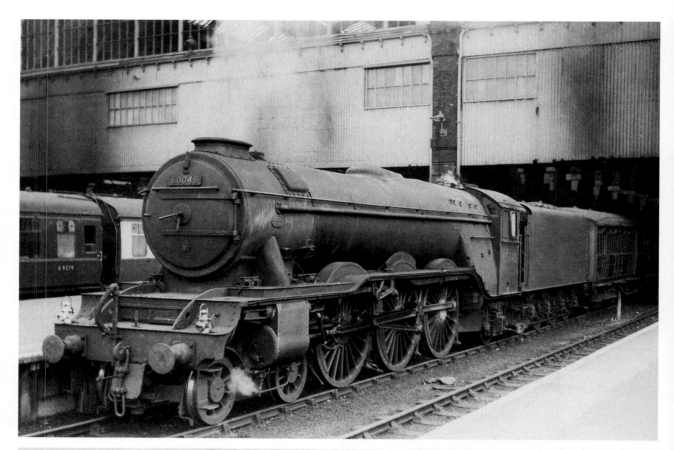

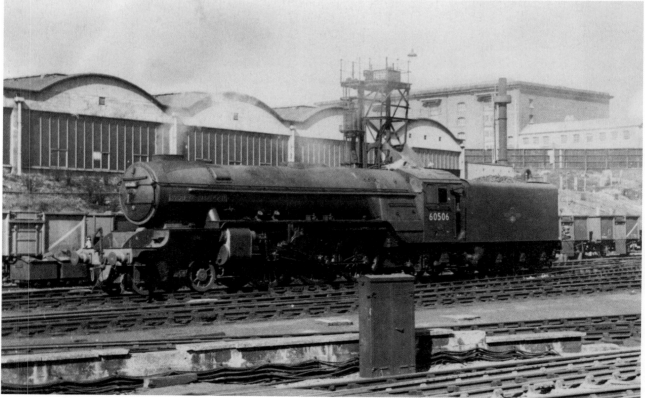

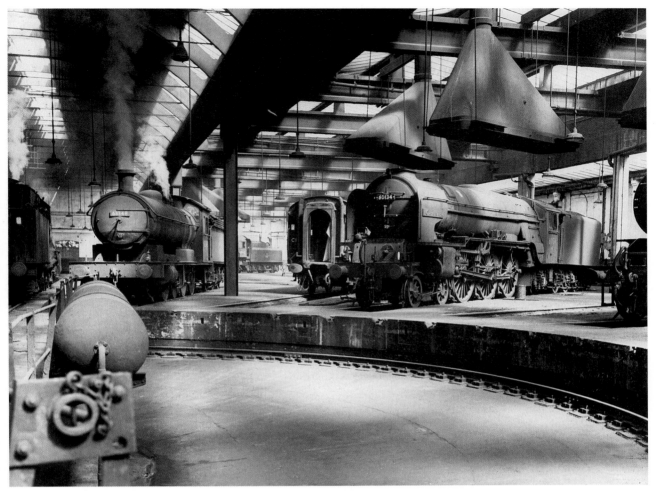

'A1' Class No. 60134 *Foxhunter*, by then transferred to Neville Hill depot, Leeds, was seen on shed on 10 May 1964. Facing the turntable, its crudely painted shed code (55H) on the smokebox door somehow detracts from the locomotive. Also on shed was 'Q6' Class 0–8–0 No. 63348, an engine of Raven design for the North Eastern Railway which performed so competently on mineral trains in the North East. In the late 1950s, No.63348 had been shedded at Selby and also York. It became a Neville Hill engine around 1960. *(G.M. Morrison)*

*Opposite, top:* 'A3' Class No. 60046 *Diamond Jubilee* was a Grantham engine when this photograph was taken at King's Cross station, possibly in late 1959. (No. 60046 had a general overhaul from December 1959 to January 1960 and this photograph may reflect its pre-overhaul state). It was, however, as a shining, single-chimneyed Doncaster engine (from September 1951–June 1959) that I remember it. *(H.G. Usmar/D.J. Hucknall Collection)*

*Opposite, bottom:* To save time, some locomotives arriving at King's Cross were coaled at the station shed. King's Cross 'Bottom' shed had a mechanical coaling system, installed in 1928, which could charge a tender using half-ton skips of coal. Here, Class 'A2/2' No. 60506 *Wolf of Badenoch* stands near the skip hoist with its tender well filled. *Wolf of Badenoch* was a Thompson rebuild of a Gresley 'P2' Class 2–8–2 which had been designed for working the Edinburgh–Aberdeen line. Although a Haymarket engine for most of its time prior to rebuilding and immediately afterwards, it became a New England engine in November 1949. It was withdrawn in April 1961. *(D.J. Hucknall Collection)*

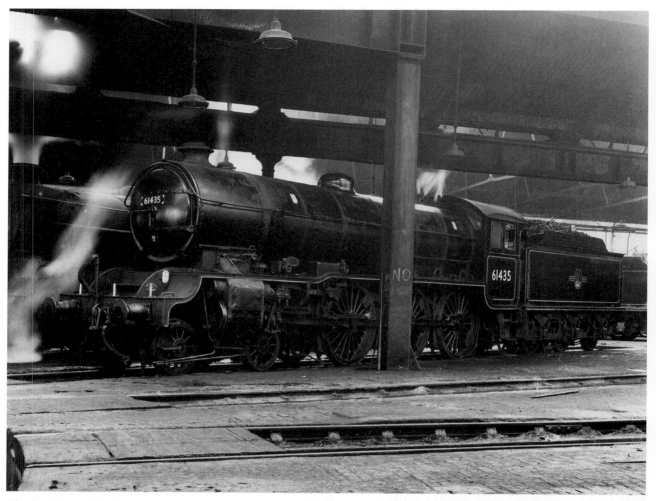

The last Raven 'B16' Class in service was No. 61435. It is seen here at its home shed of Neville Hill on Friday 24 April 1964. The B16s were versatile engines, seldom used on main-line expresses, they were regarded as fast goods engines. At the end of 1935, they were allocated to Darlington (3), York (22), Hull (Dairycoats) (26) and Neville Hill (9) but, from 1943 until 1949, the whole class was stationed at York. At the end of 1949, 41 'B16's were transferred to either Neville Hill or Dairycoats and, in late 1952, Neville Hill had 33 examples. Withdrawal of the class started in January 1958 (with No. 61474) but No. 61435 survived until July 1964. *(G.M. Morrison)*

*Opposite:* Sun streaming through the roof of Ardsley in May 1954 illuminated 'A1' Class No. 60134 *Foxhunter*. No. 60134 was one of five 'A1's allocated initially to Copley Hill depot. They were involved with the shed's four principal workings to London, including the southbound 'Queen of Scots' Pullman, the evening 'Bradford Flyer', the Up 'Yorkshire Pullman' and the 'Harrogate Sunday Pullman'. Some fourteen years later, No. 60134 was transferred to Ardsley. Its last shed was Neville Hill (April 1962) from where it was withdrawn in October 1965. *(J.C. Hillmer)*

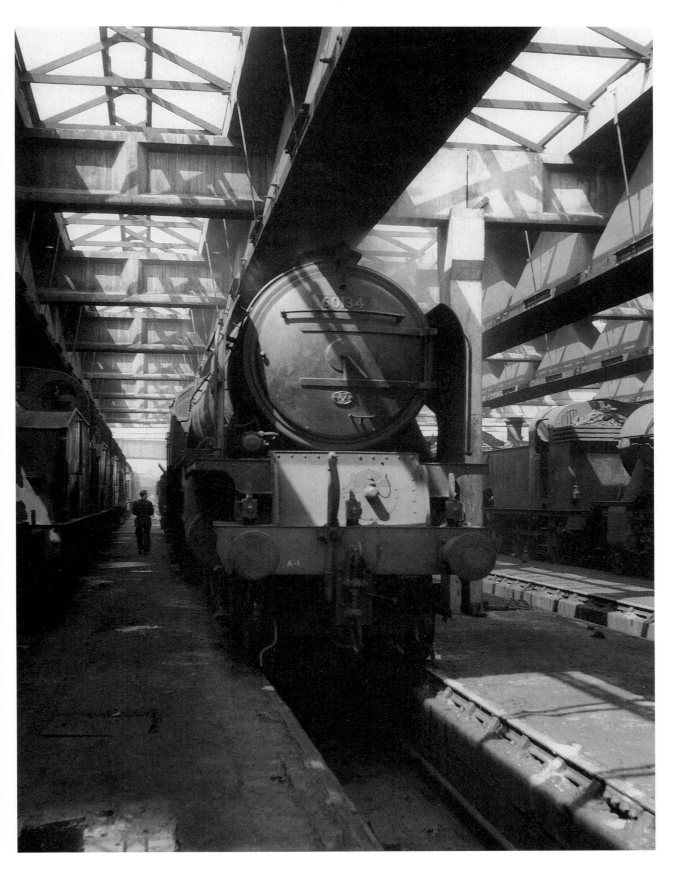

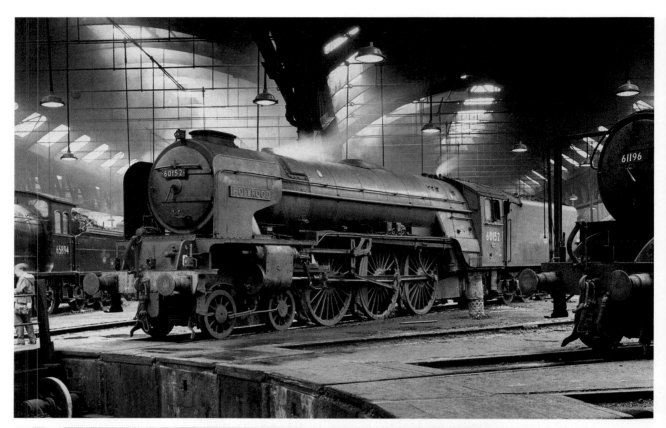

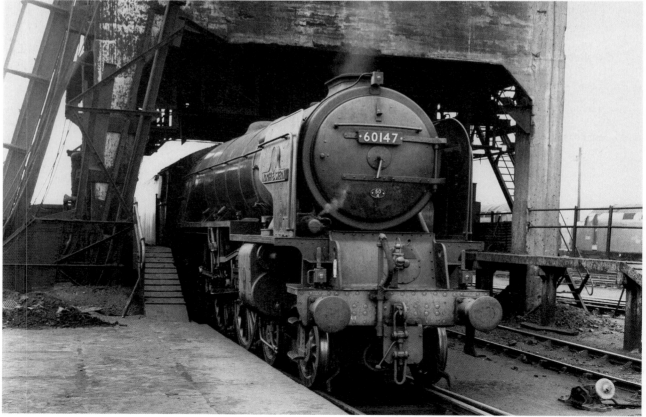

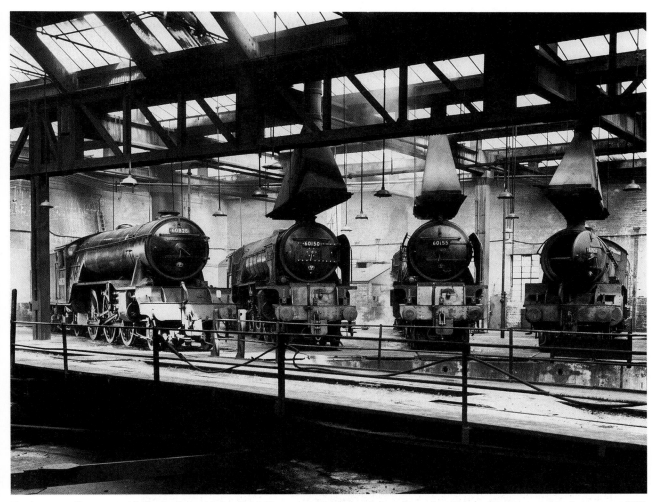

In the roundhouse at York shed on 11 April 1964 was a selection of that depot's engines. Present at the time were 'V2' Class No. 60828, 'A1's No. 60150 *Willbrook* and No. 60155 *Borderer* and 'B1' Class No. 61021 *Reitbok*. Of the 'A1's, Nos 60150 and 60155 served Gateshead well for many years in the 1950s, working up and down to London with the 'Night Scotsman' with a return trip to Edinburgh being fitted into the period between the King's Cross legs. *(G.W. Morrison)*

*Opposite, top:* A superb photograph of Peppercorn 'A1' Class No. 60152 *Holyrood* at York shed, in the company of a Doncaster 'B1' Class No. 61196 and 'J27' Class No. 65894, on 6 February 1965. *Holyrood* was allocated to Haymarket in July 1949 and, apart from a couple of short stints at Polmadie (from which shed it worked to Edinburgh, Crewe and Carlisle), .it remained one of that shed's well-cared-for locomotives until 1963. After a year at St Margaret's (September 1963–September 1964), No. 60152 went to York shed from where it was withdrawn in June 1965. *(G.W. Morrison)*

*Opposite, bottom:* Under the coaling plant at York shed on 11 April 1964 was 'A1' Class No. 60147 *North Eastern*. The coaler was a tall, ugly structure built by the Mitchell Engineering Co. in the early 1930s for the LNER. It had a capacity of 500 tons and dominated the shed and its surroundings north of the station. No. 60147 was one of Gateshead's original 'A1's and was transferred to York in September 1963. As can be seen, the locomotive was fitted with electric lighting powered by a turbo-generator located on the right-hand-side running plate behind the smoke deflector. *(G.W. Morrison)*

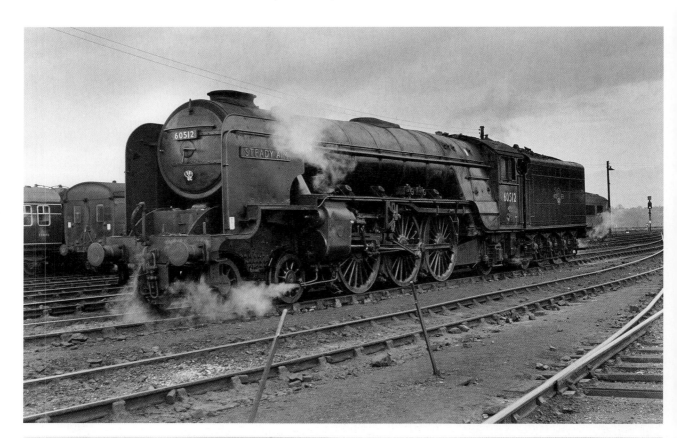

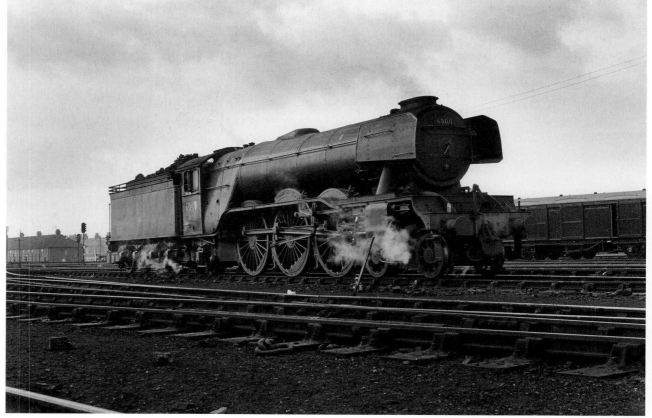

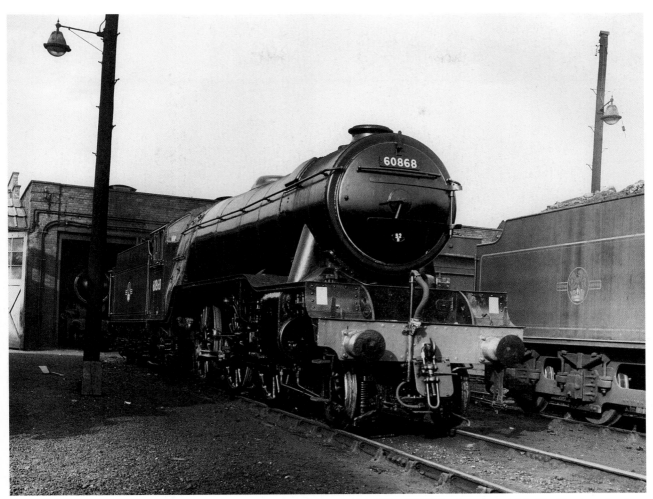

Probably fresh from the works, one of Heaton's 'V2' Class 2–6–2s No. 60868 is shown outside Darlington shed on 29 September 1962. The shed was a seven-road structure built in the late 1930s as a replacement for an 1880s structure which had been a wagon repair shop. The latter had the appearance of the stable block of some decaying stately home. With parts of the roof without slates, Hooper (1984) preferred to describe it as looking like 'a besieged regimental HQ'. *(G.W. Morrison)*

*Opposite, top:* Thompson 'A2/3' Class No. 60512 *Steady Aim*, as No. 512, entered service in August 1946 from Gateshead shed. The following month, however, it was transferred to Heaton and it worked from there until 1952 when it became a York engine. At York, it was involved with passenger and goods turns on the East Coast Main Line until 1962. In December 1962, as part of an exercise to eliminate the Class from the North Eastern Region's stock, it was sent to St Margaret's. In a further move the following September, No. 60512 was allocated to Polmadie but saw little work. It was eventually withdrawn from Dundee in June 1965. *(K.C.H. Fairey)*

*Opposite, bottom:* The personnel at King's Cross 'Top' shed seemed to take care of the locomotives in their care, particularly those used on express passenger turns. Griffiths and Hooper (1989) indicated that the shed employed full-time cleaners at one time, rather than 'lads on the footplate grade'. Here, on 13 May 1962, King's Cross 'A3' Class No. 60110 *Robert the Devil* is shown at York depot looking very presentable. *(K.C.H. Fairey)*

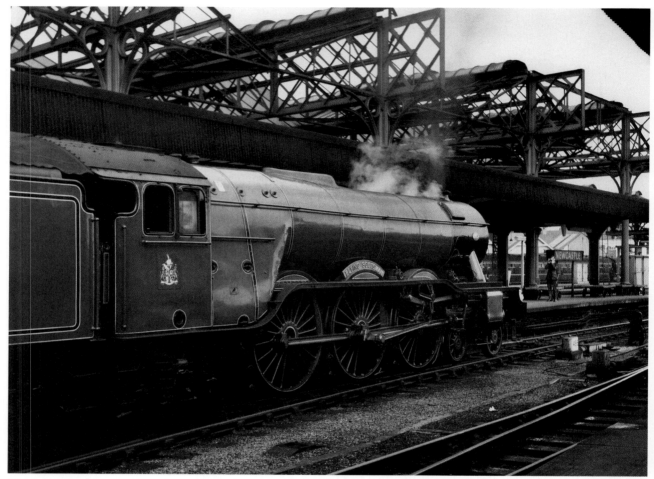

*Flying Scotsman* is now the sole survivor of Gresley's un-streamlined Pacifics. It was withdrawn from service in January 1965 and bought by Alan Pegler. It was subsequently overhauled at Doncaster Works where its trough smoke deflectors were removed and a single chimney refitted. Its original number (4472) was painted on the engine's buffer beam and cab sides. No. 4472 entered Darlington Works in March 1965 for a boiler change and general overhaul. During this period, the works painted the cylinders in its own style – green with black-and-white lining. It is in the Darlington livery that No. 4472 was seen at Newcastle station, probably in September 1967, when it worked the 'Scunthorpe Forum Flyer'. *(David Hucknall)*

*Opposite, top:* 'A3' Class No. 60040 *Cameronian* is seen on stand-by duty at Darlington station on 29 May 1960. As new, *Cameronian* was allocated to Haymarket. About two years later (in November 1936), it was transferred to Gateshead and it remained associated with the North East for the remainder of its life. Although a Darlington engine at the time of this photograph, it was moved to Gateshead the following month, although it returned to Darlington's stock two years later. *(David Holmes)*

*Opposite, bottom:* Published maps (see, for example, BRILL 14, 8 (2004)) show that Gateshead shed, certainly in 1947, was a large, rambling structure. It enclosed at least four in-line turntables and their associated roads (Hoole 1972). In this photograph, taken on 25 June 1950, one of Wilson Worsdell's 'G5' Class 0–4–4Ts stands outside this daunting edifice. The 'G5's were described as 'sturdy yet economical' and 'equally at home on branch-line or heavy suburban passenger trains' (see RCTS 1964, *Locomotives of the LNER, Pt. 7*). Between the 'G5' and the building is what appears to be a Raven 'A7' Class 4–6–2T. *(H.C. Casserley)*

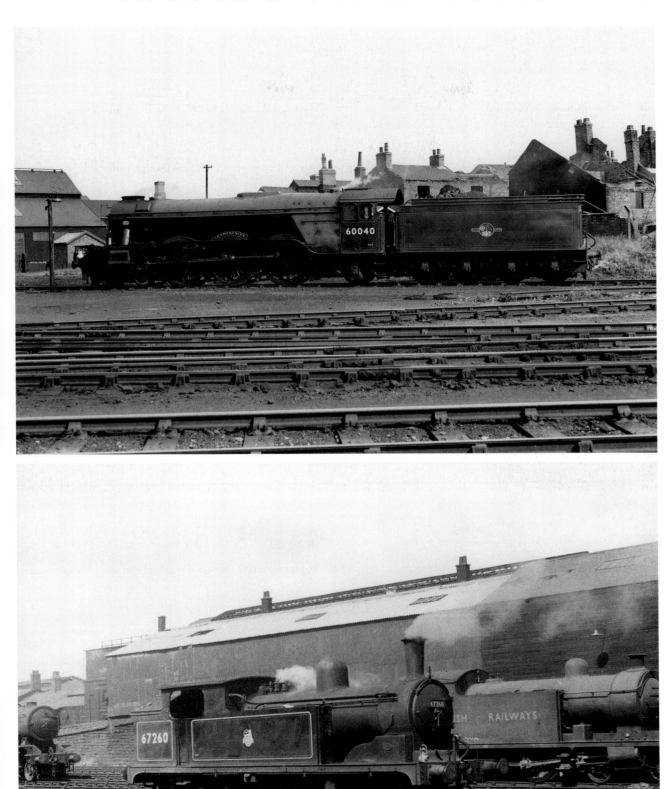

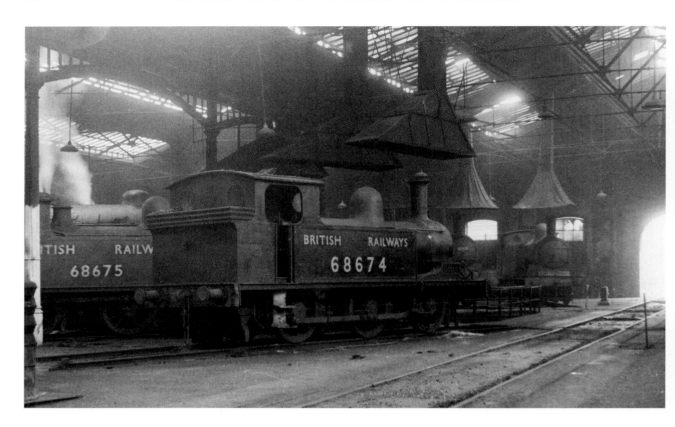

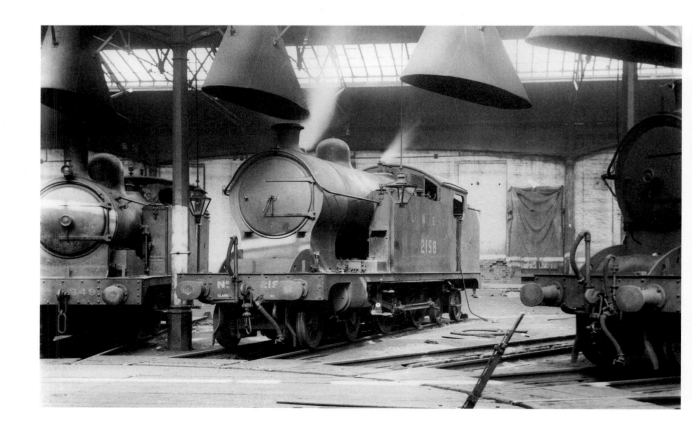

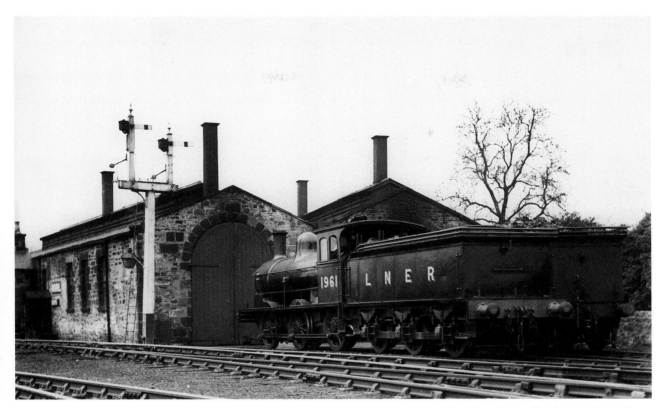

Lines to Barnard Castle were opened in 1856 (by the Stockton and Darlington Railway) and 1861 (by the South Durham and Lancashire Railway). The Stockton and Darlington and, eventually, the NER acquired the whole line and its branches. The 1861 station was a substantial stone structure with an overall roof to protect the passengers. The line, however, existed mainly for freight and, opposite the station, were an extensive series of sidings. Here, one of W. Worsdell's 'P1' Class (LNER 'J25') 0–6–0s, No. 1961, stands outside the stone shed at Barnard Castle. The structure was actually two sheds built at a slight angle to each other. It was closed a few years after this photograph was taken on 4 June 1935. (No. 1961 became No. 65645 under British Railways. It was withdrawn in April 1962). *(H.C. Casserley)*

*Opposite, top:* 'J72' Class (Wilson Worsdell's 'E1' Class) Nos 68575 and 68574 were seen inside the cavernous Gateshead shed on 26 May 1950. At the time, Gateshead had 9 'J72's. The two examples shown here were withdrawn in September/October 1961 – after approximately sixty-three years in service shunting carriages and goods and making local trip workings. *(H.C. Casserley)*

*Opposite, bottom:* In one of the four roundhouses at Gateshead shed on 1 April 1934 were 'H1' Class 4–4–4T No. 2158 (built at Darlington in March 1914 and subsequently re-built as an 'A8' Class in May 1935). The 'A8's worked heavy suburban duties and long-distance coast trains 'with vigour and reliability' (RCTS, 1964). To the left of the picture is an 'N8' Class 0–6–2T No. 349, built at Darlington in February 1889. It was withdrawn in June 1937. *(H.C. Casserley)*

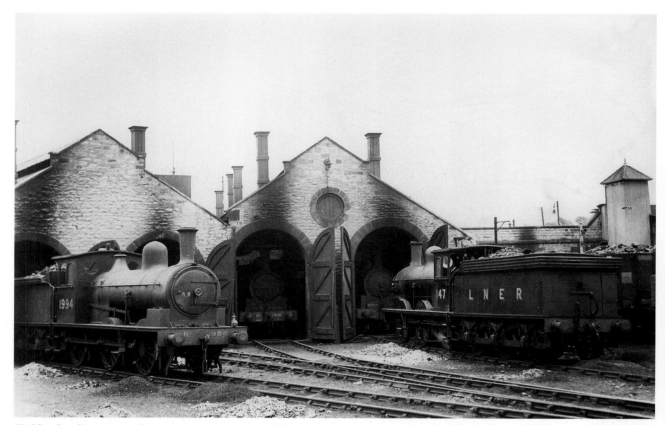

Kirkby Stephen is seen here as it was on 5 June 1935 with several engines 'on shed' including 'J25' Class 0–6–0 No. 1994 and, inside the shed, 'G5' Class 0–4–4T No. 1916, among others. The shed was a sturdy stone structure which had its origins with the engine accommodation built by the South Durham and Lancashire Union Railway in 1861. No. 147's tender was preventing a view of Kirkby Stephen station. *(H.C. Casserley)*

# Chapter Two

# The London Midland Region

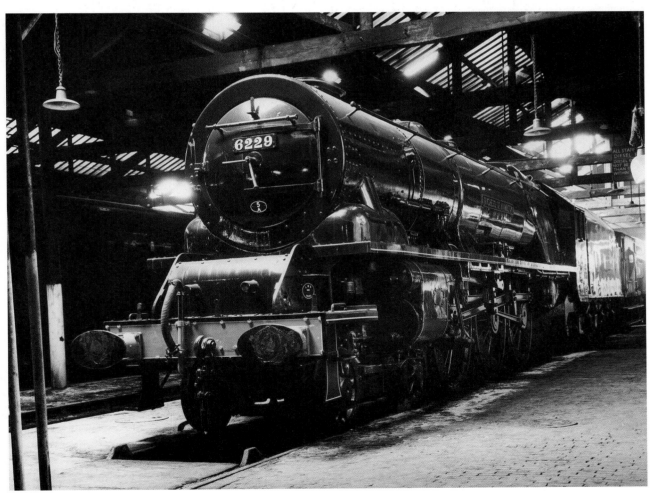

Stanier Pacific No. 6229 *Duchess of Hamilton* was completed at Crewe Works (Lot 145) in 1938 and entered service on 7 September 1938. Appropriately, it is seen here at Crewe North shed on Saturday 18 April 1964, having been restored to its original state before departure to Pwllheli for display at the Butlin's Holiday Camp. *(G.W. Morrison)*

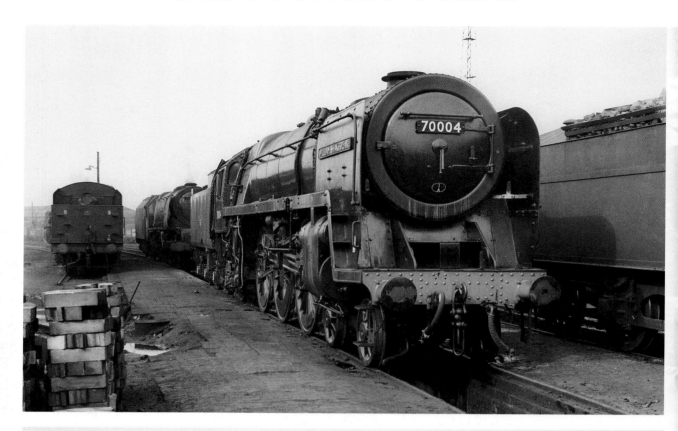

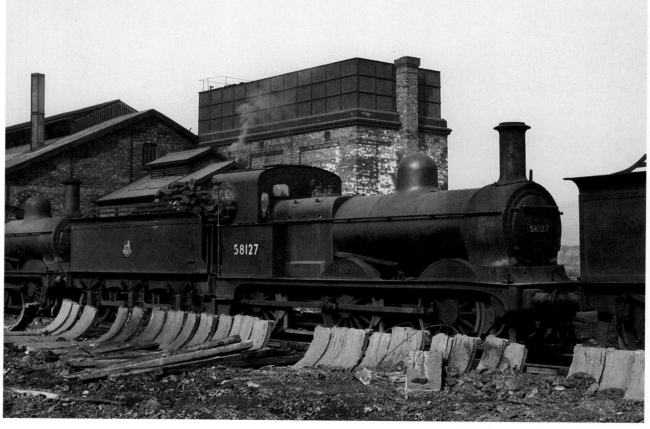

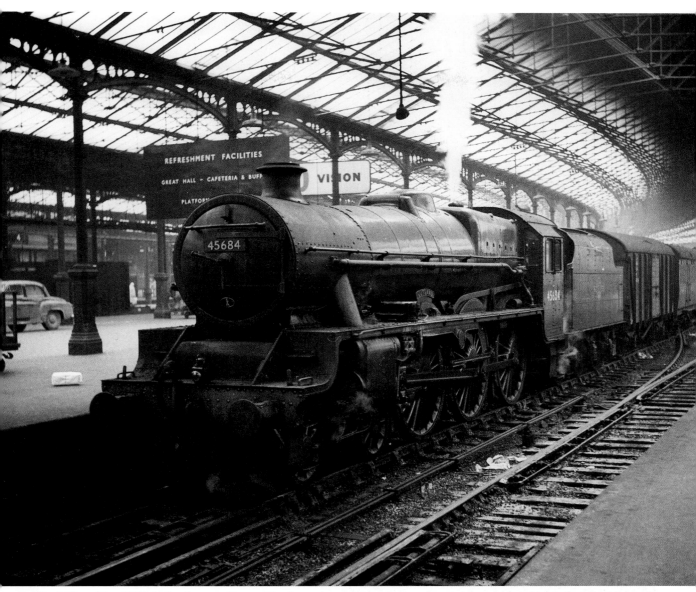

'Jubilee' Class No. 45684 *Jutland* was a Crewe North engine at the outset and, apart from a brief period at Bushbury, it remained a Crewe engine until December 1960. Here, in mid-1960, No. 45684 stands at Platform 2 of Euston station waiting for the stock of its train to be hauled away. (*H.G. Usmar/D.J. Hucknall Collection*)

*Opposite, top:* Willesden's 'Britannia' No. 70004 *William Shakespeare* stands outside Crewe North shed on 18 April 1964, probably fresh from overhaul at Crewe Works. No. 70004 was initially allocated to Stewarts Lane shed in November 1951 and regularly worked the 'Golden Arrow' until transferred in November 1958. No. 70004 was eventually withdrawn in December 1967. (*G.W. Morrison*)

*Opposite, bottom:* Canklow's Johnson Class 2F 0–6–0 No. 58127 was one of a group of locomotives introduced in 1917 by the Midland Railway. It was a very familiar engine to me when I was a boy in the early 1950s. I would see it frequently in the sidings which served the Up goods line that ran behind the rarely used Platform 4 at Parkgate and Rawmarsh station. It never seemed to be busy and spent long periods standing quietly ready for its next duty. When photographed in March 1953, it was standing in the siding which emerged from the South end of Canklow shed. Behind the locomotive, part of the south and west elevations can be seen. Behind the tender is the shed's fitting shop. (*J.C. Hillmer*)

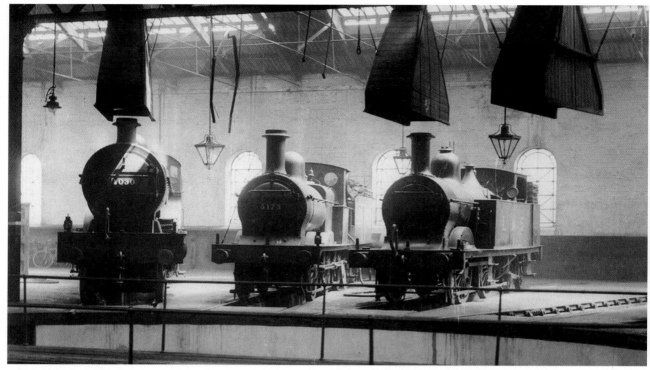

The Midland Railway's shed at Bristol was opened in 1873. It was a standard roundhouse (Hawkins and Reeve (1981)). This view of the interior of the shed on 27 May 1935, shows '4P' Class Compound No. 1030 and an 0–4–4T No. 1228 around the turntable. (*H.C. Casserley*)

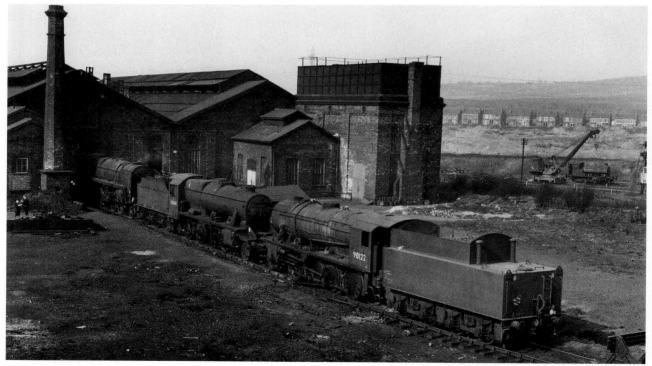

A view of the South elevation of Canklow shed, looking north-east on 12 April 1964, shows the water tank and support, with the fitting shop sharing a common wall, and the sand house and chimney. In the yard were three types of freight locomotive, '9F' Class No.92005 (of York), '8F' Class No. 48368 (formerly allocated to Willesden, Northwich and Speke Junction sheds in the 1950s) and an 'Austerity' Class 2–8–0 No. 90122. (*David Hucknall*)

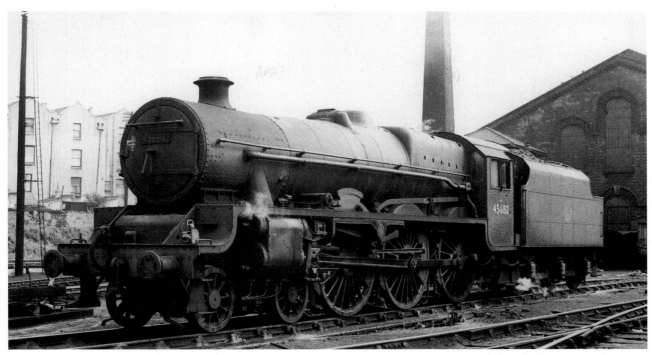

With a background dominated by the sand house chimney and part of one of the three pitches of the shed building, 'Jubilee' Class No. 45682 *Trafalgar* is shown on one of the roads leading into Bristol (Barrow Road) depot in July 1963. No. 45682 had a long association with Barrow Road and, in the 1950s, it was a regular sight on the former LMS line through Rotherham heading Bristol–York or Bristol–Newcastle trains. *(C.L. Caddy)*

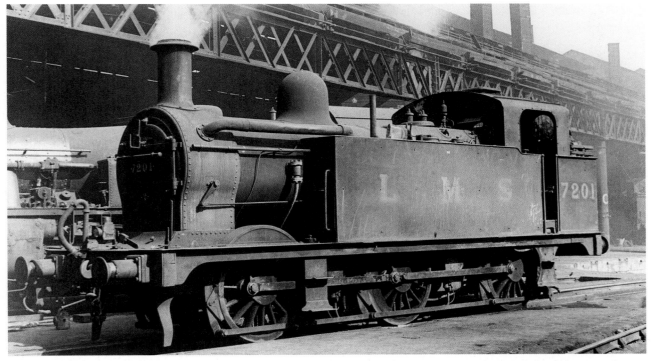

Former Midland Railway Johnson '3F' Class 0–6–0T No. 7201, was a Cricklewood engine when this photograph was taken on 23 August 1947 (it was later transferred to Lancaster). It appears to be fitted with condensing equipment but is specifically mentioned in the contemporary 'stock' books (see, for example, the Winter 1956/57 Edition of *The ABC of British Railway Locomotives*, Ian Allan Ltd) as a non-condensing engine. Cricklewood shed, dating from 1882, dealt with traffic generated by Brent Sidings and the 0–6–0Ts were used on pilot duties for the sidings. *(H.C. Casserley)*

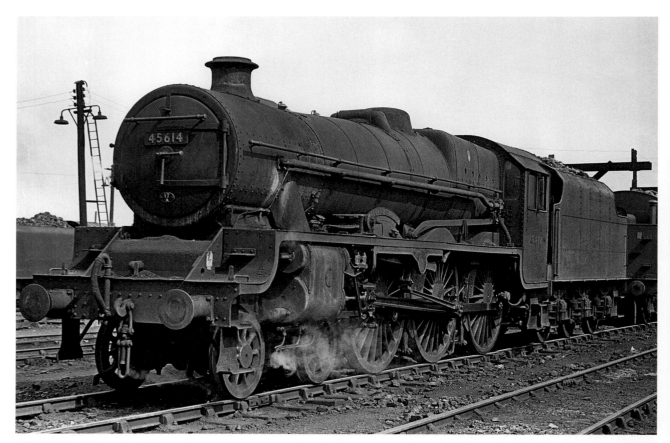

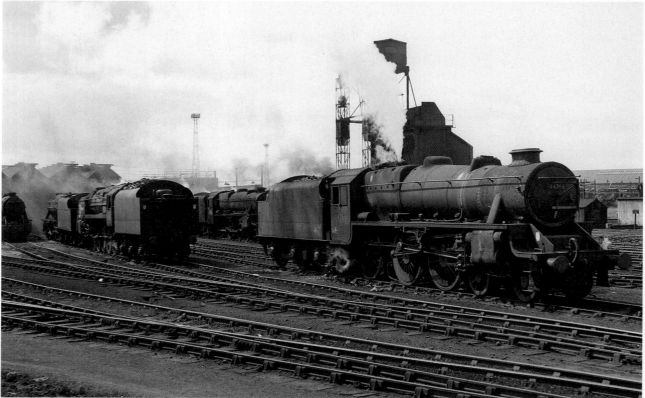

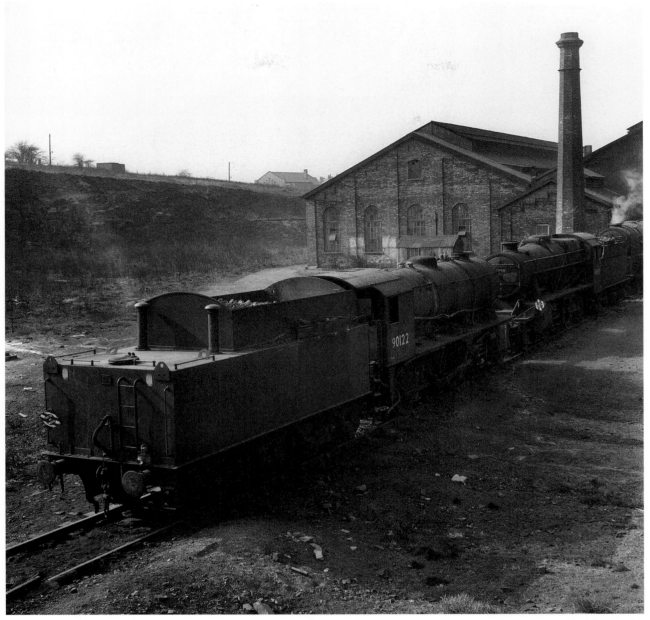

A further view of the rear of Canklow shed looking north-west, taken on 12 April 1964, shows reasonably clearly the brick columns and three-step corbels which supported the roof at the gable end. This was a common feature of many of the former Midland Railways sheds. *(David Hucknall)*

*Opposite, top:* Derby's 'Jubilee' Class No. 45614 *Leeward Islands*, seen here at Cricklewood on 1 July 1963, spent the major part (May 1940–March 1960) of its working life assigned to Kentish Town. It was a regular performer on the former Midland main line to Leeds. By July 1963, servicing facilities for visiting locomotives at Kentish Town were no longer available owing to dieselisation. This may account for 45614's presence at Cricklewood. It was obvious, however, that by 1963 little care was being taken of the 'Jubilee'. *(D.J. Hucknall Collection)*

*Opposite, bottom:* Looking roughly south-west towards the coaling plant, this view of Crewe South shed, on 8 July 1967, shows an apparently very busy scene. In the foreground, Class 5 No. 44766 – introduced in 1947 and fitted with a double chimney – had worked the 05.35 local from Preston. At the time, twelve locomotives were in steam, seventeen were 'dead' and a further thirty, including the Standard 8P No. 71000 (formerly *Duke of Gloucester*), were either stored or withdrawn. *(W.A.C. Smith)*

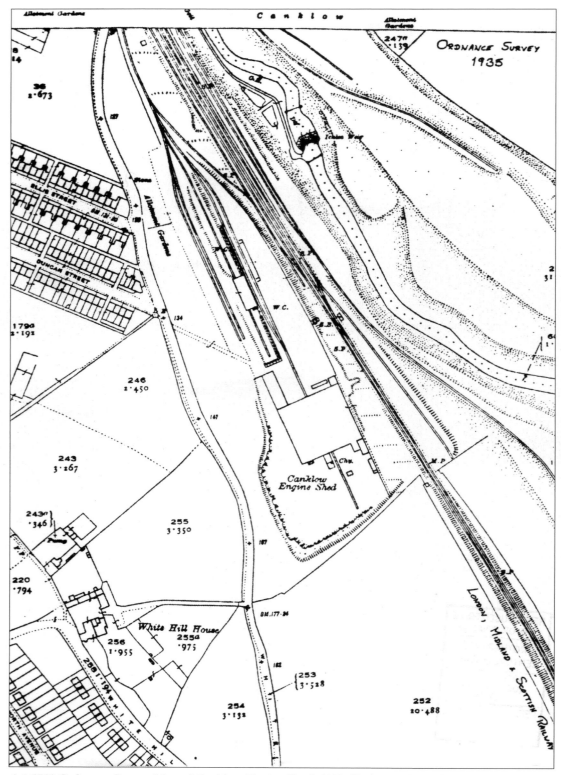

A 1:2500 Ordnance Survey Map of Canklow Engine Shed, 1935. *(Ordnance Survey)*

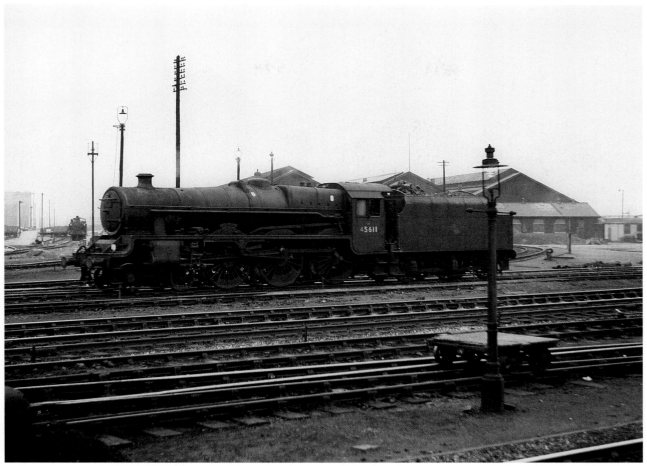

The exploits of Stanier's 'Jubilee' Class from the 1930s to the late 1950s have been reported widely (see, for example, C.J. Allen, *The Railway Magazine*, November 1938; id., *ibid*., August 1954; id, *Trains Illustrated*, April 1957; O.S. Nock, *The Railway Magazine*, November 1964). Nock, having studied the logs of many runs, even concluded that their later performances were generally superior to those lauded between 1935 and 1939. 'Jubilee' Class No. 45611 *Hong Kong* (allocated to St Pancras from February 1935–September 1937; Leeds (April 1940–March 1945); Nottingham (May 1948–November 1961) has not, perhaps, been praised to the extent of, for example, *Rooke* or *Keyes* or *Bhopal* but, nevertheless, it would have played its part. Seen here against a background of Derby engine shed, in about 1960, No. 45611 would probably have been in no condition to challenge the performance of a Sulzer 2500hp diesel on a main line train. (*D.J. Hucknall Collection*)

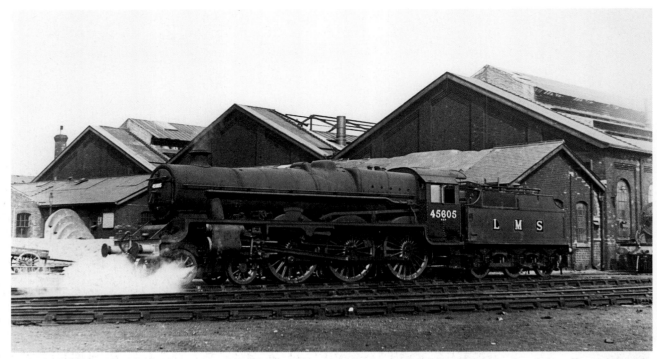

Looking from a westerly direction, near London Road Junction, Derby, with Engine Shed No. 4 and the offices alongside its northern wall, Holbeck's 'Jubilee' Class No. 45605 *Cyprus* can be seen. The date was 10 July 1948 and 45605 appears to have been recently renumbered. *(H.C. Casserley)*

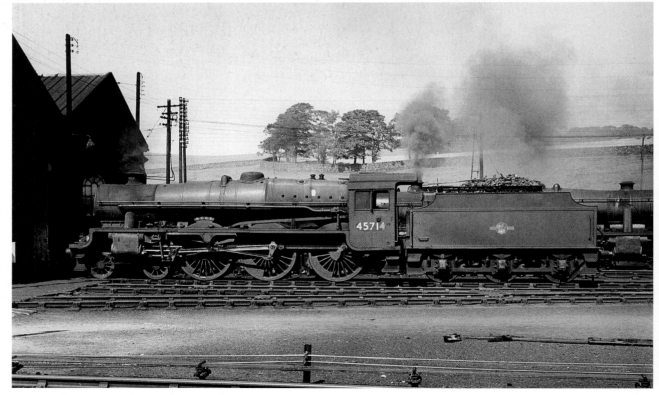

A view, looking to the north-east, shows part of the yard and the entrance to Hellifield shed on 29 June 1961. A Kingmoor 'Jubilee' No. 45714 *Revenge* dominates the scene. *Revenge* was a Kingmoor engine for most of its working life. Having been allocated there in November 1936, it remained a Carlisle engine until September 1961. *(G.W. Morrison)*

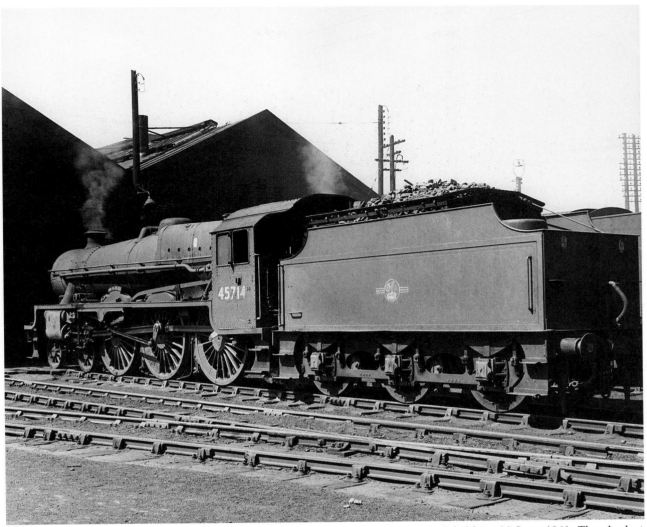

This is a fine and unusual portrait of 'Jubilee' Class No. 45714 *Revenge* at Hellifield on 29 June 1961. The shed at Hellifield was opened by the Midland Railway in 1880. It was a straight shed and, as this view to the north shows, it had twin roof pitches, each covering two roads. When it was opened, Hellifield was a significant junction and its men worked trains to Carlisle, Leeds, Bradford, Manchester and Morecambe. *(G.W. Morrison)*

Kentish Town had three roundhouses (Engine Sheds Nos 1, 2 and 3). Inevitably, these suffered roof damage during the Second World War and they were subsequently re-roofed. No. 2 was the last shed to be dealt with. Even by 1959, as this photograph shows, the work had not been completed. On 24 May 1959, three locomotives – 'Black 5's Nos 44658 and 45279 and '2P' Class 4–4–0 No. 40657 – were seen in the roundhouse. Of the engines, No. 40657 had been transferred to Kentish Town (14B) from Crewe North in November 1957 while the 'Black 5's were 14B engines at the time and had been throughout the 1950s. *(W.A.C. Smith)*

*Opposite, top:* A much-travelled Standard Class 4 No. 80059 pauses at the Down platform of Evercreech New station in the summer of 1965. The engine, originally allocated to Kentish Town in March 1953, was subsequently transferred to Chester Midland (October 1956), Bangor (May 1958), Neasden (September 1958), Dover (December 1959), Ashford (January 1960), Tonbridge (May 1961), Exmouth Junction (June 1962), Templecombe (September 1964), Barrow Road, Bristol (June 1965) and, eventually, Bath in July 1965. Evercreech New station was located between Evercreech Junction and Shepton Mallet. It was a small station and rarely, if ever, featured in Ivo Peters' photographs. *(D.J. Hucknall Collection)*

*Opposite, bottom:* 'Jubilee' Class No.45572 *Eire* (Bristol Barrow Road, October 1947–September 1961) was a very common sight to South Yorkshire trainspotters. It always, however, seemed to be kept in fine condition by the shed staff at Barrow Road. Here, the engine is shown standing in the yard at Millhouses shed, Sheffield, sometime in 1958. *(K.R. Pirt, with permission of BLP)*

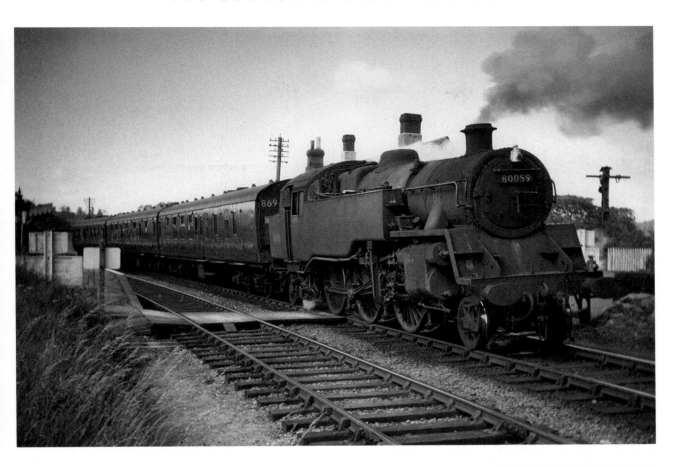

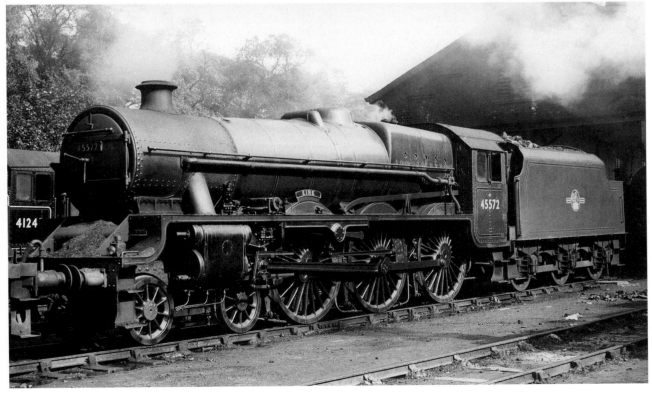

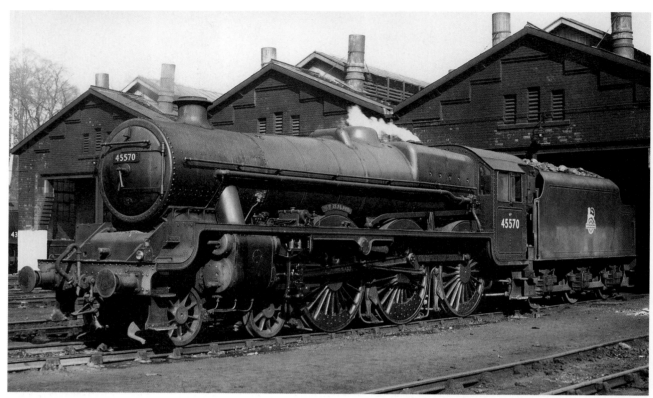

'Jubilee' Class No.45570 *New Zealand* (Millhouses June 1957–December 1961) was seen at its home shed sometime in 1958. Millhouses shed was opened in 1901. An eight-road shed, it was the largest of the straight sheds built by the Midland. Millhouses, for most of its working life, was the shed for passenger locomotives in the Sheffield and Rotherham area working on the former Midland lines between Leeds and the South. A fascinating description of Millhouses shed and associated activities is given in an article by J.R. Morton published in *LINK* (the Journal of the Engine Shed Society, Issue 75, p. 55, Winter 2005). Closure of Millhouses shed came with the dieselisation of expresses on the former Midland mainline. As Morton reports, 'the lights went off promptly at 10pm on the last day of 1961'. *(K.R. Pirt, with permission of BLP)*

*Opposite, top:* Two of Stanier's magnificent Pacifics, No. 46251 *City of Nottingham* (in red livery) and No. 46237 *City of Bristol* (in green livery) stood in the shed yard at Carlisle Upperby on 12 July 1964. It seems hard to believe but both were withdrawn some two months after this photograph was taken. In the 1950s, No. 46251 was associated with several sheds on the West Coast Main Line including Camden, Upperby, Edge Hill and Crewe North. No. 46237 was allocated to either Camden or Upperby but, in the spring of 1955, it spent one month based at Old Oak Common shed and hauled West of England expresses between Paddington and Plymouth. *(W.A.C. Smith)*

*Opposite, bottom:* 'Patriot' Class No. 45503 *The Royal Leicestershire Regiment* is seen on the outside turntable at Upperby shed, Carlisle, on 15 June 1958. To the left of the picture can be seen part of the octagonal roundhouse, very similar to the building at Leicester shed, which British Railways had built in the mid-1950s. The reason for this was that, according to Hawkins and Reeve (1981), 'By Nationalisation, the shed must have been one of the most decrepit (for a major depot) on the LMS'. Of the engine, No. 45503 was a Crewe North locomotive for most of the 1950s, apart from brief periods at Upperby (September–October 1956), Newton Heath (July–September 1958) and Warrington (June 1959–June 1960). *(W.A.C.Smith)*

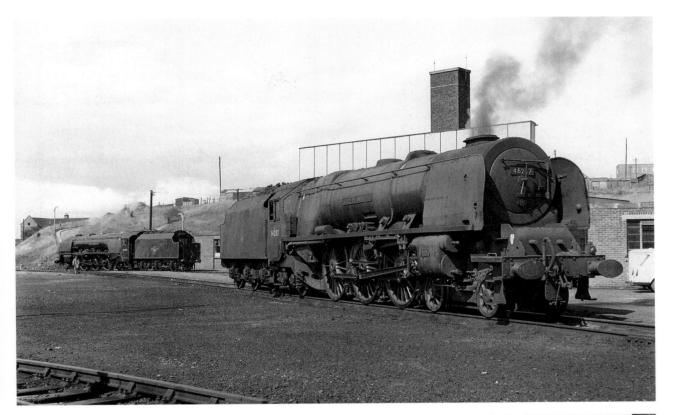

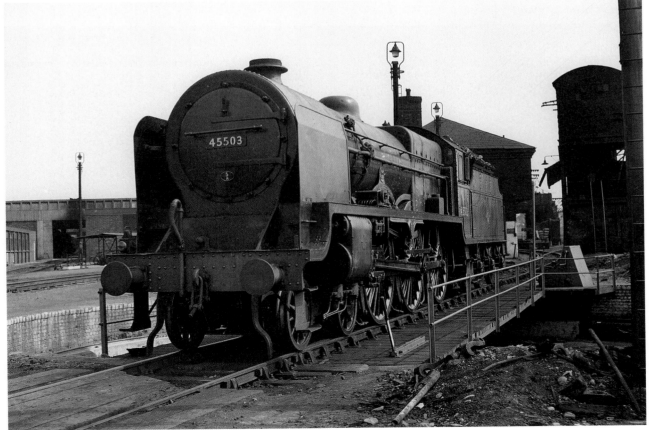

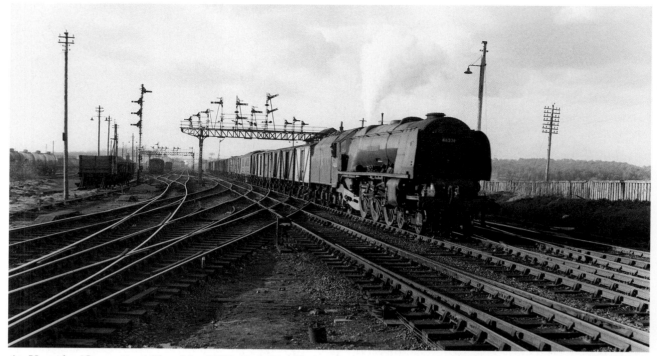

An Upperby 'Coronation' Class No. 46236 *City of Bradford* is seen at Mossend with, probably, a Carlisle–Glasgow freight train. Mossend, to the south-east of Glasgow, lies between Motherwell and Coatbridge. Mossend has two significant junctions. At the South Junction, the lines deviate to follow either the East Curve or the South Curve. At the North Junction, the Mossend North Curve joins the line. It remains an important centre for freight handling in the south of Scotland. *(W.A.C. Smith)*

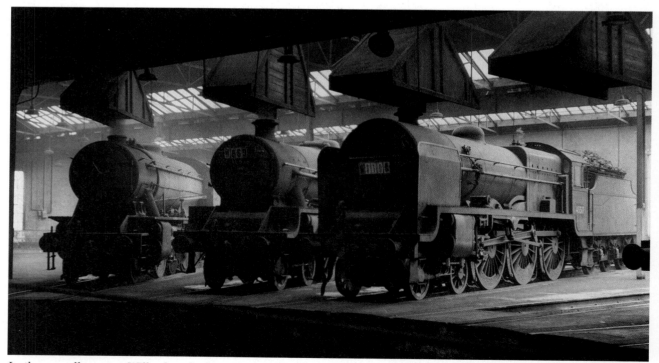

In the roundhouse at Willesden shed on 12 August 1956, were 'Austerity' Class 2–8–0 No. 90726 (of Farnley Junction shed), Longsight's 'Jubilee' Class No. 45638 *Zanzibar* and Willesden's un-named 'Patriot' Class No. 45517. The latter engine was transferred to Willesden from Upperby in June 1953 and, later, re-allocated to Bank Hall in July 1958. In contrast, No. 45638 remained on Longsight's books throughout the 1950s. *(G.W. Morrison)*

# Chapter Three

# The Scottish Region

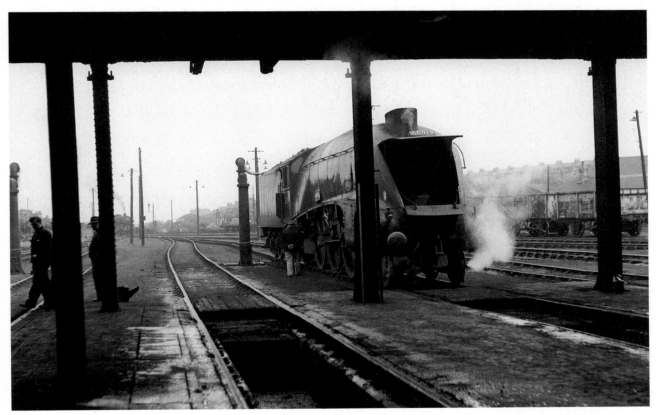

For the first six weeks of the summer timetable of 1966, 'A4' Class No. 60019 *Bittern* was rostered for the 08.25 from Buchanan Street Glasgow to Aberdeen ('The Grampian'), and returned to Glasgow on the 17.15 ('The Granite City'). No. 60019 had been transferred to Aberdeen in November 1963, having been a Gateshead engine for the previous twenty years. The locomotive is seen here being serviced at Ferryhill shed, Aberdeen, on 15 June 1966, having worked 'The Grampian'. It would return, of course, with 'The Granite City'. Apart from spending the following month out of service, it worked to the end and was withdrawn in September. *(W.A.C. Smith)*

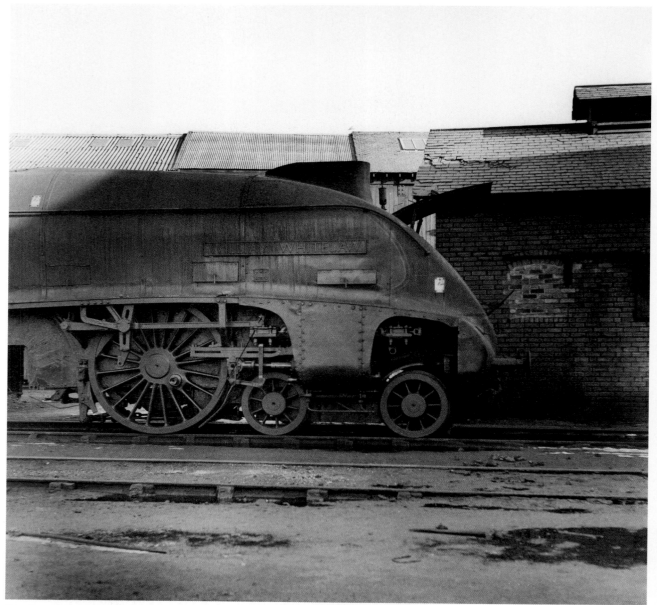

Work was in progress on 'A4' Class No.60004 *William Whitelaw* as it stood outside the repair shop at Ferryhill on 6 March 1965. Immediately behind No. 60004 is the sand kiln and, further back, part of the coaling stage can be seen. As No. 4462 *Great Snipe*, the locomotive was initially allocated to King's Cross. Thereafter, it gradually moved to the north via Gateshead (February 1938), Heaton (June 1940), Haymarket (July 1941) and Aberdeen (June 1962), where it remained, apart from a brief return to Haymarket, until it was withdrawn in July 1966. *(David Hucknall)*

*Opposite, top:* 'N15' Class 0–6–2T No. 69125 was seen in the yard of Ferryhill shed, Aberdeen, on the morning of 3 August 1953. (The north-west corner of the shed, together with a 'J38' Class, is in the left background.) The 'N14's and 'N15's were 'most useful engines that did a tremendous amount of work over a long period' (RCTS, *Locomotives of the LNER*, Part 9A, 1977). No. 69125, as LNER No. 9863, was transferred to Kittybrewster from Edinburgh in 1927 – indeed this shed name is stencilled on the buffer beam – for shunting in the former GNoSR goods yard. For twenty-three years this was the engine's job, but in 1950 it was transferred to Ferryhill for duties at Aberdeen station. It was withdrawn in March 1954. *(David Holmes)*

*Opposite, bottom:* Rather a long way from its home shed of Aberdeen Ferryhill, 'A4' Class No. 60024 *Kingfisher* was at Salisbury station on 27 March 1966. It was heading an LCGB Special, 'The A4 Commemorative Rail Tour'. *(George Harrison/D.J. Hucknall Collection)*

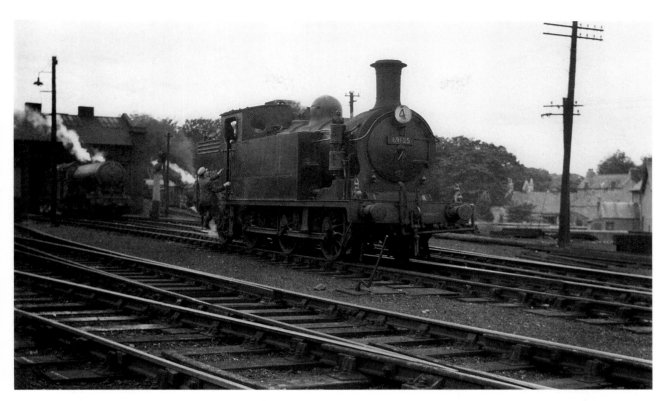

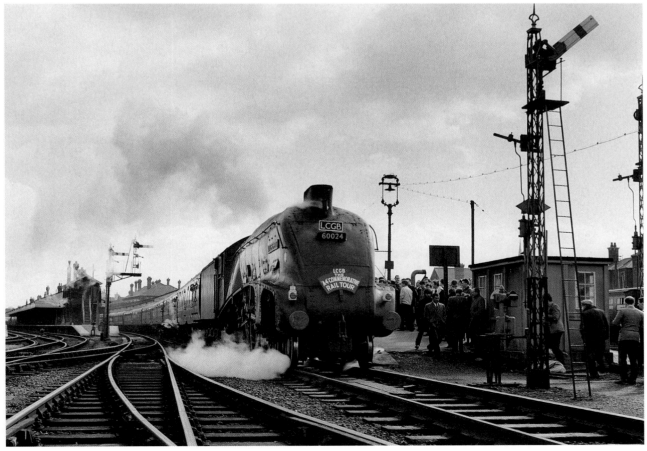

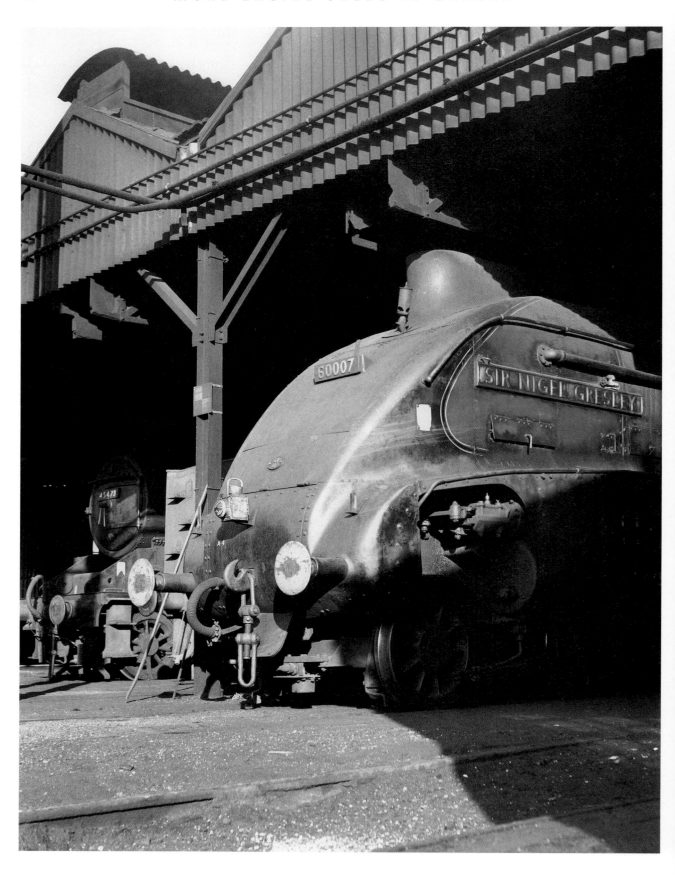

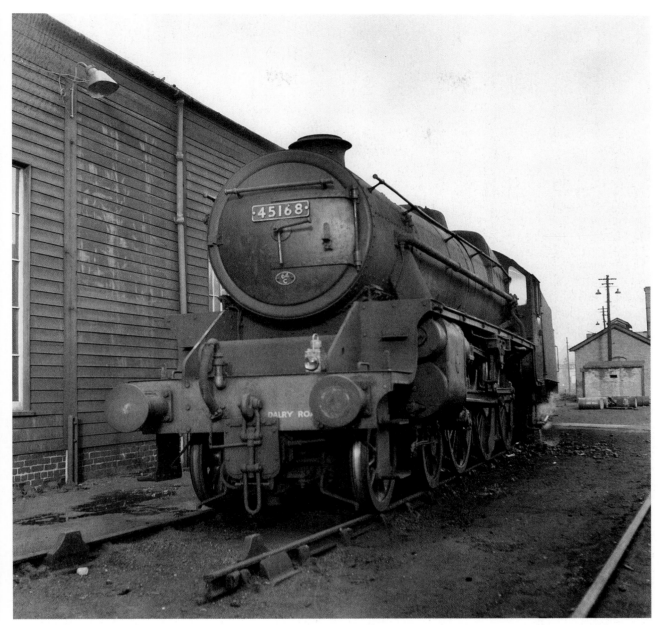

'Black 5' No. 45168 was a Corkerhill engine in 1947 and remained so until March 1953 when it was transferred to Perth. After seven years serving at Perth, it changed allocation again – firstly transferred to Polmadie for a few months and then to Motherwell. In October 1964, it became a Dalry Road locomotive and it is shown here at Dalry Road, on 13 February 1965, standing in one of the roads on the south side of the repair shop. *(David Hucknall)*

*Opposite:* Among the locomotives 'on shed' at the time of an early evening visit to Perth shed on 25 June 1965 were Ferryhill's 'A4' No. 60007 *Sir Nigel Gresley* and one of Perth's 'Black 5's, No. 45473. ('Black 5's Nos 45474 and 45475 were also in the vicinity). Two years earlier, No. 60007 had been a King's Cross engine and, on closure of the 'Top' shed, it was one of eleven 'A4's transferred to New England. In November 1963, it was moved to Scotland and placed in store. It became a Ferryhill engine on 20 July 1964 and worked reliably on the former Caledonian Railway's line between Glasgow and Aberdeen until it was withdrawn in February 1966. *(David Hucknall)*

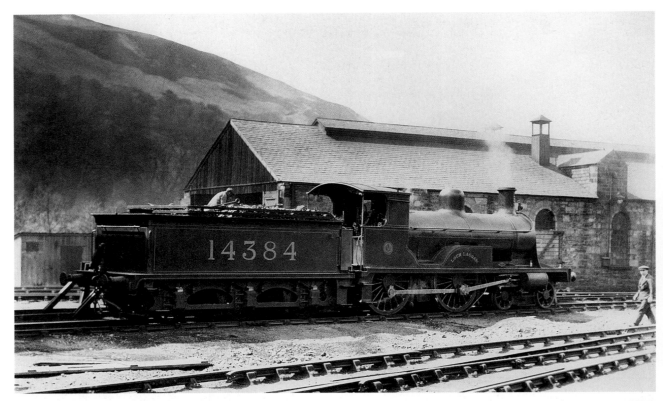

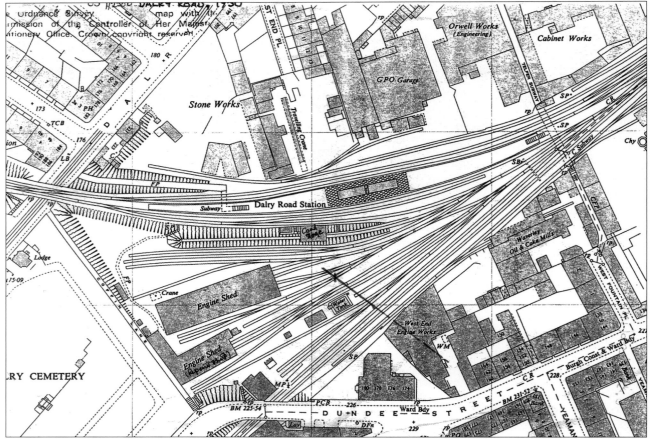

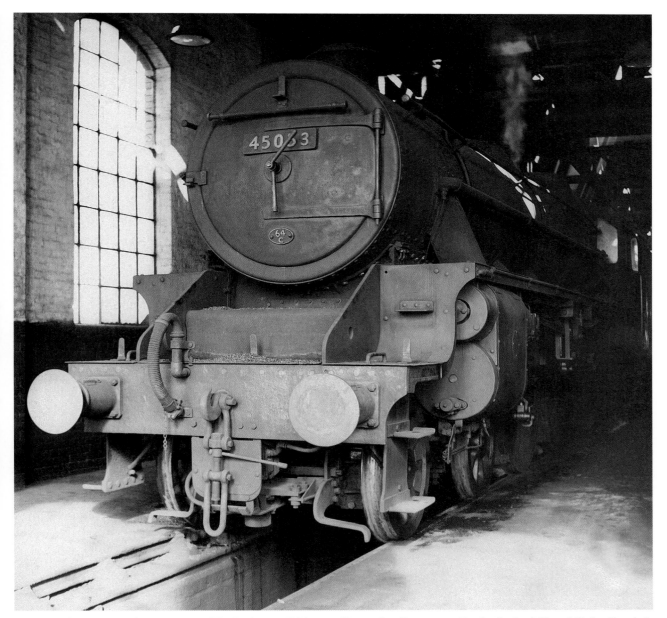

At times during its railway service, 'Black 5' No. 45053 was allocated to Inverness, Perth, Corkerhill and Dalry Road. It is seen here, on 29 March 1965, inside Dalry Road shed. (*David Hucknall*)

*Opposite, top:* Blair Atholl station is on the former Inverness and Perth Junction Railway. The 18-mile climb to Druimuachdar begins here and banking engines were stationed at Blair Atholl's shed up to the early 1960s. The first shed (1863) at Blair Atholl was a wooden structure which 'perhaps . . . was burnt – or blown down' (Hawkins, Reeve and Stevenson, 1989). By 1869, a new shed, incorporating materials from a partially demolished Keith shed, was in use. It was a stone shed, with two roads and four smoke ventilators. Here, the shed is shown as it was on 15 May 1928 with former Highland Railway 'Loch' Class 4–4–0 No. 14384 *Loch Laggan* standing outside its home shed. (*H.C. Casserley*)

*Opposite, bottom:* Part of the OS 1:2500 map that shows Dalry Road shed in 1950. (*Ordnance Survey*)

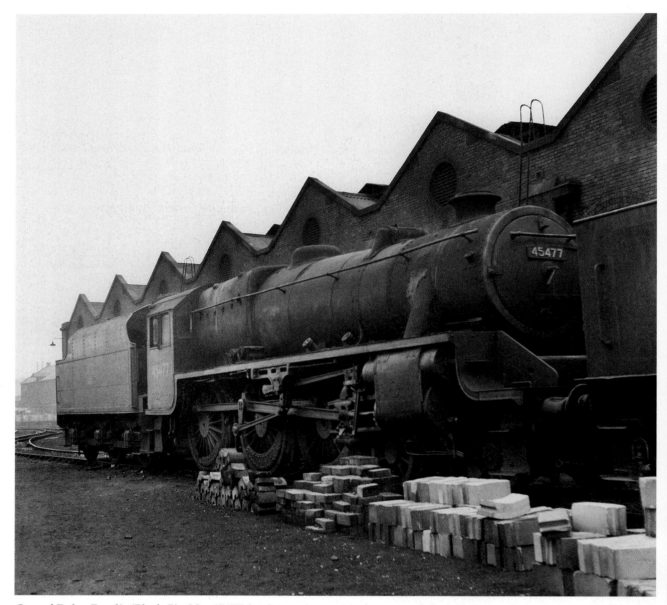

One of Dalry Road's 'Black 5's, No. 45477 (an Inverness engine for most of the 1950s, moving to 64C via Perth in late 1961) standing outside its home depot on 13 February 1965. The siding on which it stood ran close to the west side of the shed building and this photograph was taken looking north-east towards the former Waverley Oil and Cake Mills. (David Hucknall)

Opposite, top: 'A2/1' Class No. 60509 Waverley was one of two 'A2's that I never saw. After having been initially allocated to Darlington in November 1944, it was transferred after two months to Haymarket. Apart from a very brief period in September 1949, it remained a Haymarket locomotive until its withdrawal in August 1960. No. 60509 and I never had coincident visits to Doncaster. Waverley is seen here at Haymarket shed on 2 October 1954. Although Haymarket's 'A4's tended to work the No. 1 link, No. 60509 and its sisters (60507 and 60510) were used on expresses to Newcastle and other main lines from Edinburgh. (W.A.C. Smith)

Opposite, bottom: Holmes Class J36 No. 65235 (formerly No. 659 of the North British Railway and built at Cowlairs in 1891) had been named Gough (after the Commander of the 5th Army in France and Belgium from 1916 to 1918). Some twenty-five members of the class received such names (including the now-preserved Maude) in recognition of their service working supply trains on the Western Front. Probably because of their reliability, good design and general usefulness, the 'J36's were long-lived engines. Seen here at Haymarket on 14 August 1960, No. 65235 was withdrawn two months later. She was stored at Bathgate from February 1962 until May 1963 and scrapped shortly afterwards. (K.C.H. Fairey)

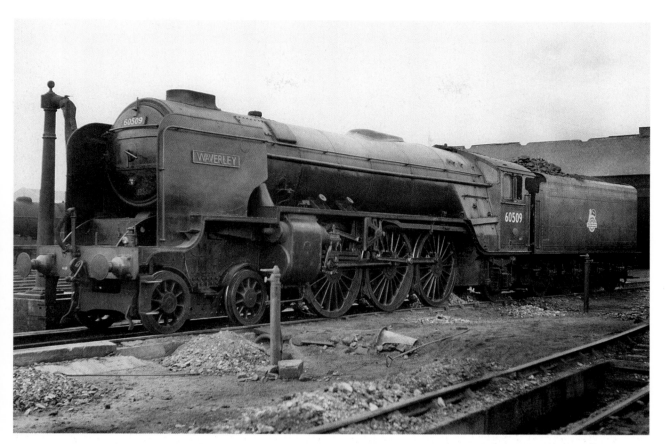

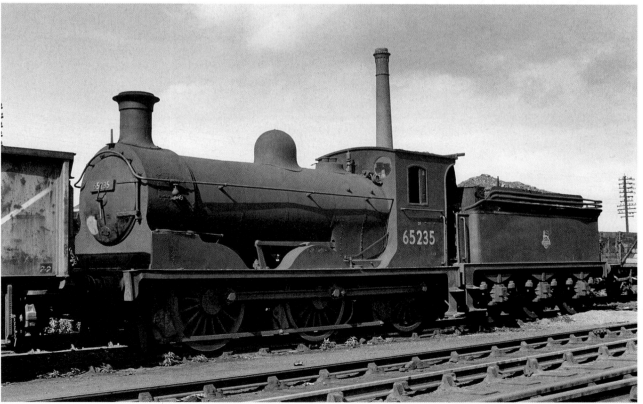

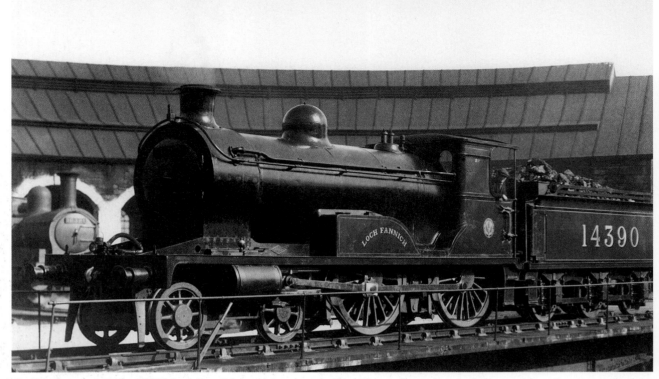

'Loch' Class 4–4–0 No. 14390 *Loch Fannich* was photographed by Henry Casserley on the turntable at Inverness shed on 27 May 1930. An example of a class of fifteen locomotives designed by David Jones and built by Duebs and Co., it entered service in 1896. It was one of ten members of the class which were rebuilt with larger Caledonian-type boilers in the mid-to late 1920s. Here, No.14390 looks superb in its full red LMS livery. *(H.C. Casserley)*

*Opposite, top:* 'Small Ben' Class No. 14408 *Ben Hope* was built in 1900 by the Highland Railway at Lochgorm Works. It is seen here taking water at the Highland Railway shed at Forres on 26 May 1928. To the rear of the locomotive can be seen the coal bank and the coaling crane. From the piles of clinker, the area was also used for engine disposal, the track nearer No. 14408 leading to the two-road engine shed. The 'Small Ben's frequently worked between Inverness and Keith. This was an undemanding stretch of line apart from Mulben Bank (1 in 60 against eastbound trains) near Keith. *(H.C. Casserley)*

*Opposite, bottom:* 'Small Ben' Class 4–4–0 No. 14398 *Ben Alder* (Highland Railway No. 2), possibly fresh from Lochgorm Works, is seen at Inverness shed on 17 May 1928. Behind the locomotive is the coal stage and, to the rear of the tender, the so-called 'Marble Arch' (the shed's 45,000-gallon water tank) through which locomotives could pass on their way to and from the engine shed. The 'Small Ben's were the first design by Peter Drummond during his time (1896–1911) as Locomotive Superintendent of the Highland Railway. Built by Duebs and Co. in 1918, the engines had coupled wheels of 6ft in diameter and, usually, six-wheel tenders although No. 14398 has an eight-wheel example here. *(H.C. Casserley)*

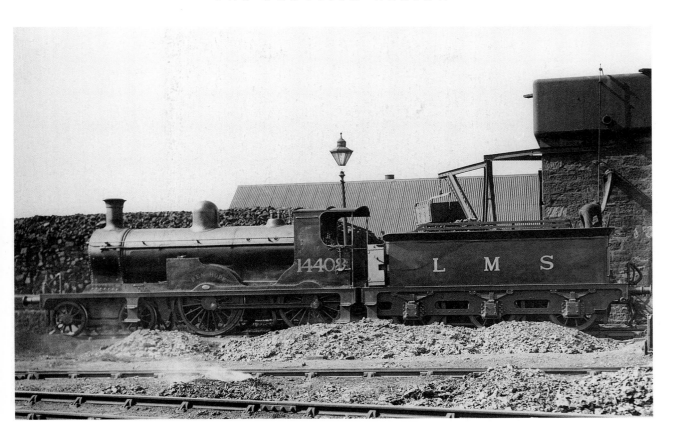

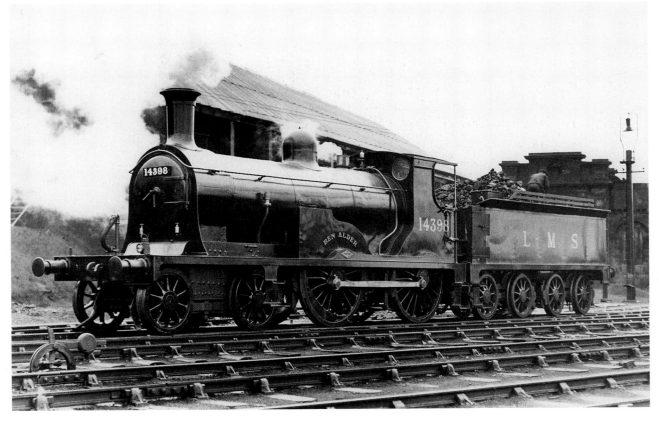

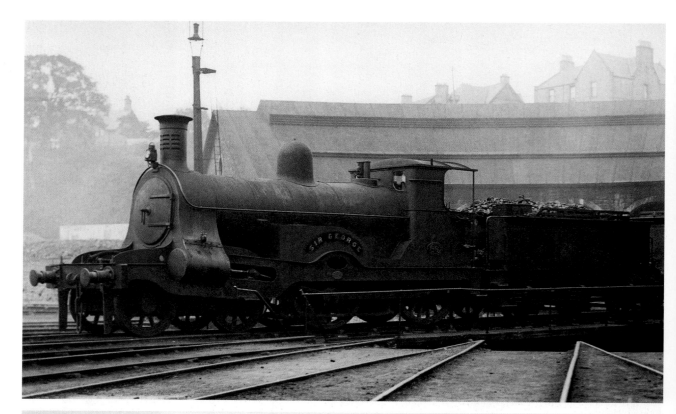

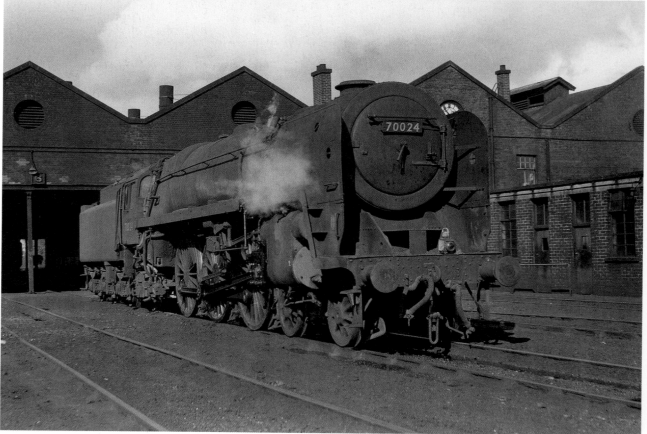

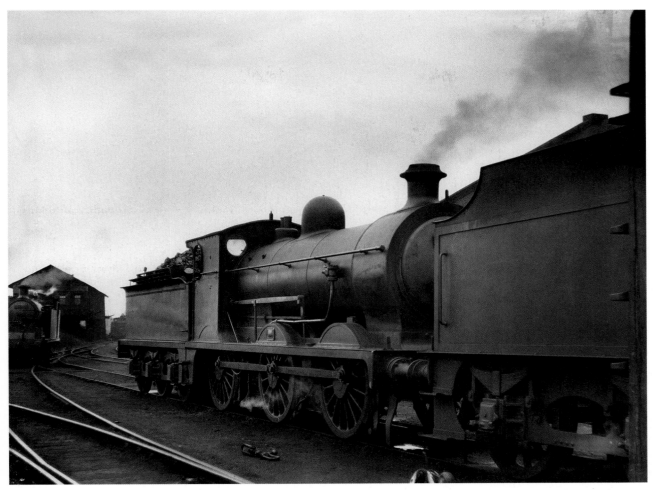

A view looking towards the coaling stage from the side of Hurlford shed, sometime between 1927 and 1937, shows a Manson '361' Class 0–6–0 and, in the background, an ex-GSWR 0–6–2T. Said to be a most successful design, the '361's were built between 1900 and 1910 by Neilson Reid (20), North British (12) and Kilmarnock Works (2). Many were rebuilt during the early 1920s at the request of Whitelegge. (The rebuilds gave rise to complaints by their crews of poor steaming and sluggish running.) The tank engine might be a Drummond '45' Class 0–6–2T, built during the First World War or, more likely, one of a further batch that Whitelegge had built in 1919. Two ex-GSWR 0–6–2Ts (Nos 16913 and 16920) were allocated to Wellingborough in the late 1930s and others went to Stourton, Toton and Workington). *(D.J. Hucknall Collection)*

*Opposite, top:* Neilson and Co. built a series of 4–4–0 tender engines for the Highland Railway in 1892. They had large double frames at the front which incorporated the outside cylinders. The series was known as the 'Strath' Class and consisted of twelve engines. Seen here on the turntable at Inverness on 21 June 1927, looking east with the houses on Millburn Road in the background, is No. 89 *Sir George*. Still bearing the legend 'H.R.' on the tender, the front vacuum pipe is laid on the buffer beam in typical Highland Railway manner. No. 89 (later No. 14271) was one of six of the class that survived into LMS days. *(H.C. Casserley)*

*Opposite, bottom:* A rather empty Kingmoor shed on 25 September 1967, had 'Britannia' Class No. 70024 (formerly *Vulcan*) standing on road 5. No. 70024 would take a return special (from Blackpool to Glasgow), from Carlisle via Dumfries, Kilmarnock and Paisley. For several years, *Vulcan* had been allocated to Cardiff (Canton) and it seemed that, of the Western Region sheds (Old Oak Common, Canton and Laira) which were given 'Britannia's initially, only Canton's staff were prepared to get the best out of them. *(W.A.C. Smith)*

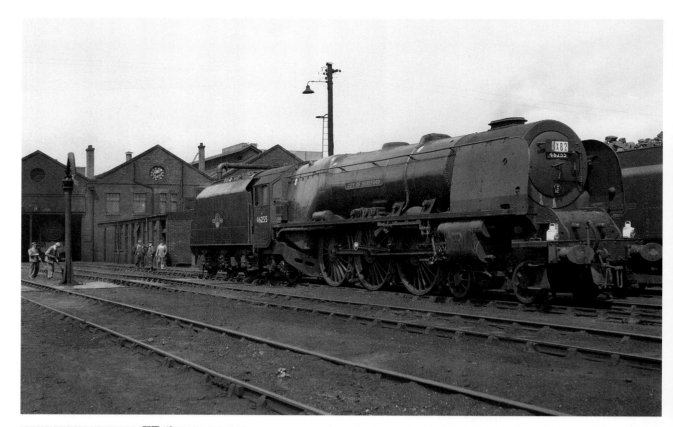

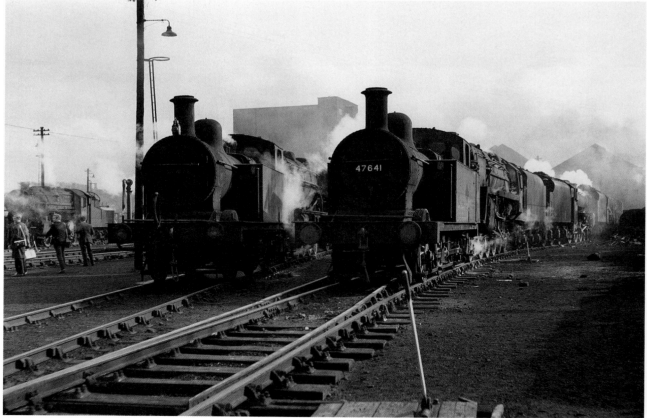

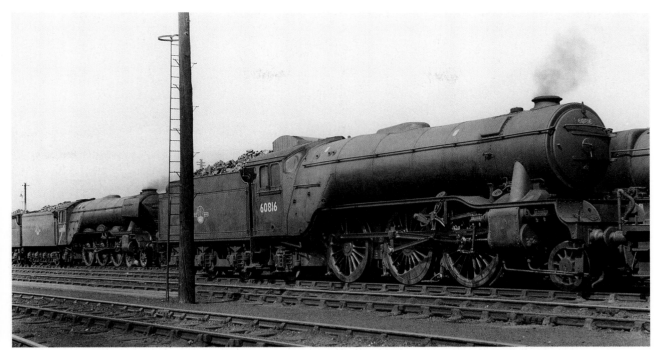

In the shed yard at Carlisle (Kingmoor) on 8 May 1965 were a St Margaret's 'V2' No. 60816 and 'A3' Class No. 60100 *Spearmint*. No. 60816 was one of seven 'V2's moved, during 1951, from King's Cross to St Margaret's. Initially, the transferred engines were used on passenger trains, particularly the 'fasts' between Edinburgh and Glasgow, but they were soon involved with East Coast route goods traffic and passenger duties to Perth, Dundee, Hawick and Glasgow. No. 60100 came to St Margaret's in January 1963 after approximately twenty-three years as a Haymarket engine. At the Edinburgh shed, as can be seen, it worked over the Waverley route on various duties and was generally used as required. *(W.A.C. Smith)*

*Opposite, top:* On No. 8 road, at the south end of Kingmoor shed on 12 July 1964, 'Coronation' Class No. 46255 *City of Hereford* takes water before working the SLS's 'Coronation Pacific Pennine Summits' railtour over Ais Gill. The outward journey, from Birmingham, had been over a more familiar route via Shap. To the rear of the locomotive, there is an interesting little scene – two railwaymen are cleaning up in the yard, watched closely by three of their colleagues. All are dressed in a style adopted by railwaymen probably from the 1930s to the end of steam. *(W.A.C. Smith)*

*Opposite, bottom:* The yard at the northern end of Kingmoor shed was busy on 8 October 1966. Leading two lines of locomotives were 'Jinties' Nos 47471 and 47641. No. 47641 was a relatively recent arrival at the shed after having been assigned to Burton Shed throughout the 1950s and early 1960s. No. 47471 was allocated to Carlisle in September 1960, again after many years of service elsewhere (Lancaster Green Ayre). *(W.A.C. Smith)*

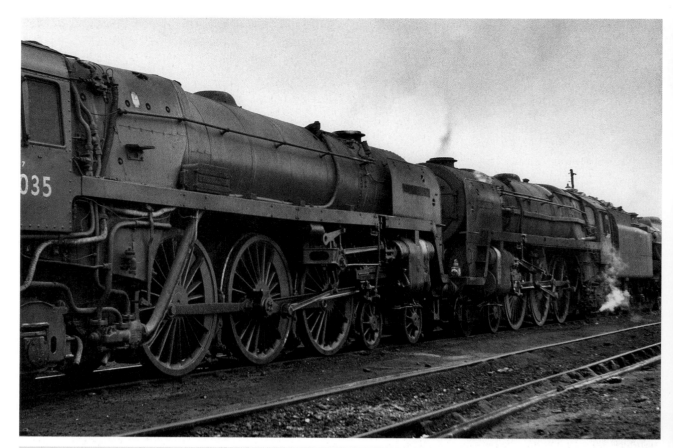

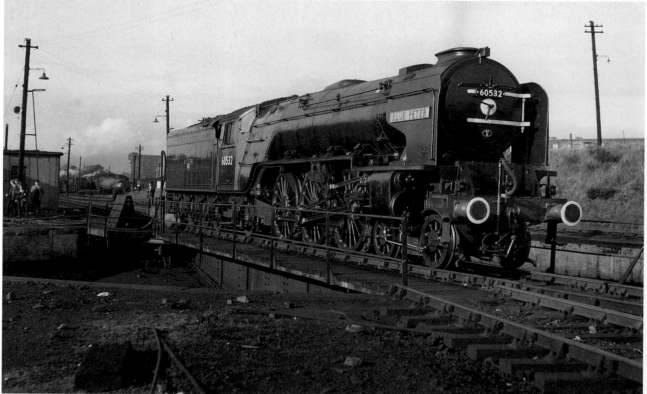

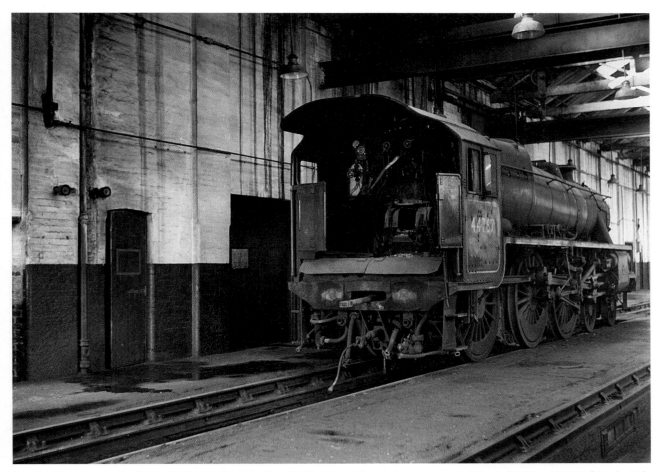

Inside Kingmoor shed, probably in September 1968, stood the now-preserved 'Black 5' No. 44767, fitted with Stephenson Link Motion. Built in December 1947 and allocated initially to Crewe North, it was a Bank Hall (Liverpool) engine for many years and worked passenger trains from Exchange station in Liverpool. As a unique 'Black 5', it was subsequently preserved and now bears the name *George Stephenson*. *(George Harrison/D.J. Hucknall Collection)*

*Opposite, top:* Fifty-five 'Britannia' Pacifics were built at Crewe Works from 1951 to 1954. Nos 70000–03/05–13/30/34–41 performed exemplary work on the Liverpool Street–Norwich line. In their later years, Carlisle Kingmoor became the home shed to most of the class, with the exception of Nos 70000/26/30/43 and 44. Here, 'Britannia's No. 70035 (formerly *Rudyard Kipling*) and No. 70006 (formerly *Robert Burns*), are seen in Kingmoor shed yard on Sunday, 21 March 1965. No. 70035 was in fine external condition and was to give service for a further three years. Although looking a little more neglected, No. 70006 survived until May 1967. *(David Hucknall)*

*Opposite, bottom:* 'A2' Class No. 60532 *Blue Peter* was built after the nationalisation of Britain's railways and allocated to York shed in March 1948. In November 1949, it was moved to Haymarket shed and took up duty on the express passenger trains between Edinburgh and Aberdeen. It was re-allocated to Dundee (Tay Bridge) in June 1961 and, according to the normally reliable RCTS Publications, remained a Tay Bridge engine until early December 1966 when it became a Ferryhill locomotive. Here, No. 60532 is seen on the turntable at Kingmoor on 2 October 1966 while working a BR excursion, advertised as 'hauled by the last remaining "A2" Pacific-type locomotive'. A 61B (Ferryhill) shed plate is clearly visible on the smokebox door. *(W.A.C. Smith)*

'Black 5' No. 44677 was introduced in 1950 and initially allocated to Kingmoor shed. In April 1951, it became a St Rollox locomotive and remained so until late 1961 when it returned to Kingmoor's stock. It is seen here in its later Kingmoor days, at Waverley station, Edinburgh, on 17 May 1965. *(David Hucknall)*

*Opposite:* A section taken from an Ordnance Survey map dating from 1933, showing Perth's Caledonian Railway Engine Shed. The later LMS engine shed, which lasted until 1967, was constructed on the site. *(Ordnance Survey)*

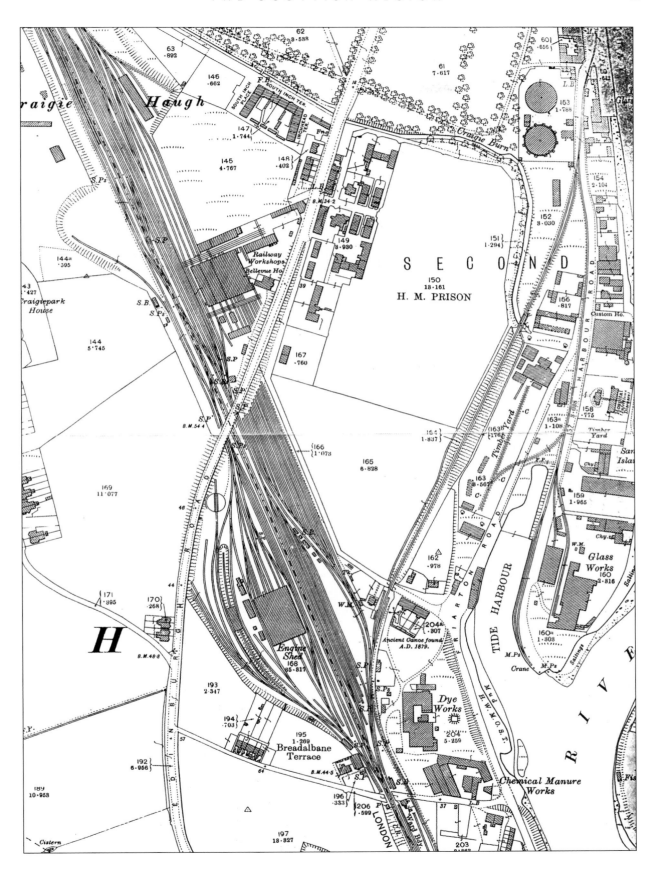

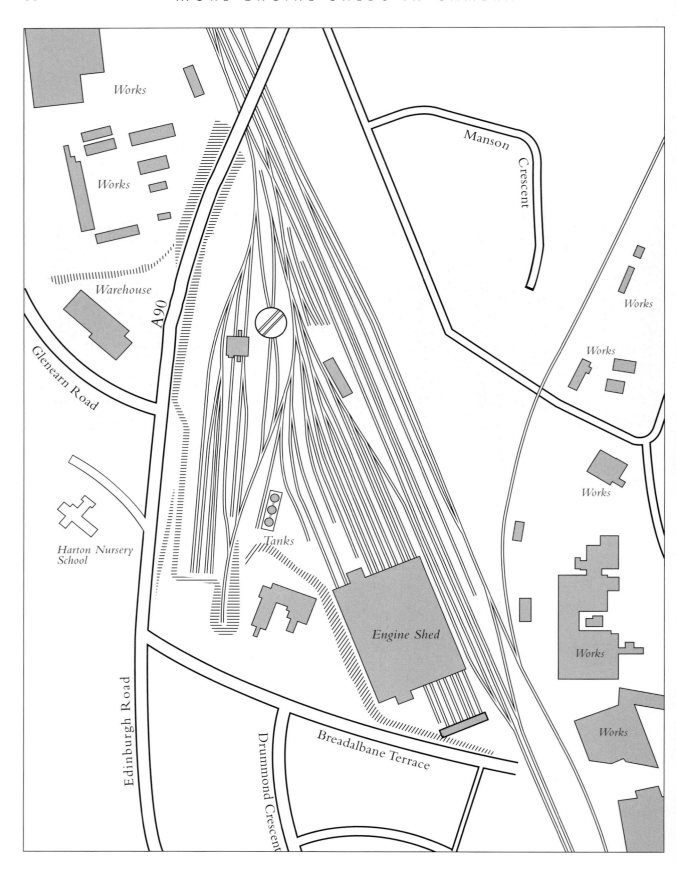

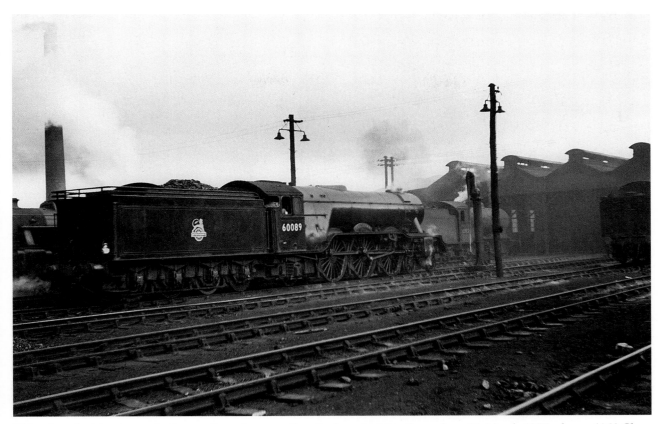

This view, looking towards the south-east, across the shed yard at Perth mpd on 26 March 1957, shows 'A3' Class No. 60089 *Felstead*, a Haymarket engine at the time, together with a 'J38' Class 0–6–0 and, behind No. 60089's tender, one of Perth's many 'Black 5's. No. 60089 would have been used on a Perth train from Edinburgh via the difficult 1 in 74 climb to Glenfarg. *(David Holmes)*

*Opposite:* A plan of the Perth Motive Power Depot as it was laid out in 1965. *(Author's collection)*

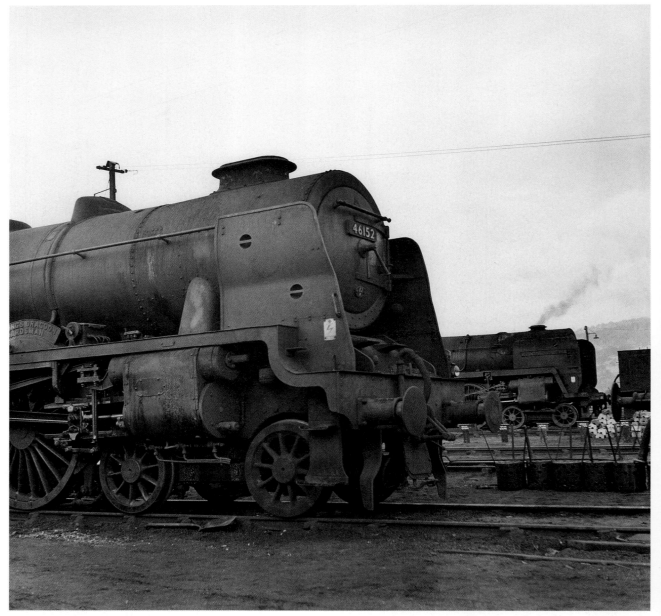

A very promising start to a visit to Perth shed on 6 March 1965 was the sight of two Kingmoor engines, 'Royal Scot' No. 46152 *The King's Dragoon Guardsman* and 'Britannia' No. 70037 *Hereward the Wake*, both with their nameplates in place. Within one month of this photograph, No. 46152 was withdrawn. *(David Hucknall)*

*Opposite, top:* The handsome Caledonian Railway 4–2–2 No. 123, built by Neilson and Co. in 1886, was seen in the shed yard at Perth on 19 April 1958. It had worked its first public excursion, from Buchanan Street station, after restoration. By the end of August the following year, it was involved in a series of special excursions run in conjunction with the Scottish Industries Exhibition, held at the Kelvin Hall in Glasgow. On 3 September 1959, for example, No. 123 worked a return train between Princes Street station in Edinburgh and Kelvin Hall. No. 123 now resides in Glasgow's excellent Transport Museum, a very short walk from the Kelvin Hall. *(W.A.C. Smith)*

*Opposite, bottom:* Looking superb in the evening sun in April 1965, 'Black 5' No. 45489 stands outside Perth shed. 'Black 5's were particularly prevalent at Perth because of their reliability and versatility. During the period July 1950–July 1951, Perth shed had some seventy-five members of the class on its books. No. 45489 had been a Perth engine throughout the 1950s and it was then assigned to St Rollox shed. By October 1961, it had moved to Hurlford and was probably running-in after overhaul at St Rollox on this occasion and would then return to its home shed. *(David Hucknall)*

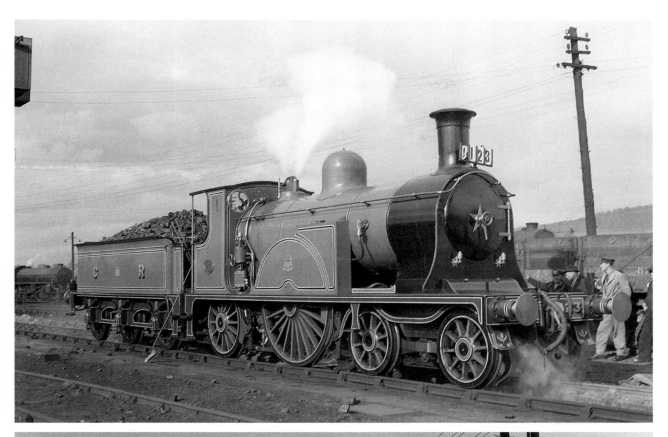

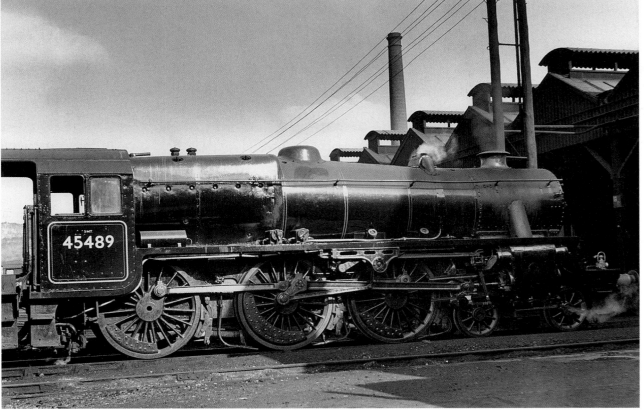

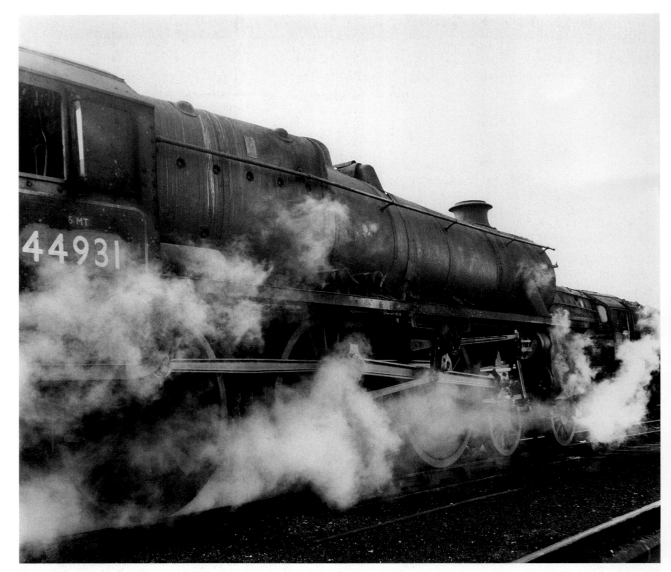

One of Perth's 'Black 5's, No. 44931 was seen undergoing fire-cleaning in the disposal sidings at its home shed on the evening of 26 April 1965. Perth had an ash-lifting plant where ash from locomotive cleaning, deposited in small hoppers, was lifted and emptied into mineral wagons for later disposal. *(David Hucknall)*

*Opposite, top:* Perth shed, on the morning of 3 April 1965, was host to St Rollox's Standard Class 5 No. 73145 (fitted with a buffer beam snowplough) and Kingmoor's 'Britannia' Class No. 70007 (formerly *Coeur de Lion*). In one of the roads to the left of No. 70007 was what may have been a 'Royal Scot'. For some reason, I didn't record this engine's number but, based on withdrawal and scrapping dates, there is the possibility that it was No. 46132 (formerly *The King's Regiment, Liverpool*). *(David Hucknall)*

*Opposite, bottom:* Behind Perth shed, and overlooked by No. 18,19 and 20 Breadalbane Terrace, there were sidings which were extensions of the shed roads. They were used for the storage of laid-off engines and stock. A view across this area on a wet 18 May 1957 shows Pickersgill Caledonian '72' Class locomotives Nos 54500, 54496 and 54494 together with 'D34' Class No. 62470 *Glen Roy* in temporary store. Five of the 'Caley' Class (Nos 54485/86/89/94 and 54500) survived into the 1960s. *(W.A.C. Smith)*

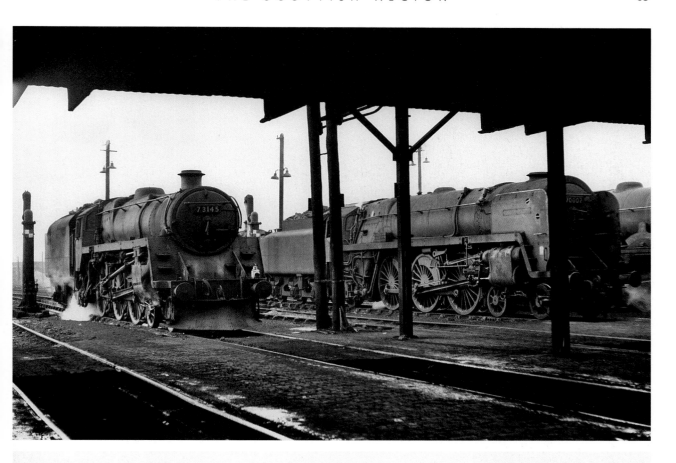

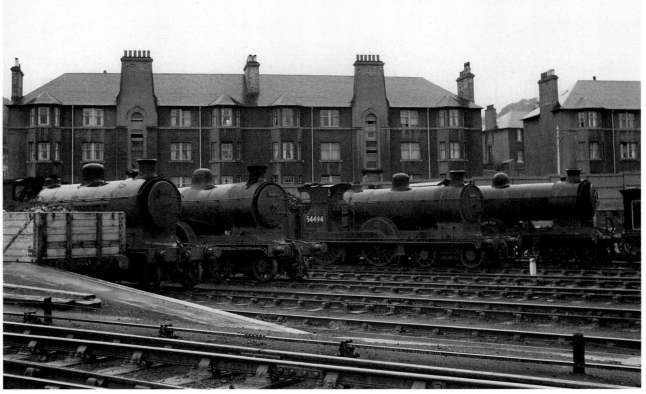

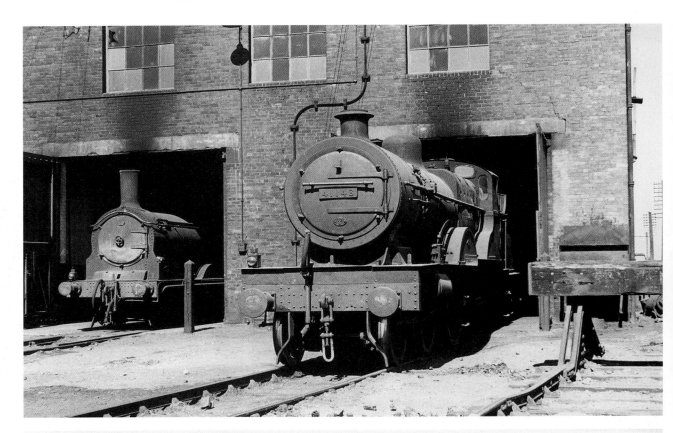

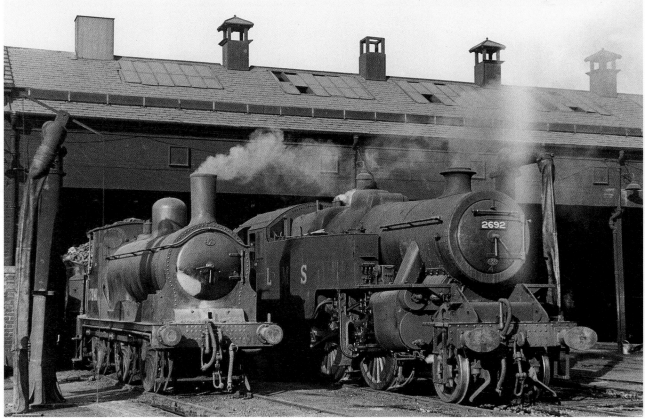

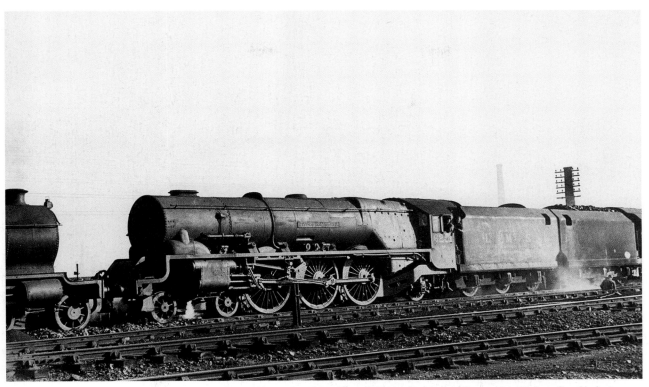

When it initially entered service, 'Coronation' Class No. 6251 *City of Nottingham* was allocated to Polmadie shed. As can be seen, the locomotive's smiling crew looked towards Henry Casserley as he photographed the engine in the yard on 27 October 1945. The autumn sun illuminated the work-dulled wartime black livery of the engine. 6251's tender and that of the 'Coronation' behind it are of the type used on the streamlined members of the class. By 1947, No. 6251 was a Carlisle Upperby engine and remained on its allocation until 1954. *(H.C. Casserley)*

*Opposite, top:* Standing outside the Repair Shop at Polmadie shed on 19 June 1949 was Kingmoor's 4P Compound 4–4–0 No. 41143. This engine had been one of fifteen of the Class (Nos 1135–49) that had been allocated to that shed in the early summer of 1925 to work on the former Caledonian Railway line between Glasgow and Carlisle. The excellent pre-war work of these locomotives was highlighted by David L. Smith (in the *Journal of the Stephenson Locomotive Society* in 1962) who indicated that their praiseworthy work continued during the war and afterwards. *(H.C. Casserley)*

*Opposite, bottom:* The westering sun illuminated the front of Polmadie engine shed on 27 October 1945 and showed, in great detail, the front ends of a pair of the depot's locomotives – a Drummond 'Standard Goods' 2F No. 17241 and a Fairburn Class 4 2–6–4T No. 2692. The shed plates on both engines showed '27A'. This was the LMSR depot number for Polmadie, the main district depot for Motive Power District 27 (Polmadie, Greenock and Hamilton). *(H.C. Casserley)*

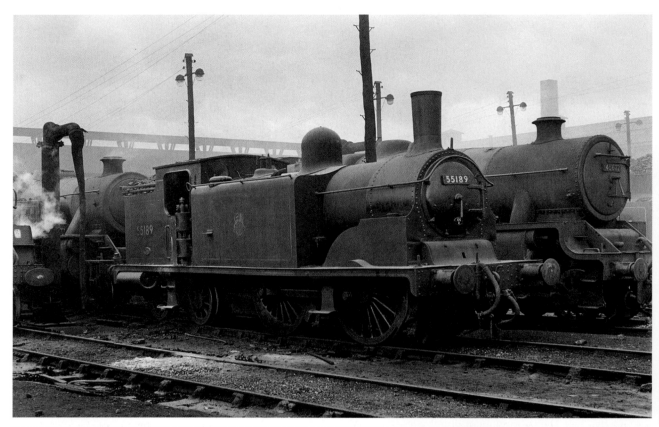

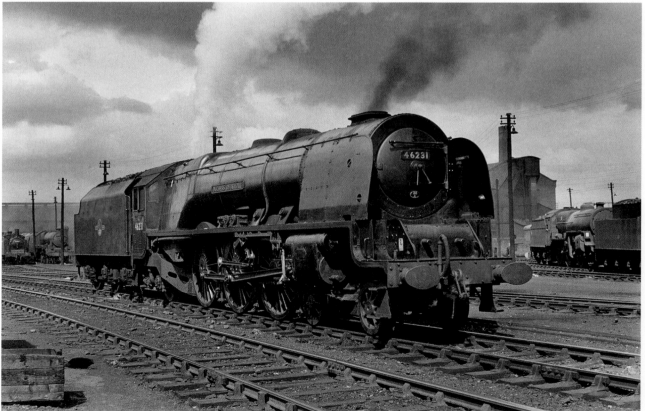

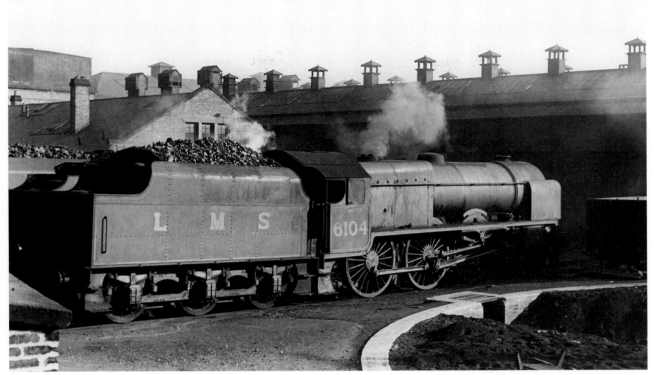

Apart from a period of approximately three years when it was based at Camden, 'Royal Scot' Class No. 6104 (later 46104) *Scottish Borderer* spent its working life in the Scottish Region. It had two periods as a Polmadie locomotive, the second one lasting from April 1942 until its withdrawal in December 1962. Photographed at the rear of Polmadie shed on 27 October 1945, No. 6104 was in its original form with a parallel boiler. (*H.C. Casserley*)

*Opposite, top:* A portrait of a McIntosh Caledonian '439' Class 0–4–4T No. 55189 in the yard at Polmadie shed on 14 August 1960. No. 55189 had been a Dalry Road engine until July 1952 when it was transferred to Polmadie's stock. On the adjacent road, to the left of the 2P, was 'Jubilee' Class No. 45672 *Anson*, then an Upperby engine but shortly to be transferred to Kingmoor. (*K.C.H. Fairey*)

*Opposite, bottom:* A Polmadie 'Duchess', No. 46231 *Duchess of Atholl* standing in the yard of its home shed on 14 August 1960. Commendably clean, with the coal in its tender trimmed to perfection, it would probably have proceeded to Glasgow Central station for an Up working. Although Polmadie's Pacifics were rarely seen south of Crewe in the late 1950s and early 1960s, Nock (1956) reported an 'outstanding' run with 46231 on the Up 'Mid-Day Scot' with Driver T. Walker of 5A in charge. With the 510-ton train, the locomotive showed 'a superb mastery of the job'. (*K.C.H. Fairey*)

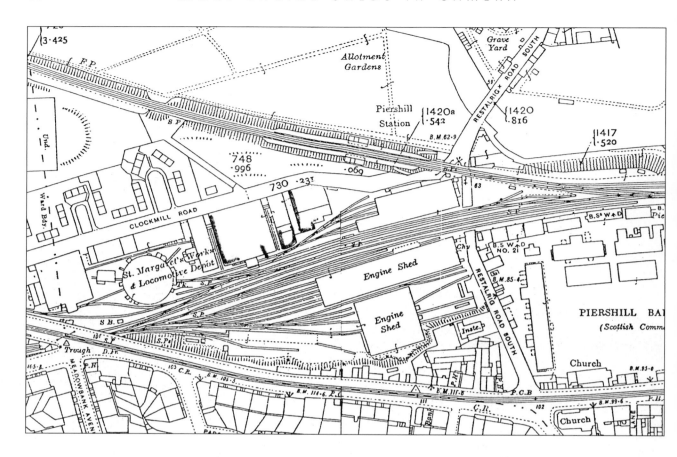

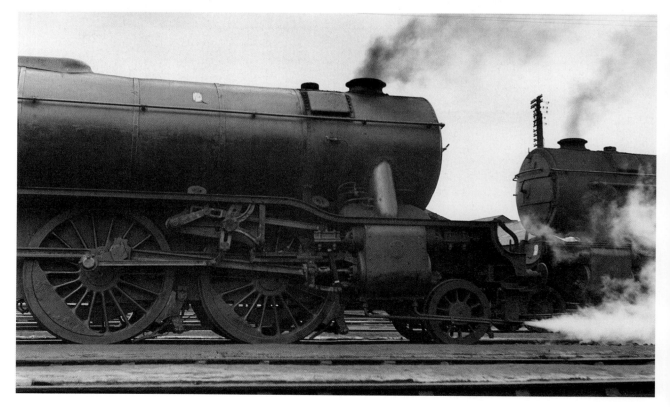

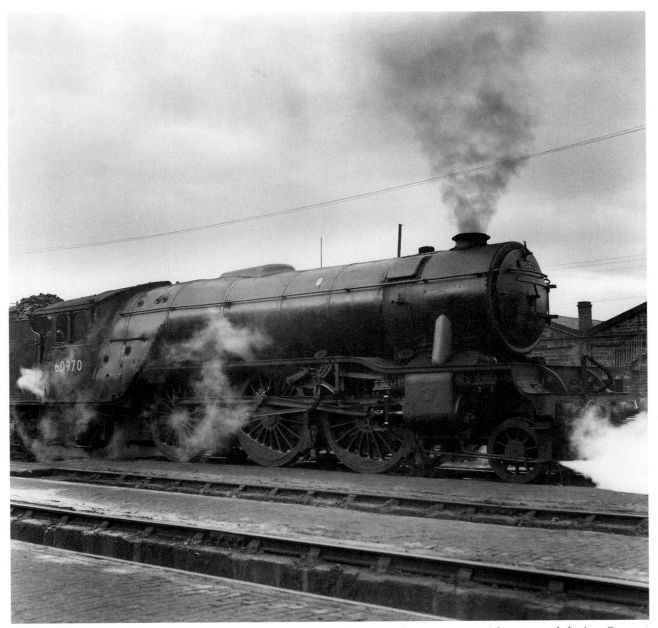

The 'V2' Class 2–6–2s were good-looking locomotives and fine performers on a wide range of duties. Seen at St Margaret's shed on 14 February 1965, this example looked to be on fine form. As No. 3682, it entered service in May 1943 at Haymarket shed and shared Top Link passenger duties with the shed's 4–6–2s. By 1949, 60970 was at Ferryhill where it was used on the former Caledonian Railway's route to Perth and even Carlisle. In 1960, No. 60970 was transferred to Perth and continued its work on the CR's lines to Glasgow, Carstairs and Carlisle. *(David Hucknall)*

*Opposite, top:* A section of a 1:2500 Ordnance Survey map of St Margaret's Shed, dating from 1931. *(Crown Copyright reserved))*

*Opposite, bottom:* Gresley 'V2' Class 2–6–2T locomotives Nos 60970 (on the left) and 60931, stood in the yard at St Margaret's shed on 14 February 1965. No. 60970 had, in the late 1950s, been an Aberdeen (Ferryhill) engine but was subsequently transferred to Perth. While at Ferryhill, one of 60970's duties involved the Up 'West Coast Postal', not a particularly demanding job, but a run with 60970 from Aberdeen to Forfar came to the attention of O.S. Nock (*The Railway Magazine*, p. 410, June 1960). Nock described a 'splendid climb' of Dunnottar bank and an arrival at Forfar 'comfortably inside schedule time'. *(David Hucknall)*

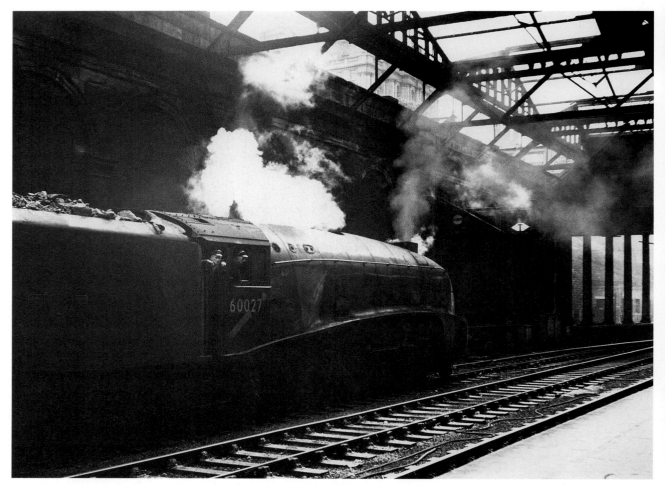

Gresley's 'A4' Pacifics will always be remembered for their work on the non-stop trains between London and Edinburgh. Writing in *The Railway Magazine* in October 1960, O.S. Nock mentioned work performed by No. 60027 *Merlin* on 'The Elizabethan' during the previous summer. Commenting on a report from one of his correspondents who had remarked 'steaming superb', Nock added, 'These runs were just what we have come to accept from the 'A4's on this crack working'. Here, No. 60027 is seen at Waverley station on 3 July 1965 with a lesser duty – the Anglo-Scottish Car Carrier. Within two months, No. 60027 was withdrawn from service and scrapped at Shieldhall in Glasgow. *(David Hucknall)*

*Opposite, top:* A view from the raised area overlooking the turntable at St Margaret's shed on 14 February 1965 shows 'V2' Class No. 60824 moving towards the shed from the preparation/disposal area in the background. Behind the tender can be seen Nos 4–12 Restalrig Road South. The shed buildings to the rear of the 'V2' housed the shed's machine shop and wheel-drop pit. The buildings behind the left-hand telegraph pole were used by the fitters and joiners. The walking figure has just passed the sand-drying facility. *(David Hucknall)*

*Opposite, bottom:* St Rollox (Balornock) engine shed was opened in 1916, in the Provanhill area of Glasgow, within an area bounded by Balornock Junction, Broomfield Road and the former Caledonian Railway line from Buchanan Street to Coatbridge. It had twelve roads and a two-road repair shop. In this 1960 view, looking roughly north-east from the sidings close to the shed-side of the coaling stage, three 'Black 5's including No. 45245, and Perth's Standard Class 5 No. 73008 can be seen. To the left of the photograph, can be seen part of the brick repair shop and the sand facility. The shed notably received a pair of 'A4's, Nos 60027 *Merlin* and 60031 *Golden Plover* in 1962 to deal with the speeded-up Glasgow–Aberdeen service. *(K.C.H. Fairey)*

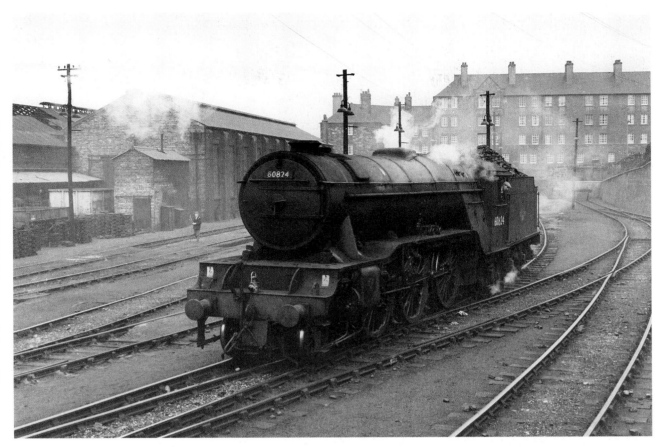

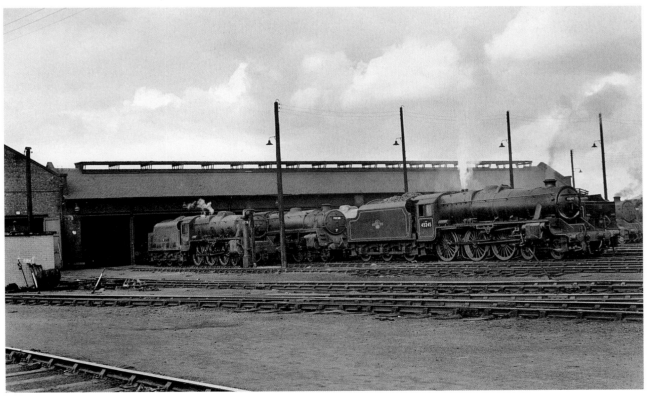

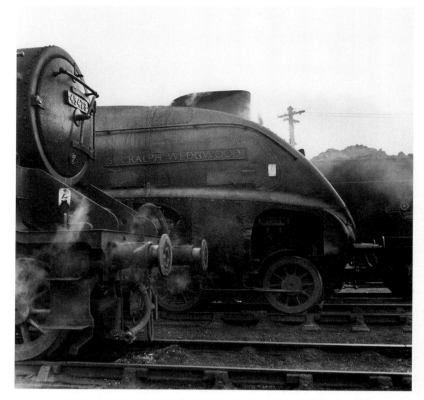

A Perth 'Black 5' Class No. 45473 and Aberdeen's 'A4' Class No. 60006 *Sir Ralph Wedgwood* were present in the yard at St Margaret's shed on a gloomy 17 April 1965. No. 60006 was one of the nine 'A4' Class transferred in October 1963 to the Scottish Region from England. All but two went into storage but No. 60006 was re-activated in March 1964 and transferred to Ferryhill shed in Aberdeen. No. 45473 would have been working a train from Perth to the south, returning later in the day with an Edinburgh–Perth and Inverness train. (*David Hucknall*)

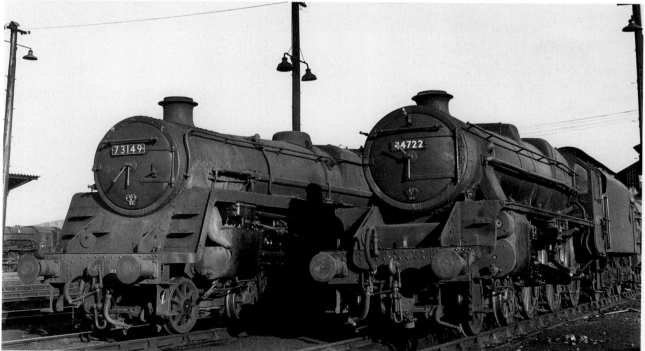

During 1957, ten BR Standard Class 5 4–6–0s, Nos 73145–154, fitted with Caprotti valve gear, were allocated to St Rollox shed. Seen here at Perth on the evening of 27 June 1965, are one of St Rollox's Caprottis No. 73149 and one of Perth's many 'Black 5's, No. 44722. The Caprotti Standards worked particularly on services from Buchanan Street station to Dundee, Dunblane and Perth, with admirable consistency. According to Welch (1993), 'one of the fastest runs on record (on the Glasgow–Aberdeen route) involved a BR Caprotti Class 5 running at just under 90mph between Perth and Forfar'. (*David Hucknall*)

## Chapter Four

# Workers & Observers –
# An Interlude

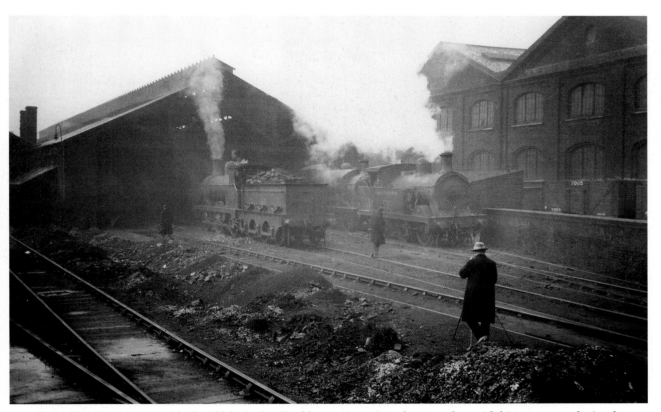

Recording the scene outside the 'Old' shed at Bricklayers Arms is a photographer with his camera and tripod. A casual observer also looks at the locomotives. In view at the time were Nos A46, A685 and A500. No. A685 was a 'C' Class locomotive rebuilt by Maunsell in 1917 into a saddle tank which worked the 'Bricks' yard.
*(H.C. Casserley)*

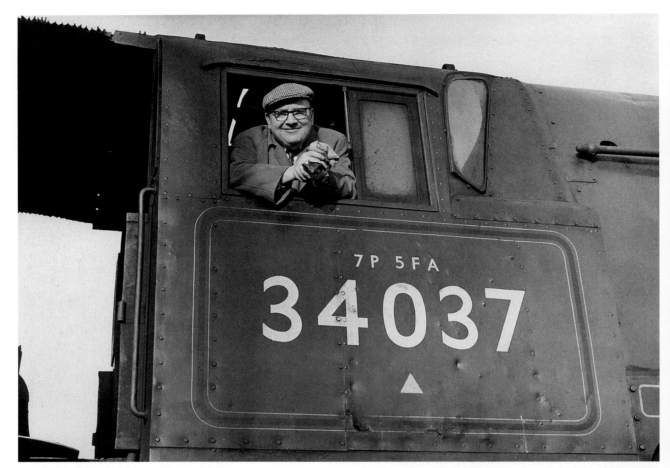

A man and his hobby – a happy George Harrison is seen on the footplate of rebuilt 'West Country' Class No. 34037 *Clovelly* at Salisbury shed. Unlike many of us, who can be regarded as dilettantes, Mr Harrison devoted a considerable amount of his spare time to his hobby and, particularly, his friendship with Oliver Bulleid. *(D.J. Hucknall Collection)*

*Opposite, top:* Two railway enthusiasts were looking for a possible photographic subject in a line of locomotives in the shed yard at York in May 1964. The grubby 'Austerity' Class 2–8–0 was unlikely to be chosen but 'B1' Class No. 61018 *Gnu* had possibilities. In the 1950s and 1960s, No. 61018 was allocated to the North East Region and was allocated, at various times, to Stockton, Haverton Hill, Thornaby and Wakefield. York was to be its final shed when it was placed there in December 1961. York's 'B1's worked local passenger trains to Harrogate, Leeds, Sheffield, Lincoln and Scarborough. They could also be seen on goods trains at destinations as widely separated as Brunswick (Liverpool) and Wath-on-Dearne. No. 61018 was withdrawn in November 1965. *(David Hucknall)*

*Opposite, bottom:* Enthusiasts stand on the ramp leading to coaling stage at Salisbury shed to watch the servicing of one of the last surviving 'N' Class locomotives, Guildford's No. 31411. It was Sunday 3 April 1966 and No. 31411 was one of the locomotives involved with an LCGB railtour. *(George Harrison/D.J. Hucknall Collection)*

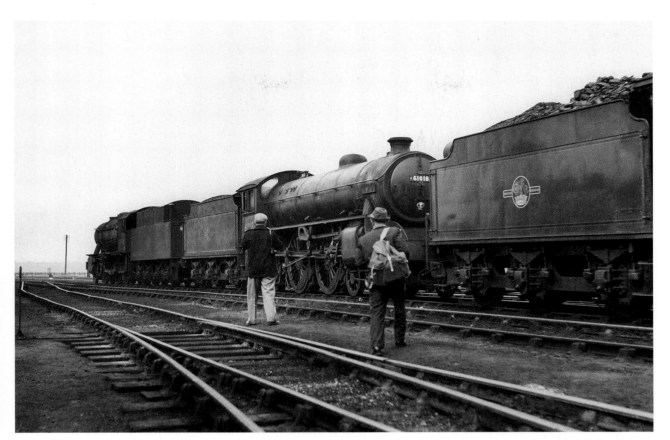

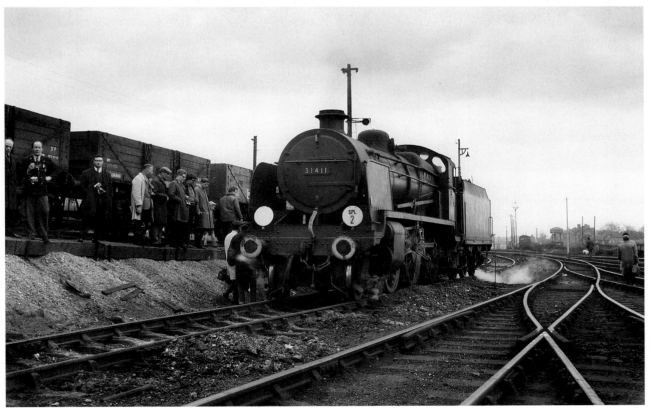

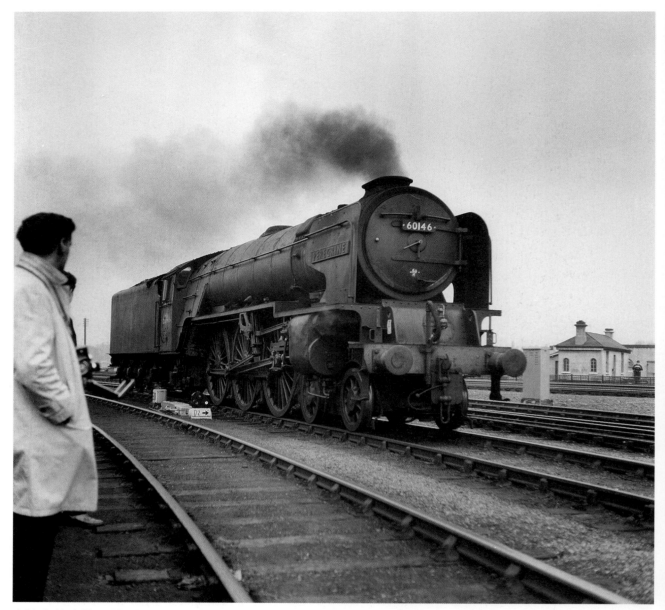

A York 'A1' Class No. 60146 *Peregrine* is seen leaving its home shed and running down to the station to pick up her train on 2 May 1964. York did not seem to have any top-class passenger work and its 'A1's must have ambled up and down to Newcastle, occasionally being used as substitutes for failed engines. *(David Hucknall)*

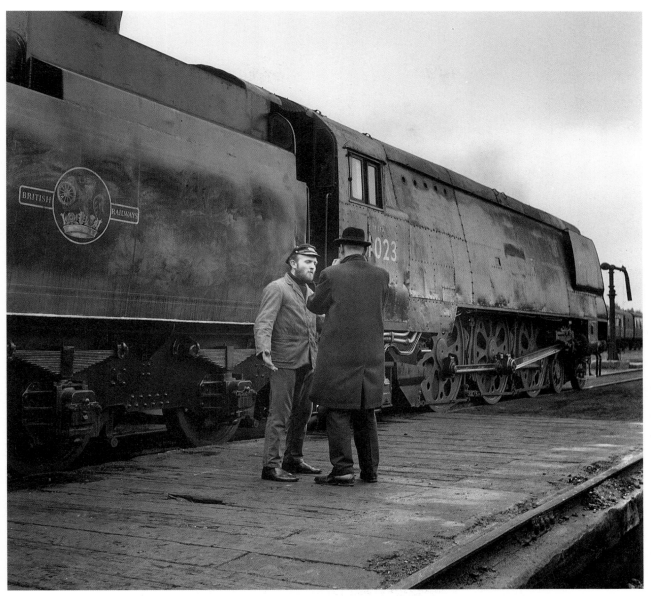

The first steaming of 'West Country' Class No. 34023 (*Blackmore Vale*) took place at the Longmoor Military Railway on 23 March 1968. The originator of the project, two years earlier, was Alan Wilton – seen here deep in conversation with Lt-Col. H.A. Dannatt, the then editor of *The Railway Magazine*. No. 34023 was considered the more mechanically sound of the only two unrebuilt Bulleid Pacifics (the other was No. 34102) remaining in traffic at the time. An offer to purchase No. 34023 for £1,900 was made by the Bulleid Pacific Preservation Society of which Mr Wilton was the Honorary Treasurer. It was accepted by the British Railways board on 3 August 1967. Attached to the acceptance letter was a note stating, 'No guarantee can be given as to the condition and suitability for further use'. *(George Harrison/ D.J. Hucknall Collection)*

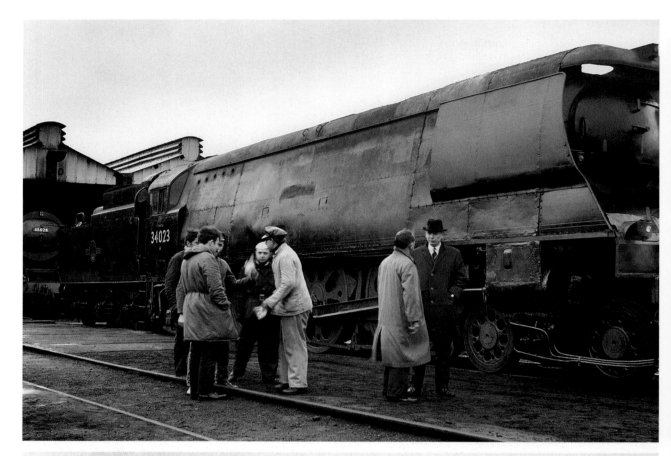

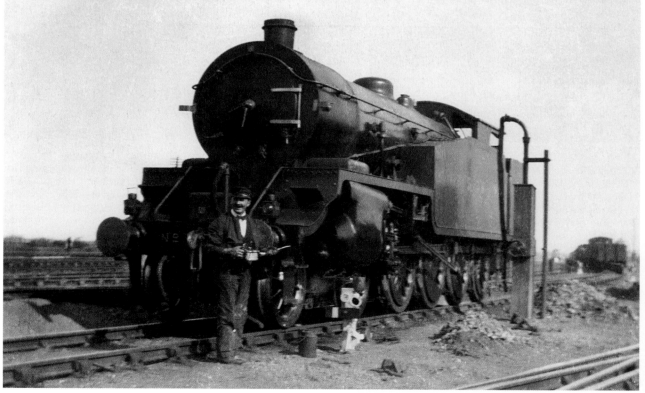

Railway works were always places of considerable interest to railway enthusiasts. Ian Allan Ltd, for example, organised a 'grand Easter Locospotters' Excursion to Doncaster Works from Paddington' on Wednesday 24 April 1957. (The cost for an adult (over 16) was quite a high 42s 6d). Captioning this photograph merely as 'Pratt and the Apprentices', George Harrison recorded a visit to Swindon Works from Porton in 1964. In an obvious break from routine, the apprentices seem happy enough to indulge their probably more enthusiastic seniors. *(George Harrison/ D.J. Hucknall Collection)*

*Opposite, top:* A further view of the first steaming of 'West Country' Class No. 34023 at the Longmoor Military Railway on 23 March 1968 is presented here. In the group on the left of the picture, an animated Alan Wilton can just be identified. The two men on the right are R.L. Curl (one of Bulleid's senior draughtsmen) and Lt-Col. H.A. Dannatt (with his hands in his pockets). *(George Harrison/D.J. Hucknall Collection)*

*Opposite, bottom:* The distinctively dressed driver of one of Robert Urie's 'G18' Class 4–8–0 tank engines paused during the oiling of the locomotive's motion, possibly at Feltham yard. Four 'G18's (Nos 492–5) were built at Eastleigh for use in the then newly constructed yard at Feltham in 1921. As can be seen from the engine's external condition, these large tank engines were popular with their crews and it is likely that this particular engine was regularly worked by this dapper individual. *(David Holmes Collection)*

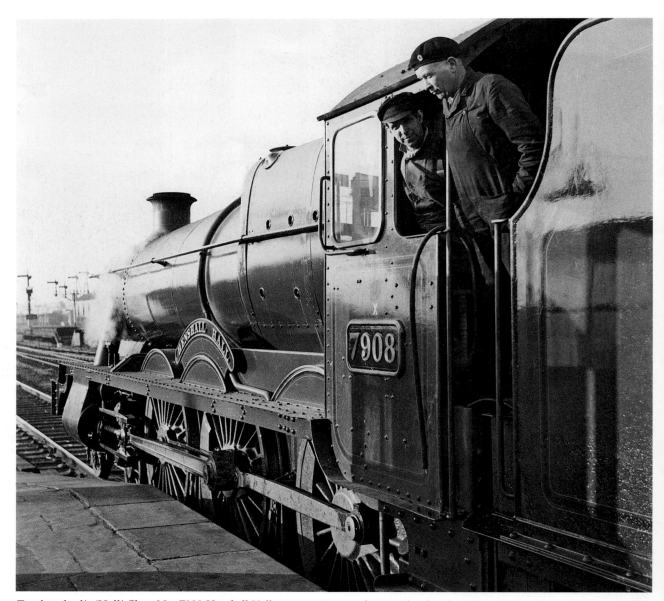

Tyseley shed's 'Hall' Class No. 7908 *Henshall Hall* was running-in after overhaul at Swindon Works when photographed at Reading station. The footplate-men, looking serious and competent, seemed justifiably proud of the locomotive in their charge. It took many years for Britain's railwaymen to progress through the ranks from engine cleaner to being responsible for Top Link expresses. Arduous work at unsociable hours was required to maintain a complex timetable for passengers and an engine-driver commanded respect in his local community. *(H.G. Usmar/D.J. Hucknall Collection)*

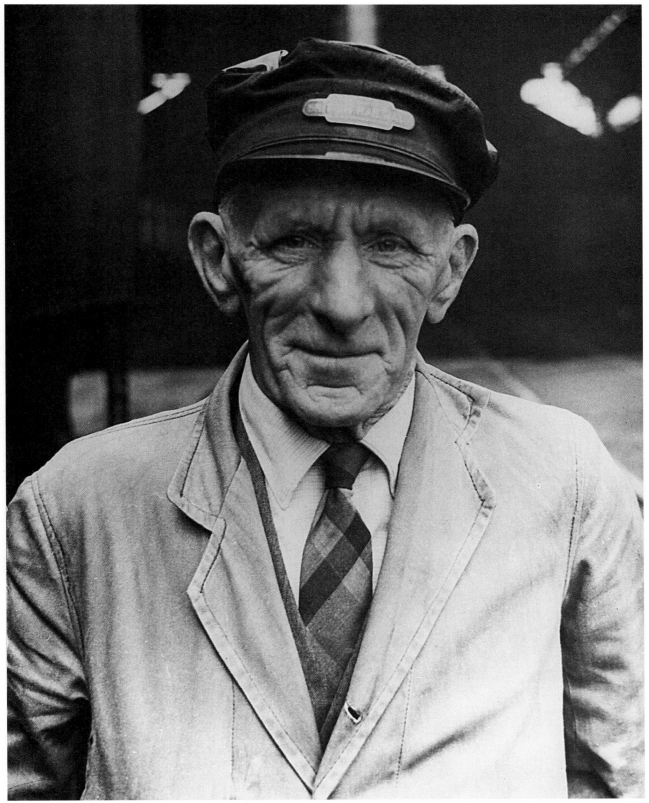

This fine portrait of one of Salisbury's former Top Link drivers, Ernest Pistell, was taken by George Harrison. In the background, Salisbury shed can be seen. *(George Harrison/D.J. Hucknall Collection)*

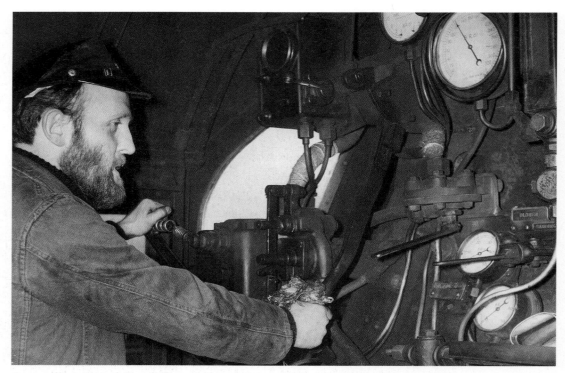

An excellent shot of Alan Wilton at the regulator of 'West Country' Class No. 34023 was taken during the first steaming of the restored locomotive on 23 March 1968. Mr Wilton must have been immensely proud of his role in the restoration. *(The late R.L. Curl/D.J. Hucknall Collection)*

The crew of LNWR 'Newton' Class 2–4–0 No. 1525 *Abercrombie*, particularly the driver, are smartly dressed. It may have been that tie and bowler hat were the normal uniform for passenger locomotive crews or this may have been pre-arranged. The shed appears to be Monument Lane but whether it was the original structure (1858) or the 'new' shed (1884) is uncertain. No. 1525 entered service in November 1866 and was one of a class of ninety-six express engines built for use on the Lancaster to Carlisle route where the earlier 'Problem' Class 2–2–2 (named after No. 184 *Problem*) had been behaving according to the class name. *(D.J. Hucknall Collection)*

'Black 5' No. 45261 seemed to be giving cause for concern at St Margaret's shed when this photograph was taken on 27 March 1965. The engine had been halted at a fairly inconvenient spot, just before a set of points leading to the ash road and sidings associated with the repair shop. No. 45261 was an Edge Hill locomotive at the time and may have been in Edinburgh after being used for a train after a visit to Cowlairs Works. *(David Hucknall)*

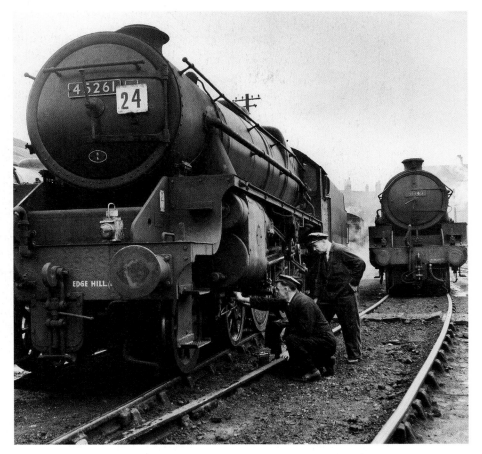

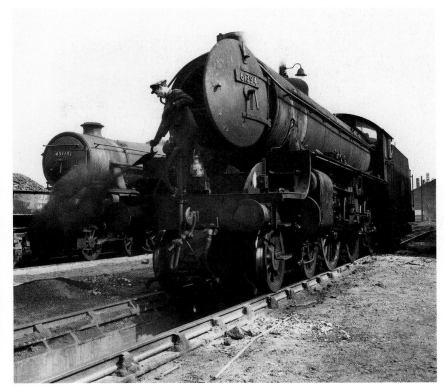

Fortunately, for both the cameraman and the fireman flinging smoke-box char from 'B1' Class No. 61394, the wind was not blowing at Canklow shed on 22 May 1965. Built in January 1952, No. 61394 had a long association with King's Cross shed. Unusually, it was transferred to Canklow in March 1963 (shortly before the closure of the former). It worked from Canklow until June 1965 and was withdrawn in November 1965. *(David Hucknall)*

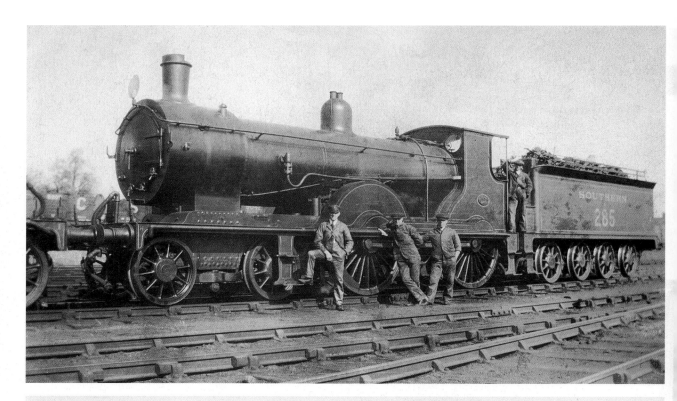

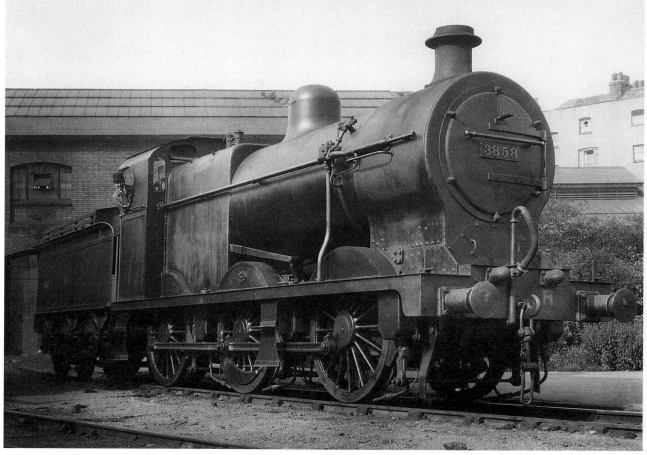

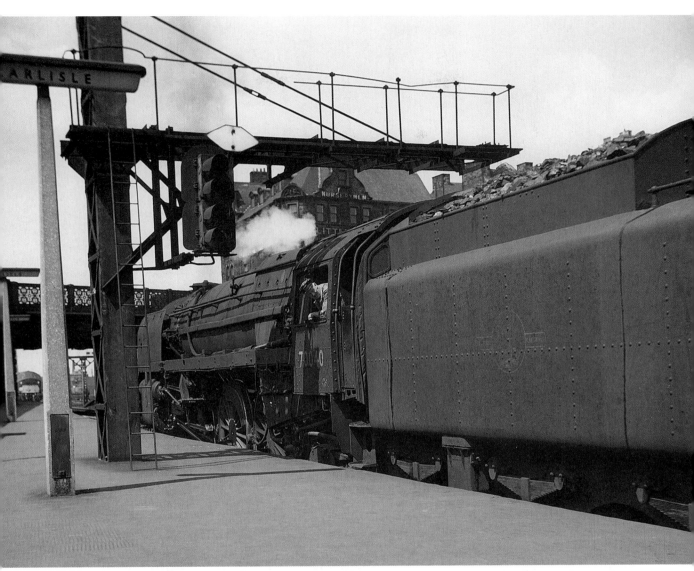

Awaiting departure from Carlisle station, to pass under the Victoria Viaduct and then head north, in May 1965, was Kingmoor's 'Britannia' Class No. 70040 (formerly *Clive of India*). The driver was looking closely for the 'right away'. Clearly seen here is the locomotive's BR Type 1 tender. It was inset to give the crew a good view when travelling in reverse. It was, unfortunately, an unappreciated design feature, giving the crews a dusty and draughty ride at speed. *(D.J. Hucknall Collection)*

*Opposite, top:* A group of drivers and firemen, arranged appropriately on 'T9' Class locomotive No. 285, poses for the camera. The date was probably in the mid-1930s (the E-prefix of No. 285 was removed in 1932) and Salisbury was the likely location. No. 285 was built at Nine Elms in 1900 and was withdrawn from service in 1958. *(D.J. Hucknall Collection)*

*Opposite, bottom:* A man in a bowler hat (perhaps one of the shed foremen) poses for a photographer on the footplate of '4F' Class No. 3858. Neither the location nor the date is known but, as No. 43858, the '4F' had a long association with Saltley. *(D.J. Hucknall Collection)*

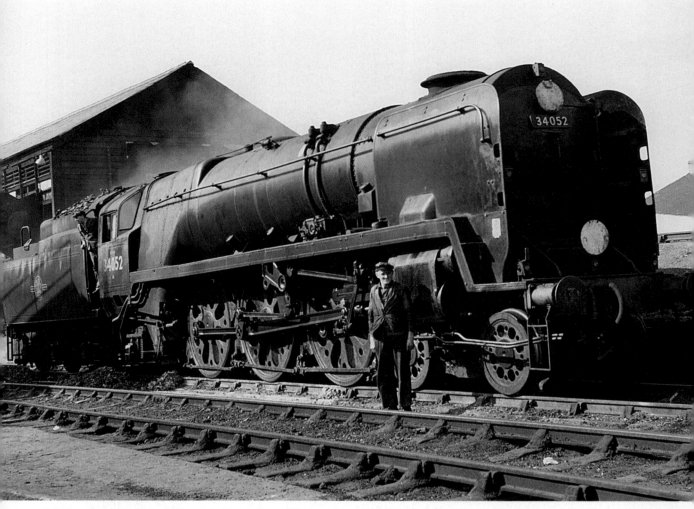

Salisbury shed's apparently ubiquitous Perce Pittman posed for his photograph by the side of rebuilt 'Battle of Britain' Class No. 34052 (formerly *Lord Dowding*). No. 34052 was carrying headcode discs associated with Waterloo–West of England trains. Freshly dropped fire burned by the rail near the rear driving wheel of the locomotive, the tender of which was fully coaled. It is probable that No. 34052 would have moved into the shed yard to take up its next duty. *(George Harrison/D.J. Hucknall Collection)*

# Chapter Five

# The Southern Region

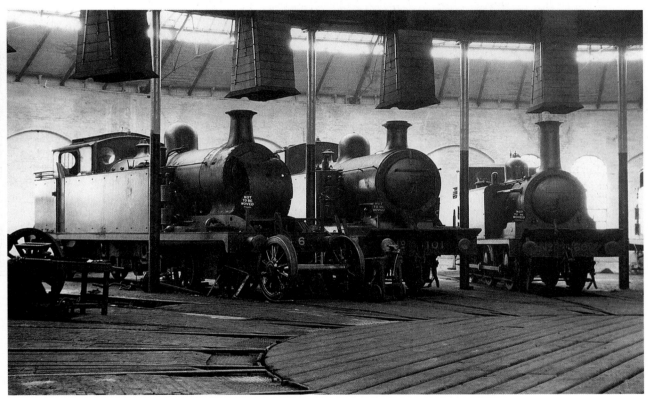

The LBSCR depot at Battersea Park is described in Hawkins and Reeve's (1979) book. It consisted of three round-houses, two on the Up side and one on the Down side of the railway viaduct. The sheds originally housed 'large numbers of tank engines for commuter work in south London'. This photograph, taken on 17 May 1921, shows three such tank engines around the turntable in one of the roundhouses. From left to right they are 'L1' Class 4–4–2T No. 6 (built in 1906; it has a clerestory roof and a Billinton chimney), 'E2' Class 0–6–0T 'goods shunting engine' No. 101 and 'E1' Class 0–6–0T, No. 691, originally LBSCR No. 91 *Fishbourne* of 1883 and renumbered in 1911. *(H.C. Casserley)*

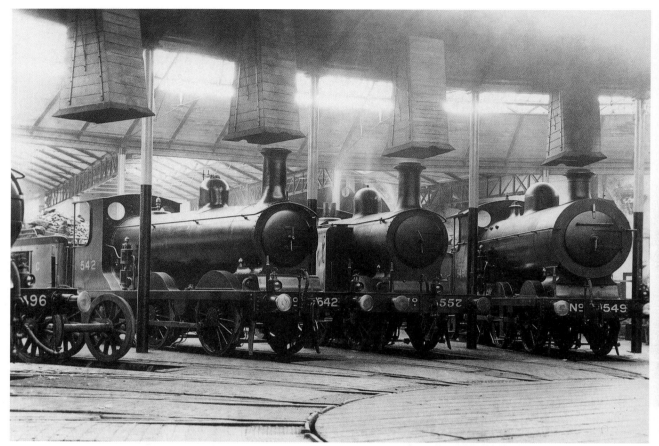

What is invariably apparent from most photographs of engine sheds in the 1920s and '30s is the cleanliness of the locomotives and the apparent good order of their surroundings. This view, inside one of Battersea shed's three roundhouses on 7 May 1921, shows a group of LBSCR locomotives, including Nos 542, 557, and 549, standing around the turntable. In spite of the fact that the shed was almost fifty years old at the time, internally at least, it seems structurally perfect. *(H.C. Casserley)*

*Opposite, top:* A fine portrait of Wainwright Class D 4–4–0 No. 31577 at its home shed, Ashford, at 1.40 pm on 16 August 1955. The view was taken looking approximately south-east towards the front of the shed. It shows the structure which was built by the Southern Railway and opened in 1931. *(David Holmes)*

*Opposite, bottom:* Bournemouth shed dated from the mid-1930s. It was located at the west end of the station. As this photograph shows, a superb view of the shed yard and entrance was afforded from the Down platform. Here, three rebuilt Bulleid Pacifics can be seen, including No. 34042 *Dorchester* (rebuilt from its original state in January 1959). The un-rebuilt 'West Country', No. 34008 *Padstow*, was modified in June 1960, indicating that this photograph was probably taken in late 1959. *(H.G. Usmar/D.J. Hucknall Collection)*

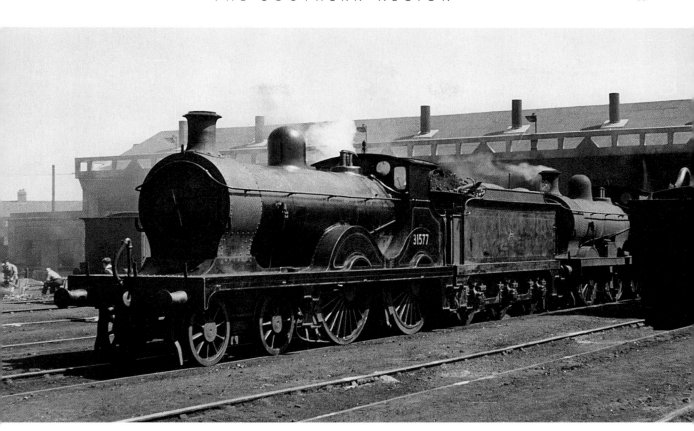

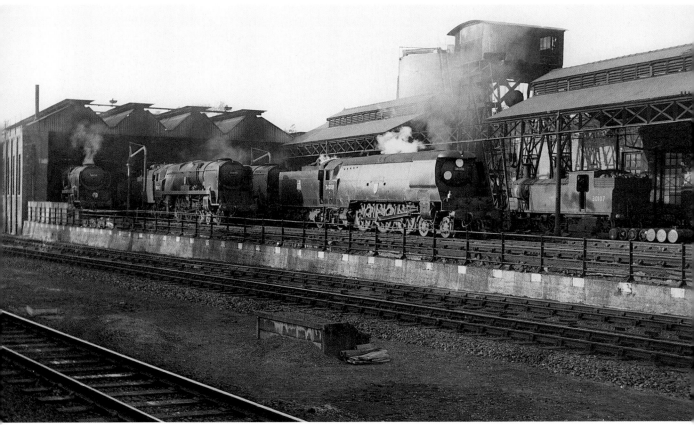

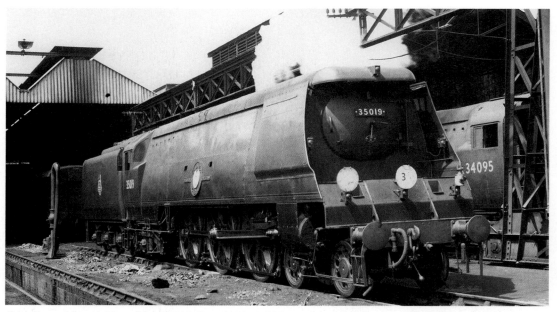

'Merchant Navy' Class No. 35019 *French Line CGT* was 'on shed' at Bournemouth on 8 July 1953. No. 35019's headcode does not explain why. It seems to indicate that the engine had worked a Waterloo (or Nine Elms)–Southampton Docks train. No. 35019 entered traffic in June 1945. It became a Nine Elms engine and it seems to have remained with that shed until August 1964 when it was transferred to Weymouth. Close examination of the shed plate, however, seems to show that No. 35019 was an Eastleigh (71A) engine at the time. This period in 1953 coincided with tests of a modified chimney which had been fitted to No. 35019 in June 1951. *(J. C. Hillmer)*

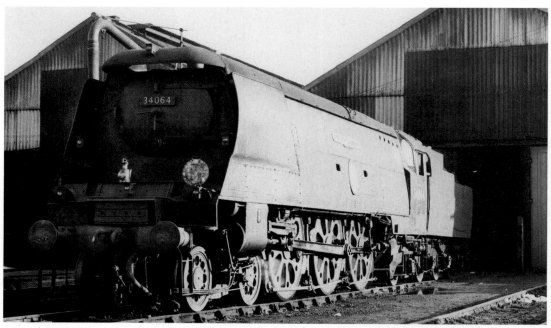

Unrebuilt 'Battle of Britain' Class No. 34064 *Fighter Command* entered traffic in July 1947 from Ramsgate shed. It was the 1,000th locomotive to be built at Brighton Works. For a number of years it was an Exmouth Junction locomotive but it was eventually transferred to Eastleigh. It is seen here at the latter shed in 1965. No. 34064 was fitted with a Giesl oblong ejector in April 1962. As with several such trials, however, the results were inconclusive. The locomotive was withdrawn from service at Salisbury shed in May 1966. After a short period in storage at Basingstoke, it was scrapped in Newport in November 1966. Fittingly, the engine's nameplate is held by the RAF Museum. *(H.G. Usmar/D.J. Hucknall Collection)*

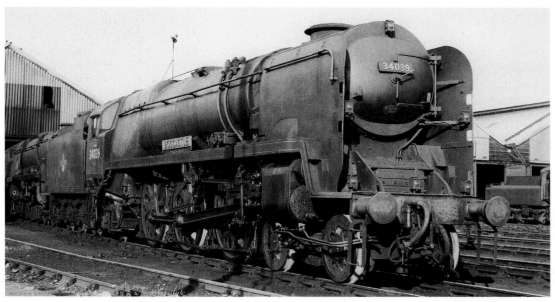

'West Country' Class No. 34039 *Boscastle* was completed at Brighton Works as No. 21C139. It was initially allocated to Stewarts Lane shed, Battersea, from where it worked until 1950. In 1948, it was the regular engine on the 'Golden Arrow'. It was also one of the engines loaned to Stratford shed to work on the former Great Eastern lines out of Liverpool Street which were, apparently, disliked by Richard Hardy, the then shed master at Stratford. As a Brighton engine (1952–9), No. 34039 worked on through trains to Bournemouth and Salisbury. It is seen here at Eastleigh during the time (September 1962–May 1965) when it worked from that shed. It is currently with the Great Central Railway but, regrettably, out of service. *(H.G. Usmar/D.J. Hucknall Collection)*

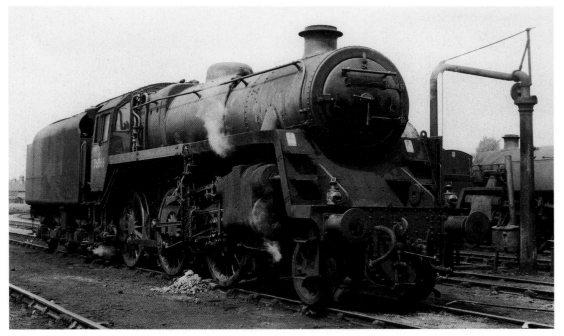

BR Standard Class 4 No. 76066 had been an Eastleigh engine in the late 1950s and was transferred to Salisbury in the early 1960s. It returned to Eastleigh's stock towards the end of steam haulage of trains on the Southern Region. Despite its lack of shed and smokebox number plates, No. 76066 gave the impression of being mechanically sound when photographed outside Eastleigh shed in 1967. The engine worked to the very end, hauling the 10.13 Weymouth–Bournemouth train on 7 July 1967. It was seen, appropriately, on No. 5 road inside Salisbury shed, awaiting scrapping one month later. *(H.G. Usmar/D.J. Hucknall Collection)*

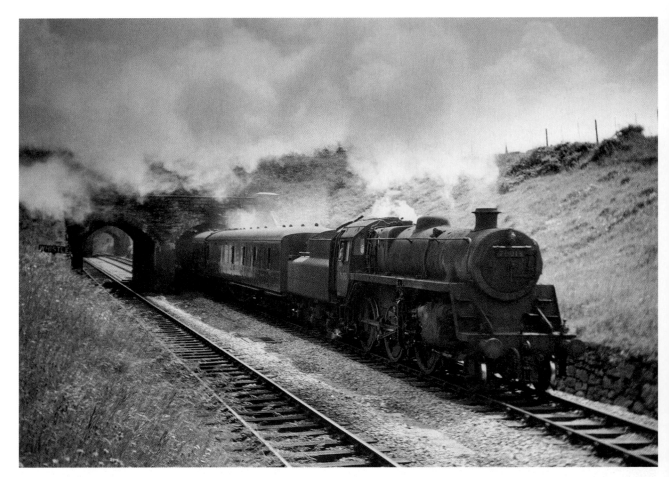

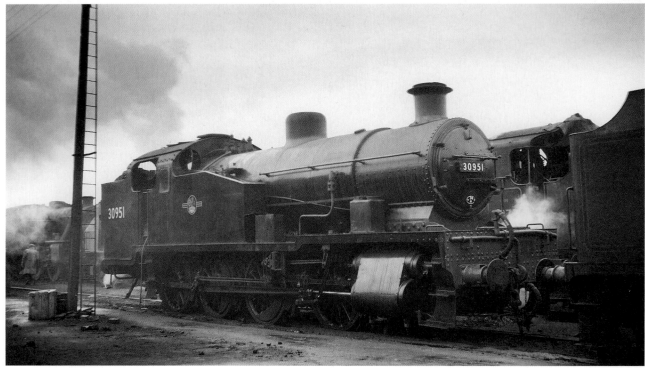

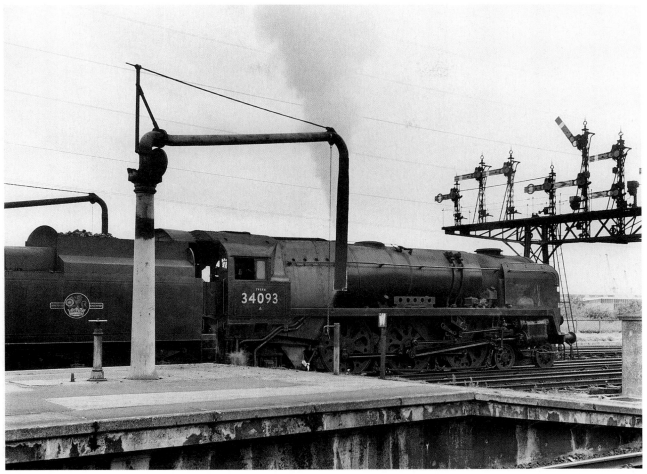

Rebuilt 'West Country' Class No. 34093 (formerly *Saunton*) was photographed at the unmistakeable Southampton Central station heading a Waterloo–Weymouth train in May 1966. In the late 1950s, No. 34093 had been a Bournemouth engine but it was transferred to Nine Elms in 1959. By 1966, it was assigned to Eastleigh. It was withdrawn in July 1967. *(George Harrison/D.J. Hucknall Collection)*

*Opposite, top:* British Railways' Standard Class 4 No. 76013 was seen at Prestleigh on the former Somerset and Dorset Joint Railway with a very short train of Western Region stock. No. 76013 had been an Eastleigh engine (March 1953–September 1964) before its transfer to Bournemouth shed. It was withdrawn in 1966. In 1958, a rearrangement of Regional boundaries occurred on British Railways and the Western Region gained control of the old S&DJR. Under its stewardship, this once-important line was reduced to an irrelevance. *(D.J. Hucknall Collection)*

*Opposite, bottom:* Fresh from overhaul, Maunsell 'Z' Class 0–8–0T No. 30951 (with a 74A – Ashford shed-plate) stands in a shed yard. The exact location and the date are unknown but it is probably Eastleigh shed yard. All the 'Z's had been transferred to Exmouth Junction by November 1959 to act as banking engines on the steep incline between St. David's and Central stations, Exeter. This does not help date this photograph, however, because sister engine No. 30955 could be seen at 72A, even in April 1960, with its 74A shed-plate intact. *(D.J. Hucknall Collection)*

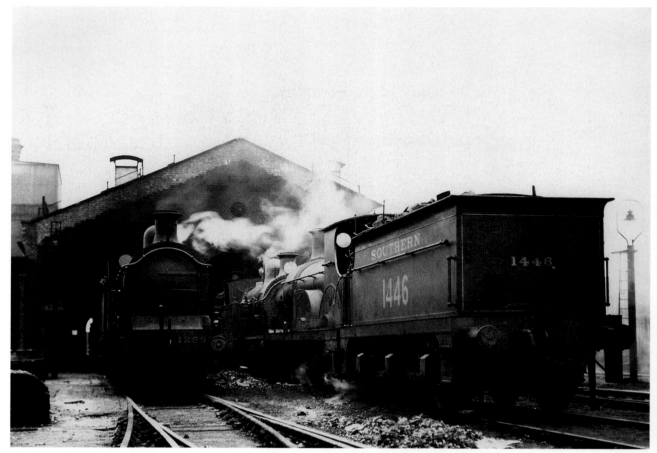

A view of the entrance to Gillingham shed, looking to the south-east on 4 February 1934, shows 'B1' Class 4–4–0 No. 1446 and 'C' Class 0–6–0 No. 1256 standing outside the shed – a brick structure with arched entrances. The shed was re-roofed by the Southern Railway in 1931 and evidence of this is clearly seen with the new courses of brickwork quite apparent above the original roof line. Of the locomotives, No. 1446 had been built in 1898 and survived until 1949. No. 1256 (built at Ashford in 1900) remained in service until 1962. *(H.C. Casserley)*

*Opposite, top:* A Class '0298' 2–4–0WT, built by Beyer Peacock, was seen outside Eastleigh Works, adjacent to Buildings 5 and 6. The 2–4–0WTs were delivered in two lots of six in 1874 and 1875. The main difference between the batches was the rectangular splashers on those engines delivered in 1875. Over the decades, the engines were rebuilt many times, firstly with Adams' boilers and, in the 1920s, as can be seen, with Drummond boilers. It is again difficult to date this photograph but behind the well tank stood what was probably a Class 'N15'. It is possible that this was taken in the early 1920s. *(D.J. Hucknall Collection)*

*Opposite, bottom:* A 'Q1' Class 0–6–0 No. 33006 of Feltham shed is seen at Eastleigh Works. The weigh-house is in the background. Bulleid's 'Q1's represented a huge departure in appearance from the conventional British 0–6–0. According to Haresnape (1977), 'Bulleid went back to basic principles in doing away with all unnecessary ornamentation and dispensing with a number of customary features'. To keep the weight within requirements (54 tons) and produce an engine that was easy to manufacture, he produced a design which, unbelievably, is said to have provoked an 'outcry' against the designer's apparent disregard for aesthetic appearance. *(H.G. Usmar/D.J. Hucknall Collection)*

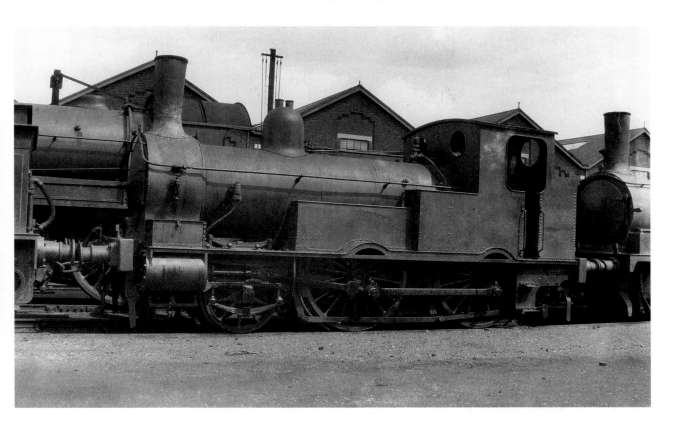

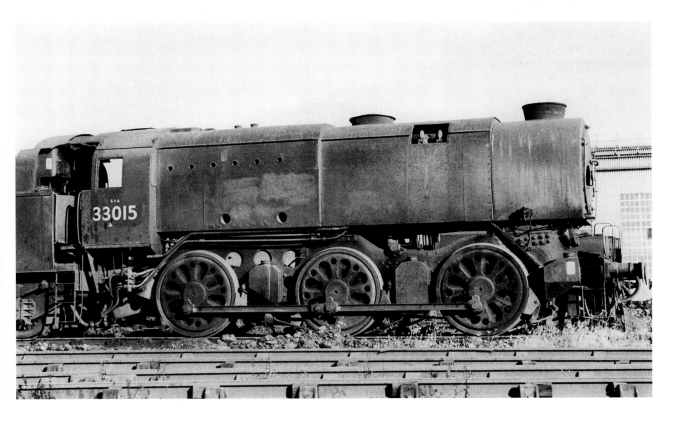

Eastleigh's BR Standard Class 4 4–6–0 No. 75079 and a BR Standard Class 4 2–6–0 are shown outside the Old Shed at Nine Elms. No. 75079 was withdrawn in 1966 but, although as yet unrestored, it is in the care of the Plym Valley Railway. *(H.G. Usmar/D.J. Hucknall Collection)*

*Opposite, top:* 'Q1' Class No. 33029 (74D – Tonbridge) is seen in the shed yard at Gillingham at 10.40 am on 30 July 1958. It was one of eleven 'Q1's assigned to Tonbridge in the early 1950s. This view, from close to the road leading to the coaling stage, shows that the shed was a good-looking brick-built structure with arched entrances to the three shed roads. To the left of the shed, in the photograph, the offices and stores can be seen. *(David Holmes)*

*Opposite, bottom:* The yard at Stewarts Lane shed is shown in this photograph of 18 September 1926. In the background is the viaduct carrying the former LSWR lines into Waterloo. At the time, this shed was known as 'Longhedge' (after the former London, Chatham and Dover Railway's Works which had been nearby) or 'Battersea'. The original shed had been built in 1862 and a new shed was built on the site in 1881. It was not until the rebuilding of the latter by the Southern Railway that the name 'Stewarts Lane' came into general use. In the yard at the time were three well-cared-for engines, Nos A550,A531 and A671. Nos A550 and A532 were Wainwright 0–4–4Ts built in 1904 and 1905, respectively. No. A674 was an 'R' Class 0–4–4T built in 1891 by Sharp Stewart. As No. 30550, A550 remained in service until 1962, the other two were withdrawn by 1952. *(H.C. Casserley)*

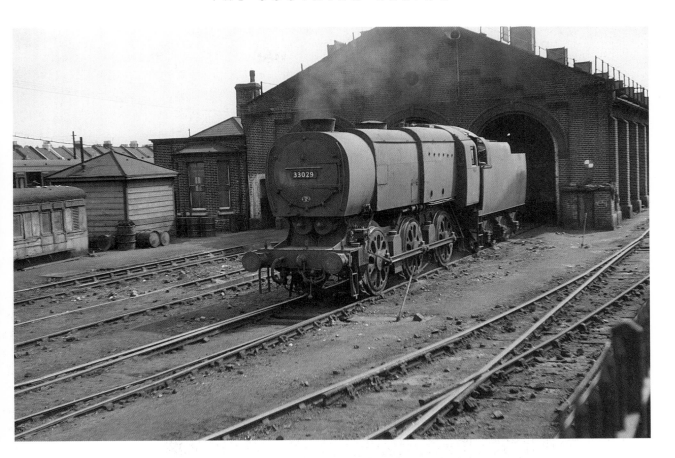

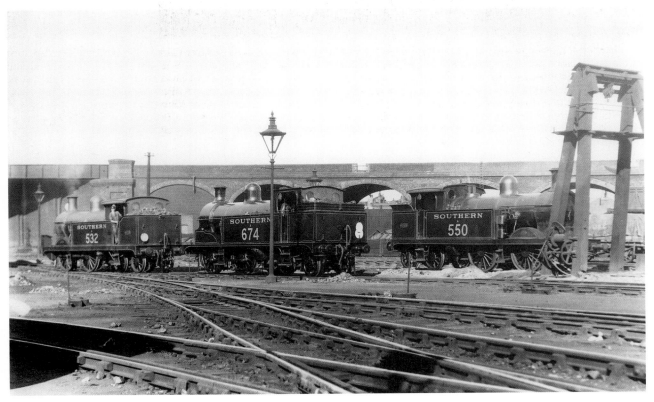

Locomotive building at Nine Elms for the LSWR Company started in 1843. It ended in June 1908 with the construction of the last locomotive, 'B4' Class (then called 'K14' Class) 0–4–0T No. 84. Seen here, 'B4' Class No. 81 (formerly named *Jersey*) had been built at Nine Elms in 1893 and went into service at Southampton Docks in the November of that year. Because of the smallness of their cabs, dock 'B4's often had these cut away so their crews would have less impaired views in the busy docks with its sharply-curving tracks. The location and date of this photograph are not known but No. 81 received neither Southern Railway livery nor an E-prefixed number. The location may have been close to Harland and Wolff's workshops and the date sometime between 1941 (no filter behind the engine's dome) and its withdrawal (1949). *(D.J. Hucknall Collection)*

*Opposite, top:* The shed at Barnstaple Junction was acquired by the LSWR in 1865 from the Taw Valley Railway. It was a two-road shed, built of timber, and stood in the goods yard by the station. By 1964 it was in a dreadful state of repair with no gable-end cladding or roof on the south end. Here, one of the shed's 'M7' Class 0–4–4Ts No. 30254, is seen at the entrance to the dilapidated building. *(H.G. Usmar/D.J. Hucknall Collection)*

*Opposite, bottom:* A further view of Barnstaple Junction shed shows Ivatt Class 2 2–6–2T No. 41238 of Exmouth Junction shed on the adjacent road to No. 30254. No. 41238 had been a Llandudno Junction engine before its transfer. It was withdrawn in 1964. *(H.G. Usmar/D.J. Hucknall Collection)*

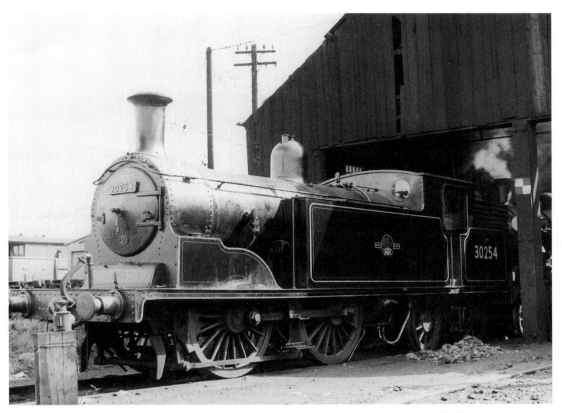

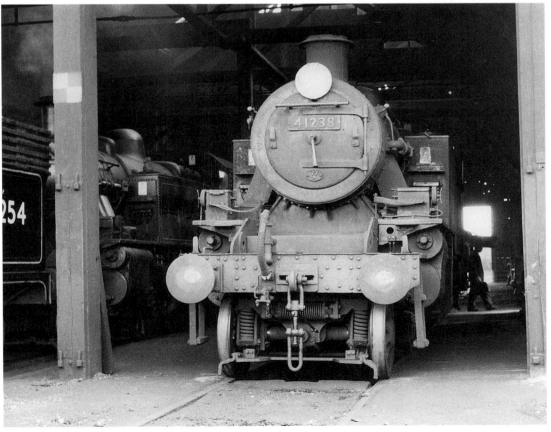

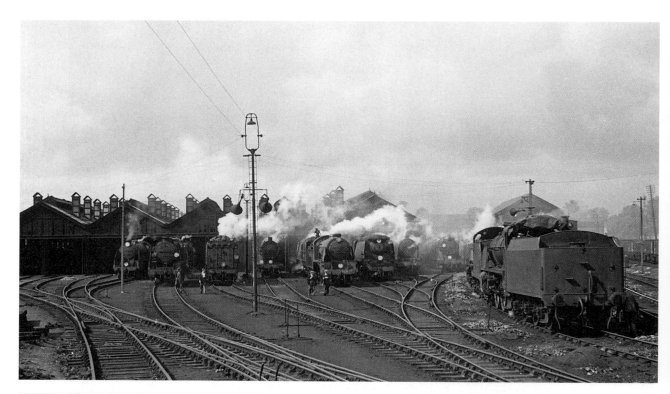

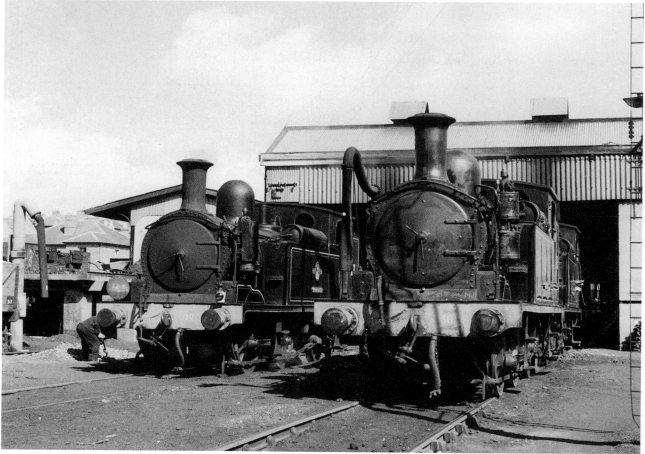

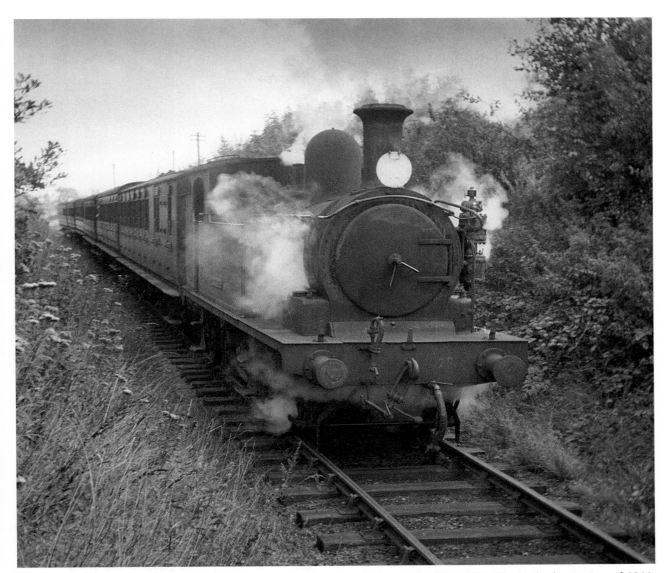

Class 'O2' 0–4–4T No. 29 *Alverstone* is shown going about its duties on the Isle of Wight. At the beginning of 1966, No. 29 was one of fourteen of the class which remained on the island. During that year, however, No. 29 (together with Nos 21, 26 and 35) was withdrawn. It was scrapped at Ryde but useful parts were retained. *(D.J. Hucknall Collection)*

*Opposite, top:* A view, looking towards the south, over the shed yard at Salisbury on 20 September 1947, shows clearly the shed with its roof with its 1901 configuration. The roof consisted then of five slated pitches, which covered ten locomotive roads, and the gable ends of the shed were glazed. The smoke vents were separate wooden structures. Understandably, by the early 1950s, the roof was in a poor state of repair and such were the maintenance costs that British Railways rebuilt the front part of the roof, particularly the gable-ends, with asbestos sheeting. *(H.C. Casserley)*

*Opposite, bottom:* Ryde St John's shed was opened in 1930 by the Southern Railway as a replacement for an earlier (1874) structure built by the Isle of Wight Railway. It was a two-road, steel-framed building, clad with asbestos sheeting, that stood at the south-west end of the station. It could house up to eight 'O2' Class tank engines. In the yard, there was a large coal-stage (seen behind No. 27) and two water columns. A structure that served as the shed's ash dump can be seen behind the ash- and clinker-filled wagon. The shed closed in 1967. The tank engines, Nos 27 *Merstone* and 30 *Shanwell*, were 'O2' Class 0–4–4Ts. No. 30 was fitted with a Westinghouse brake and No. 27 had a Drummond boiler. *(H.G. Usmar/D.J. Hucknall Collection)*

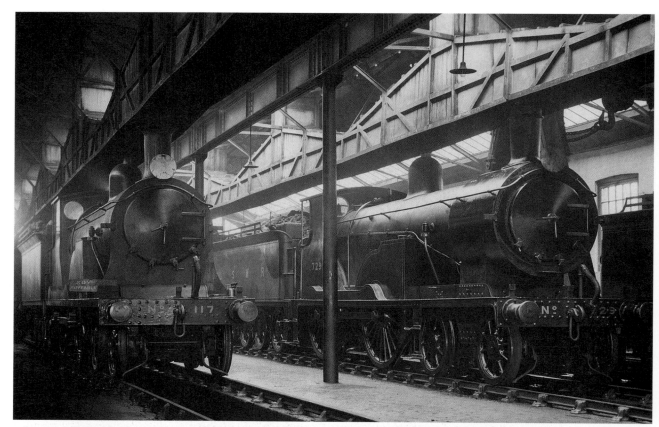

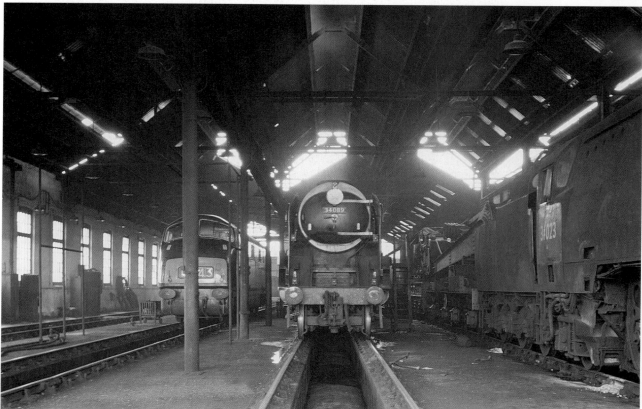

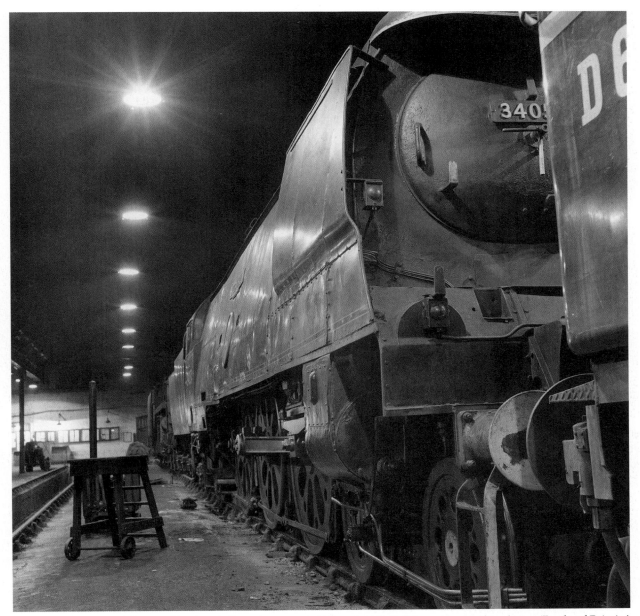

Unmistakably one of George Harrison's fine photographs taken inside Salisbury depot, this shows 'Battle of Britain' Class No. 34057 *Biggin Hill* in commendably clean condition. The rear wall of the depot, with its glass-fronted notice boards, is also clearly visible. Mr Harrison rarely dated his photographs but, from the state of the locomotive with its previously painted buffers, it may have been shortly after No. 34057 and sister-engine No. 34006 *Bude* had worked a Special from Bournemouth to Bath on 5 March 1966 – the last day of operations over the former S&DJR. *(George Harrison/D.J. Hucknall Collection)*

*Opposite, top:* Inside Salisbury shed on 25 October 1925 were Drummond 'T9' Class 4–4–0 Nos 117 and 729. No. 117 was built at Nine Elms in 1899 and No. 729 was built by Duebs and Co. in 1900. The smoke ducting above the locomotives appears heavy and flimsily braced. It did, however, last until the roof was replaced in the early 1950s. *(H.C. Casserley)*

*Opposite, bottom:* A view inside Salisbury shed looking to the south-west (towards Cherry Orchard Lane) shows a 'Warship' Class diesel locomotive, 'Battle of Britain' Class No. 34089 *602 Squadron* and unrebuilt 'West Country' No. 34023 (formerly *Blackmore Vale*). To the rear of No. 34023 is the depot's 36-ton Cowans Sheldon breakdown crane No. 375. Clearly visible, at the rear of the shed, are two of the original roof pitches and the gable-end glazing. The junction of the original and later roof is also seen. *(George Harrison/D.J. Hucknall Collection)*

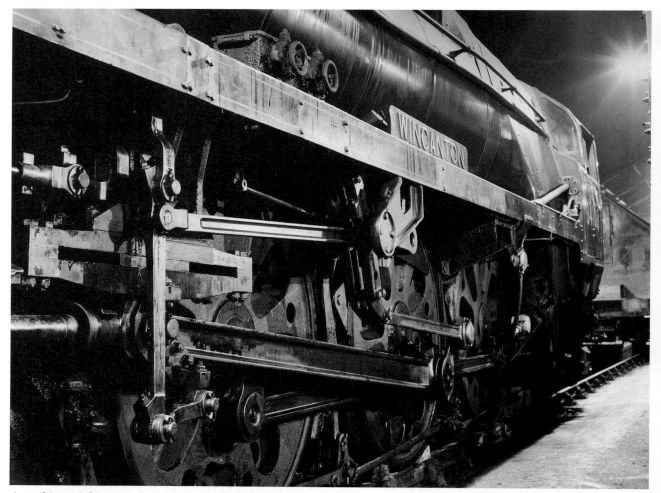

A striking night-time close-up shows rebuilt 'West Country' Class No. 34108 *Wincanton* on Salisbury shed. It was beginning to look a little work-stained and oily grime had begun to accumulate on the engine's wheels and motion. Allocated to Bournemouth shed in the early 1950s, No. 34108 was subsequently transferred to Exmouth Junction. At the end of its working life, it was one of Salisbury shed's carefully tended locomotives. It was withdrawn from that shed in July 1967. *(George Harrison/D.J. Hucknall Collection)*

*Opposite:* This night-time shot shows 'Battle of Britain' Class No. 34066 *Spitfire* inside Salisbury depot. It was one of fourteen unrebuilt Bulleid Pacifics which had survived until January 1966. Before that date, the original Bulleid locomotives were withdrawn as they became due for a major overhaul. Although it was withdrawn during 1966, No. 34066 looked clean and cared-for. *(George Harrison/D.J. Hucknall Collection)*

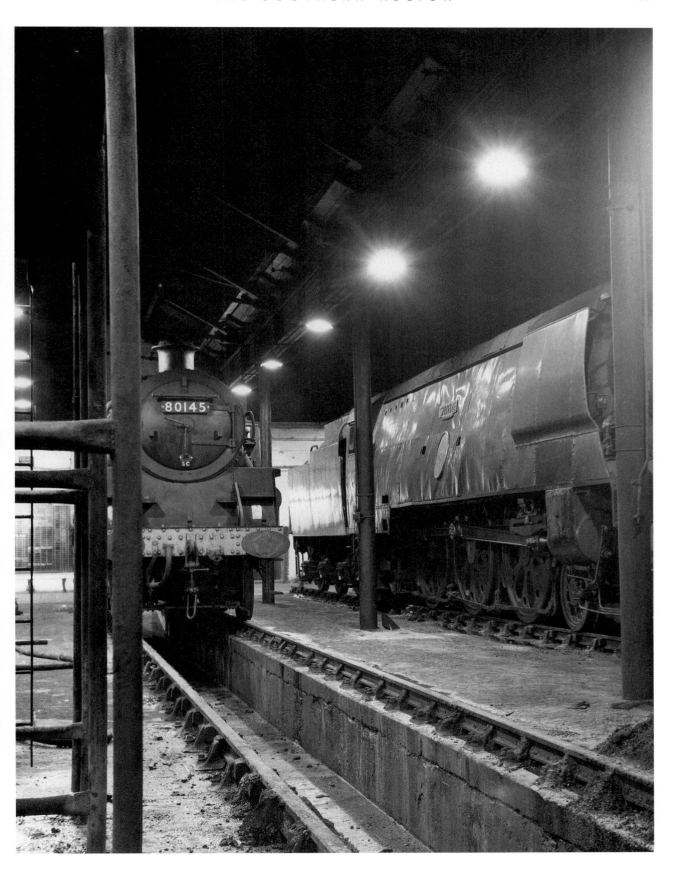

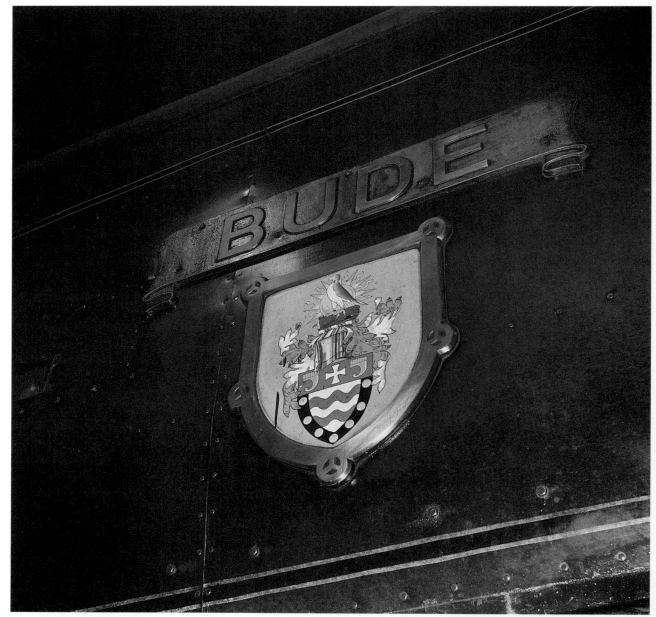

When the first 'West Country' Class locomotives were named, they carried shields below their name-plates usually showing the coats of arms of the relevant town. There were exceptions. Some Cornish examples (*Bude, Wadebridge, Padstow* and *Bodmin*) carried the county shield because, in some cases, town crests did not exist. In 1945, the Publicity Department of the Southern Railway asked the towns with county shields for their specific coats of arms. Bude was a town which then applied for and received a town crest. Here, the nameplate and town coat of arms carried by No. 34006 are shown. The shield had an overall height of about 2ft and a width of approximately 20in. (*George Harrison/ D.J. Hucknall Collection*)

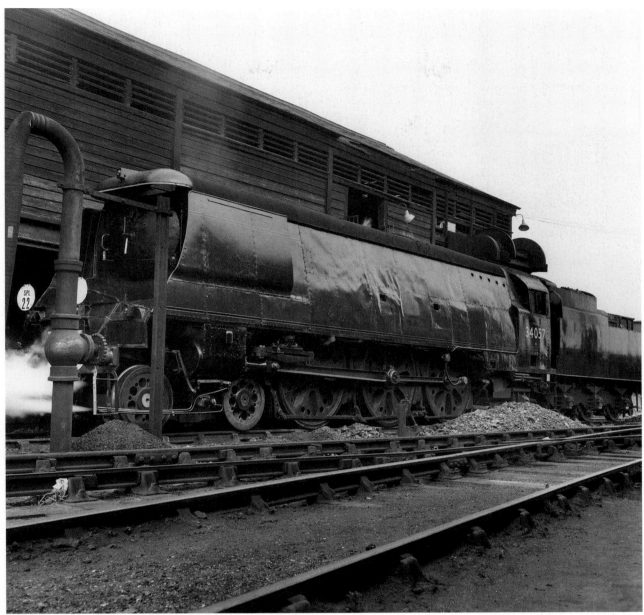

Well-cleaned, unrebuilt 'Battle of Britain' Class No. 34057 was seen as it stood by the south side of the coaling stage at Salisbury shed. No. 34057 played a significant part in the restoration of sister locomotive No. 34023 to a state closely resembling Bulleid's original design. In the mid-1960s, unlike No. 34023, No. 34057 had the original Bulleid-designed crosshead and had cylinder sizes which were similar to No. 34023. The rear covers of No. 34023's cylinders, however, had been altered to accommodate a modified gland-packing box so all the rear covers from No. 34057 were exchanged with those from No. 34023. It was then found that there was insufficient clearance at the rear of the left-hand cylinder. It was found necessary to remove $\frac{5}{32}$ of an inch from this – a long and difficult task. *(George Harrison/D.J. Hucknall Collection)*

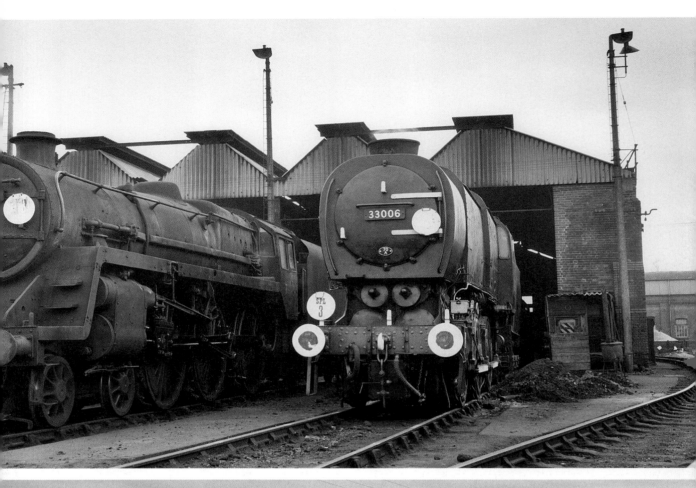

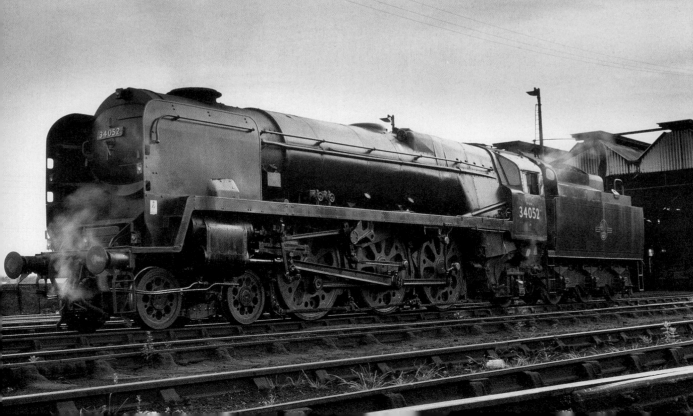

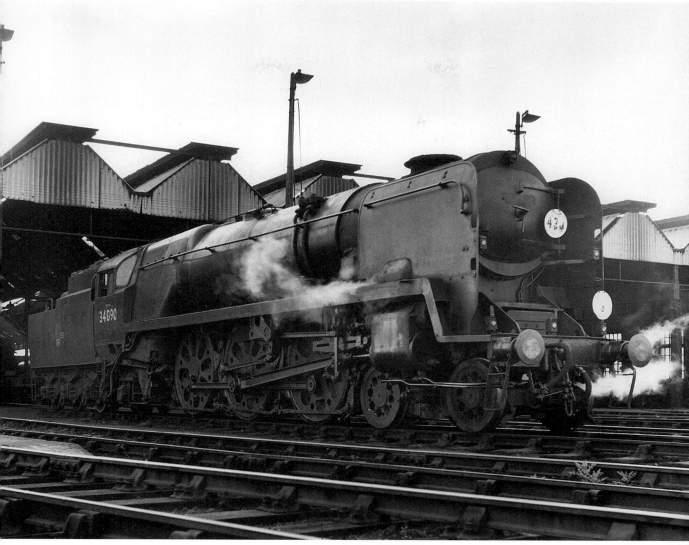

The wasteful scrapping of what was effectively a new locomotive could not have made economic sense. Such was the case with 'Battle of Britain' Class No. 34090 *Sir Eustace Missenden*. The rebuilt locomotive entered service in August 1960 and survived until the end of steam on the Southern Region in July 1967. Before and immediately after rebuilding it was a Nine Elms locomotive but towards the end of its working life, it worked from Eastleigh shed. Seen here at Salisbury depot in early 1967, No. 34090 was displaying a head code which was associated, among others, with an Exeter Central–Nine Elms (market goods/fish) working. Duty numbers in the '400' series would have been allocated to either Salisbury shed or Exmouth Junction. *(George Harrison/D.J. Hucknall Collection)*

*Opposite, top:* On 3 April 1966, Salisbury depot played host to what was then the last working 'Q1' Class 0–6–0 No. 33006. Beyond the shed, the track winds away to the turntable and in the background is the former visiting enginemen's dormitory with its roof formed by the huge water tank. *(George Harrison/D.J. Hucknall Collection)*

*Opposite, bottom:* Rebuilt 'Battle of Britain' Class No. 34052 (formerly *Lord Dowding*) is seen at Salisbury shed in this classic portrait by George Harrison, possibly in May 1967 when the locomotive was being prepared for its next duty, the 'Feltham Goods'. *(George Harrison/D.J. Hucknall Collection)*

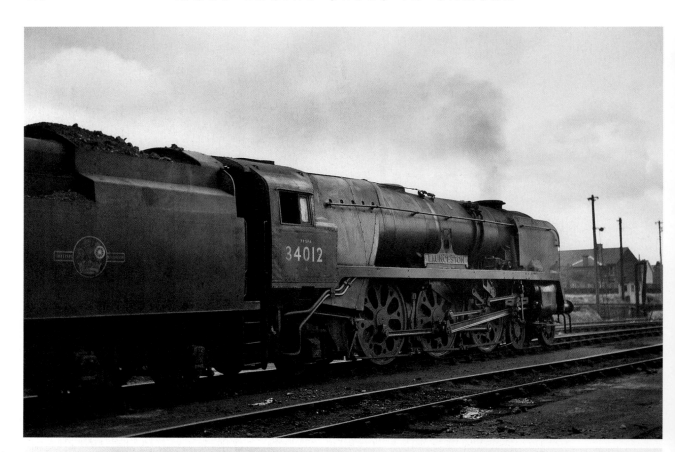

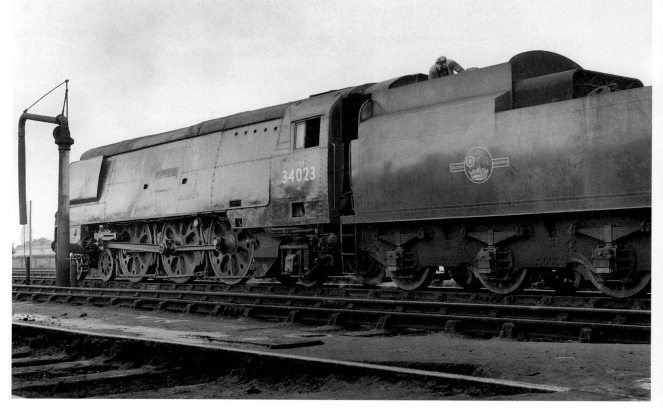

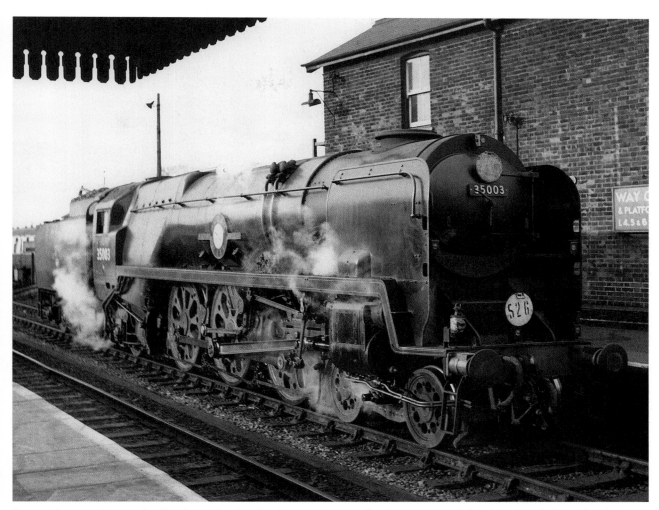

It was the practice on the Southern Region for locomotives to display on one of the directional discs the diagram number of the duty on which they were being used. This was to help in the identification of a light engine moving from the shed to pick up its train. Here, 'Merchant Navy' Class No. 35003 *Royal Mail* (at the time allocated to Exmouth Junction), involved with West-of-England–Waterloo train No. 526 (the 10.30am from Exeter), is seen at the west end of Platform 1 at Salisbury station. It was possibly proceeding to the holding space opposite Salisbury East signal-box before replacing the locomotive on the incoming train or, more probably, returning to shed after coming off the 10.30 a.m. No. 35003 had, according to Winkworth (1974), achieved 105mph at Winchfield on 28 June 1967 with the 6.15 pm Weymouth–Waterloo train. At the time, it would have been a Bournemouth engine. *(H.G. Usmar/D.J. Hucknall Collection)*

*Opposite, top:* 'West Country' Class *Launceston* was built in 1945 (as 21C112) and, as No. 34012, rebuilt in January 1958. In the early 1950s, it was a Nine Elms locomotive but in the latter part of the decade and into the early 1960s, it worked from Stewarts Lane. By 1961, Stewarts Lane had only two regular Pacific duties and was closed to steam in 1963. No. 34012 is shown here on the road leading to the coaling stage at Salisbury in 1966, its tender filled with some awful looking fuel. Although *Launceston* survived until the beginning of 1966, it was withdrawn during that year. *(George Harrison/D.J. Hucknall Collection)*

*Opposite, bottom:* No. 34023 *Blackmore Vale* and No. 34102 *Lapford* were the only two unrebuilt Bulleid Pacifics remaining in service at the end of steam on the Southern Region. About three weeks before the closure of Nine Elms shed and the subsequent sale of the land, Alan Wilton, with the assistance of his motive power colleagues (Hubert Brown, Jim Lester, Dan Stewart, Micky Thomas and Brian Ventham), had No. 34023, which had been bought from the British Railways Board on 3 August 1967, taken out of service with the intention of carrying out as much work as possible on it. After a considerable amount of work, No. 34023 was moved from Nine Elms to Longmoor on 13 August of that year. Here, on one of its last duties, No. 34023 is seen being prepared at Salisbury shed. *(George Harrison/D.J. Hucknall Collection)*

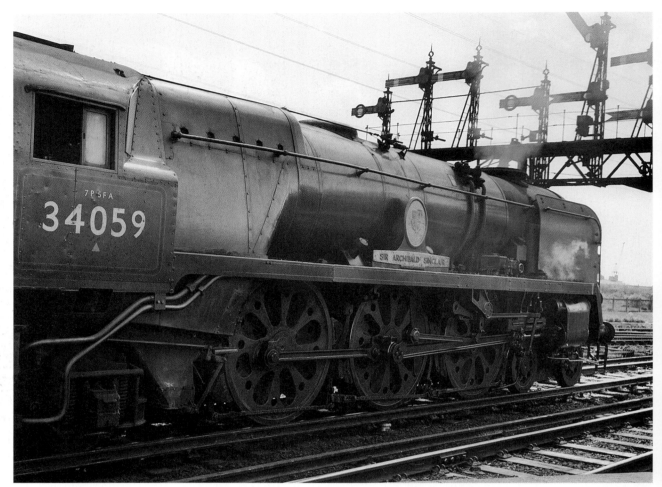

Rebuilt 'Battle of Britain' Class No. 34059 *Sir Archibald Sinclair* was heading a Down Weymouth train when seen at Southampton Central. Initially a Nine Elms locomotive, it was transferred, albeit briefly, in the spring of 1949, to Stratford shed for work on services serving East Anglia. Published information on its subsequent movements seem oddly inconsistent. It seems to have been transferred to 72A in April 1951 and to Salisbury in March 1953, where it remained until March 1959. After rebuilding, it is reported to have returned to Exmouth Junction but another source suggests that it worked in Kent during 1960 and 1961. It was transferred to Salisbury in January 1965 and withdrawn on 29 May 1966. It is now undergoing restoration on the Bluebell Line. *(George Harrison/D.J. Hucknall Collection)*

*Opposite, top:* An odd photograph of 'West Country' Class No. 34034 (formerly *Honiton*) shows the locomotive, with its driver, cup in hand, waiting to move it out of the yard at Salisbury. No. 34034 was as dirty as an engine could probably be, with marks on the tender consistent with an attempt to scrape off the grime. It also seems to have been coaled with some very dubious-looking fuel. At the time, it would have been a Nine Elms engine and it was withdrawn from that shed in July 1967. I never saw No. 34034 in any state other than this. As a small boy on holiday from South Yorkshire, I saw it at Seaton Junction when even its nameplate was almost unreadable. For some time afterwards, I was convinced I had seen an engine named 'HON TON'! *(George Harrison/D.J. Hucknall Collection)*

*Opposite, bottom:* In the summer of 1967, many withdrawn engines from the Southern region were assembled at Salisbury ready for removal to the scrapyards in South Wales. Bearing in mind the photographs of these two engines published elsewhere in this, and a previous book, it must have been a rather sad occasion for George Harrison to record 'West Country' Class locomotives Nos 34006 and 34056 waiting for their final journey. *(George Harrison/ D.J. Hucknall Collection)*

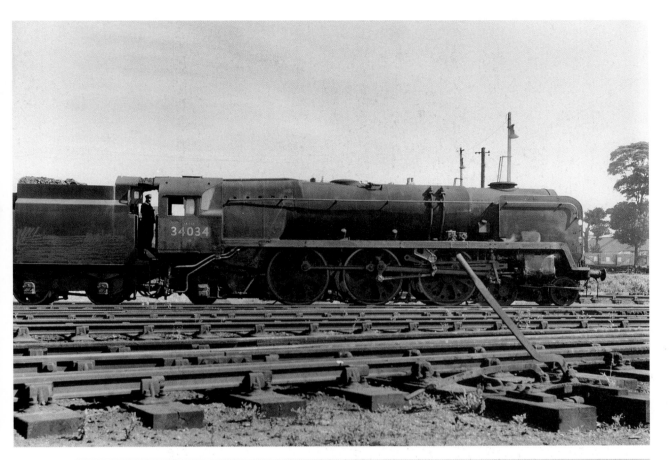

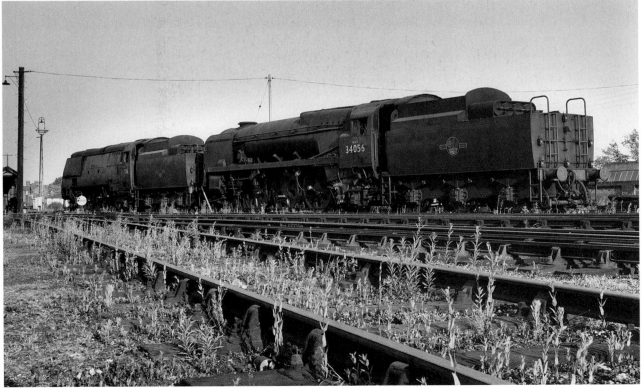

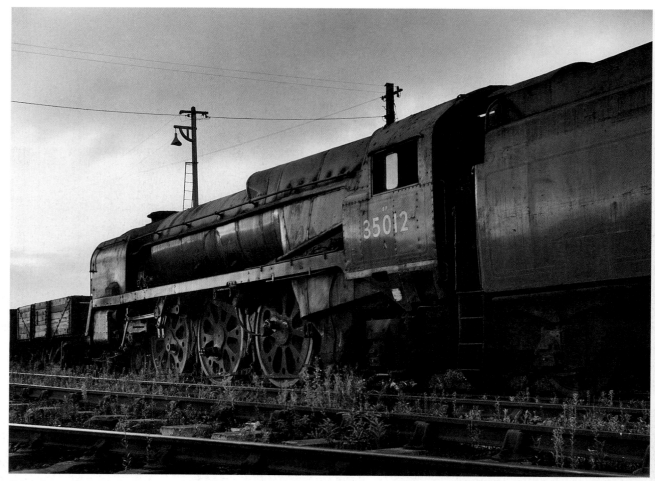

'Merchant Navy' Class No. 35012 (formerly *United States Line*) is seen awaiting removal for scrap in mid-1967.
A relatively short time had passed since the locomotive had worked, so competently, the 'Solway Ranger' between
Leeds and Carlisle on 13 June 1964. In the meantime, No. 35012 and some other members of the class had been
transferred to Weymouth because of the very poor condition of the Old Shed building at Nine Elms. It returned to that
shed in April 1967 only to be taken out of service. In a note to George Harrison in July 1966, Oliver Bulleid wrote, 'In
designing the Merchant Navy engines, I did everything I could to make the engines comfortable and easy to handle'.
*(George Harrison/D.J. Hucknall Collection)*

*Opposite, top:* 'Merchant Navy' Class No. 35012 *United States Line* is seen at Carlisle station on 13 June 1964. It had hauled
the 'Solway Ranger' to Carlisle from Leeds via the West Coast Main Line. It returned south via the Settle–Carlisle route
where, according to contemporary records, it put up a superb performance. *(W.A.C. Smith)*

*Opposite, bottom:* For a couple of years before demolition, Salisbury shed stood empty and falling slowly into disrepair.
An image of that period is shown here. On the left, Salisbury signal-box can be seen while, in the centre background, the
spire of the cathedral dominates. *(George Harrison/D.J. Hucknall Collection)*

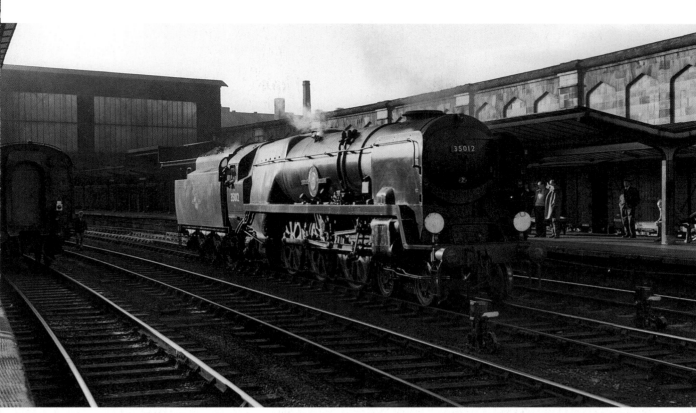

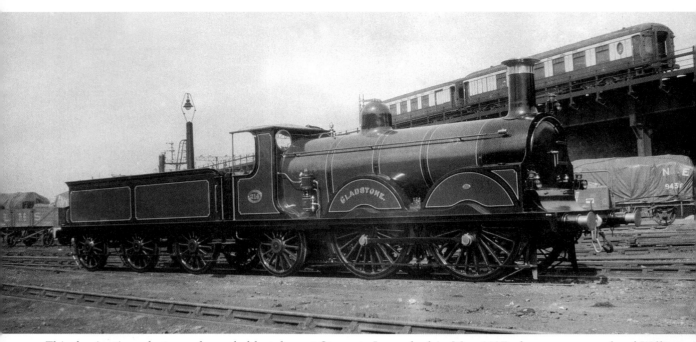

This fascinating photograph, probably taken at Stewarts Lane shed in May 1927, shows an example of William Stroudley's last express design – No. 214 *Gladstone* – which was built at Brighton in December 1882. The Stephenson Locomotive Society, in the late 1920s, held No. 214 in such high regard that, on payment of £140 to cover restoration costs, it persuaded the Southern Railway to preserve it. Restored at Brighton Works, it was exhibited at Brighton station from 2 to 7 May 1927 in the condition seen here. On 14 May, it was exhibited at Waterloo, together with No. 850 *Lord Nelson*. As a temporary storage measure, it was taken to York Railway Museum on 31 May 1927. It has remained there since then. *(D.J. Hucknall Collection)*

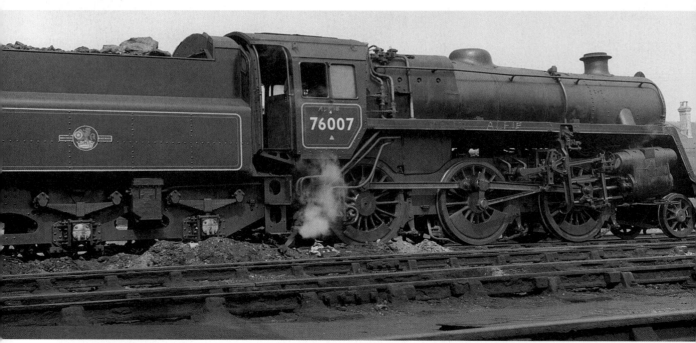

BR Standard Class 4 2–6–0 was allocated to Salisbury in May 1958, where it remained in the allocation until April 1967 when it was transferred to Bournemouth. At Salisbury, No. 76007 was the regular engine of driver Alfie Smith and it was informally named 'Alfie'. At the time of this photograph, No. 76007 was carrying a disc referring to duty No. 254. This involved the engine acting as a spare for Eastleigh shed for 'special traffic', a duty normally assigned to a 'West Country' or a 'Battle of Britain'. *(George Harrison/D.J. Hucknall Collection)*

# Chapter Six

# The Western Region

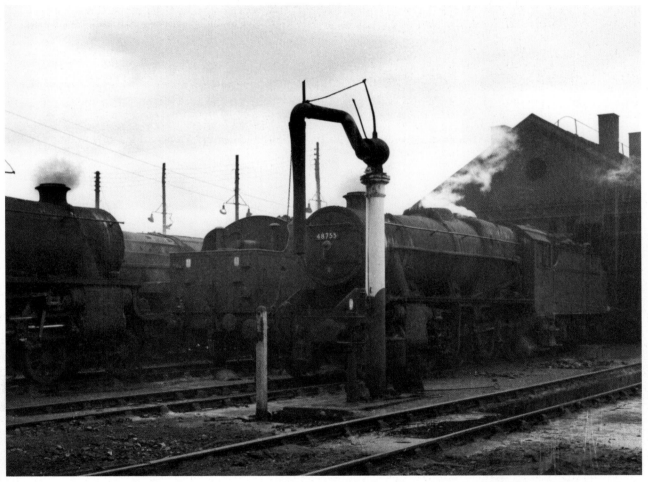

Banbury shed on 2 January 1966, ten months before closure on 3 October 1966, had a very different allocation of locomotives to that in the late 1950s. In the shed yard were '8F' Class No. 48755, two 'Black 5's and, just visible between the 'Black 5's, 'Britannia' Class No.70053 (formerly *Moray Firth*). Also on shed at the time was Eastleigh shed's rebuilt 'West Country' Class No. 34098 *Templecombe*. A GWR standard 8in water crane with a cranked arm dominated the foreground. *(David Hucknall)*

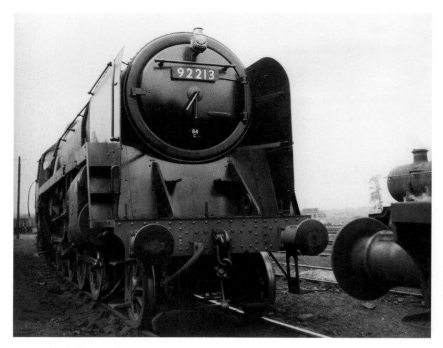

In this undated photograph, '9F' Class No. 92213 stands at its home shed, Banbury. The shed had several BR Standard '9F's in its allocation. At one time, Nos 92212–15, 227/228, 232–4 were among its locomotives. A major part of their duties involved the five daily ironstone trains that were worked to Cardiff, Llanwern and Severn Tunnel Junction for the steel works which then existed in South Wales. On closure of Banbury shed, No. 92213 was moved on. It went north to become a Kingmoor locomotive.
(H.G. Usmar/D.J. Hucknall Collection)

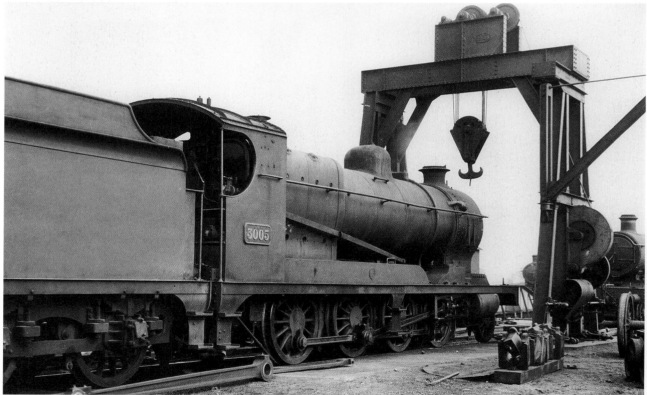

The pre-Second World War Banbury shed had limited engine-lifting facilities in the form of a crane straddling a track near the turntable (part of which can be seen just beyond the buffer beam of the ROD.) This facility can be seen clearly in this photograph of an 'ROD' Class 2–8–0 No. 3005, taken on 11 September 1937. No. 3005 was one of twenty Robinson-designed engines (Nos 3000–19) that were bought by the Great Western Railway in about 1919. The locomotives had been part of a batch of 521 ordered by the British Government which had not been used abroad. This batch gave good service in contrast to numbers 3059–99 which were a poor lot, scrapped by 1931.
(H.C. Casserley)

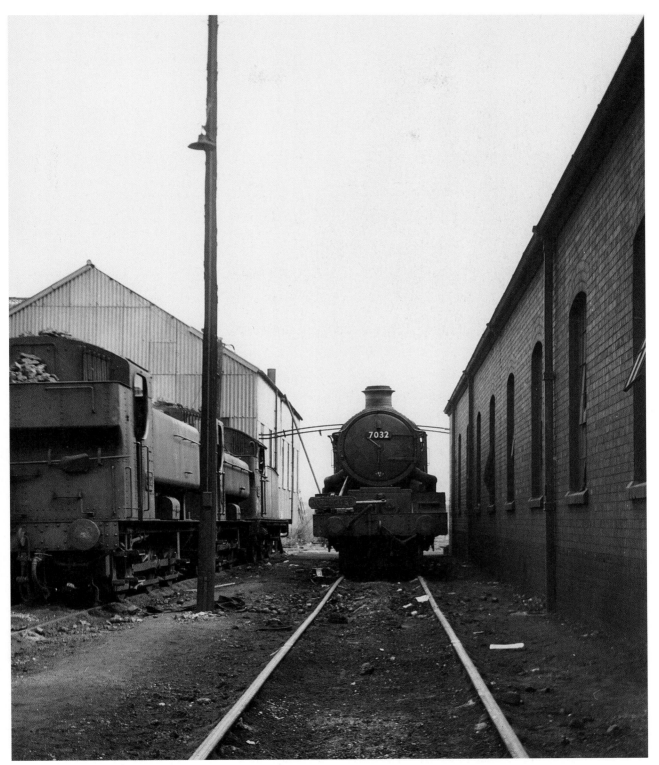

The construction of a new engine shed at Banbury, to replace one opened in 1889, was announced in April 1906. It opened in early September 1908. It was a standard straight shed, built of brick, with two roof pitches spanning four tracks. In this photograph, taken looking south on 6 August 1958 (almost fifty years after the opening of the 'new' shed), Old Oak Common's 'Castle' Class No. 7032 *Denbigh Castle* occupies the road immediately adjacent to the main shed. The corrugated structure on the left was the lifting shop, which came into operation in about 1943. On the road next to No. 7032 are two pannier tanks Nos 8452 and 3646 and a '5600' Class 0–6–2T No. 6627. (*David Hucknall*)

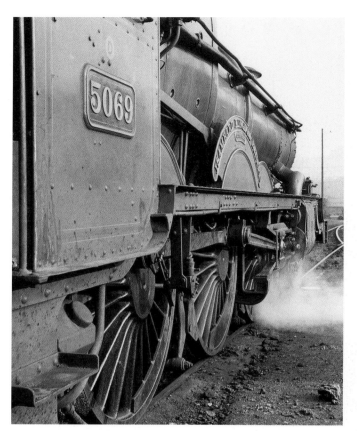

In this excellent study, capturing the essentials of a locomotive 'on shed', Laira's 'Castle' Class No. 5069 *Isambard Kingdom Brunel* is seen by the coaling stage at Bristol Bath Road shed. No. 5069 was built in June 1938 and allocated to Old Oak Common. It was a Laira engine for many years until its removal from service in February 1962. (*H.G. Usmar/D.J. Hucknall Collection*)

*Below:* With its tender well coaled and trimmed, 'Star' Class No.4056 *Princess Margaret* was seen at Bath Road depot, Bristol, at 7.15 pm on 23 April 1954. Almost fifty years old when this photograph was taken, No. 4056 had been a Bath Road engine in 1950 and was withdrawn from the same shed in October 1957. (*David Holmes*)

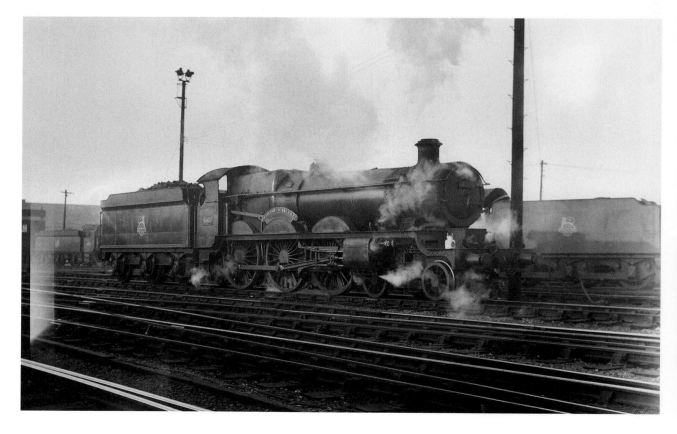

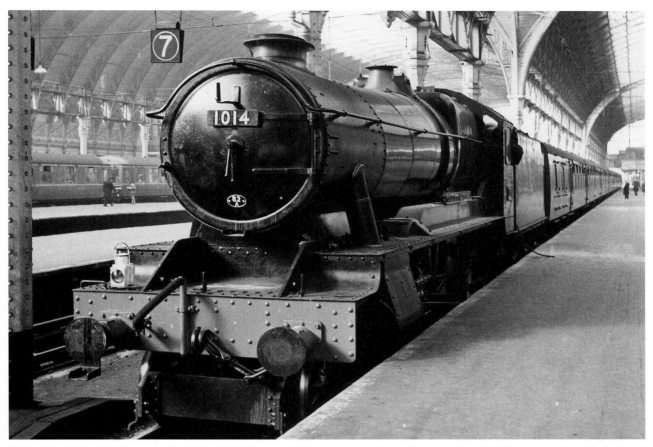

Bristol Bath Road's 'County' Class No. 1014 *County of Glamorgan* stands at Platform 6 at Paddington station. Bath Road was No. 1014's first shed in February 1946 and it remained an 82A engine until September 1960 when it was transferred to another Bristol shed – St Philip's Marsh. Its final shed was Swindon. *(H.G. Usmar/D.J. Hucknall Collection)*

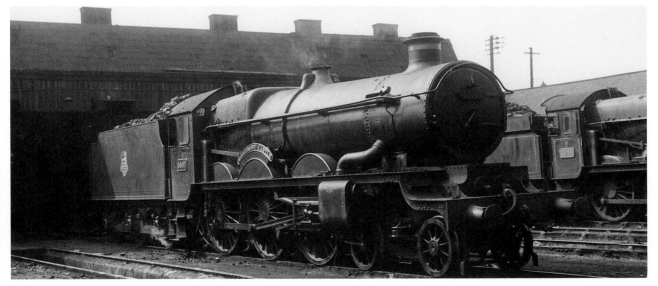

In his book *Steam on Shed*, P.B. Whitehouse said, probably with some justification, 'When Nationalisation came to British Railways . . . the Big Four were dissolved. In their place sprang up five regions and the GWR. . . . The pride and spirit was still there and apparent.' 'Castle' Class No. 5007 *Rougemont Castle* was seen in front of the straight shed at its home depot – Cardiff Canton on 6 May 1951. Facing London and well-coaled and cleaned, the engine appeared to be in the perfect state for its next duty. *(H.C. Casserley)*

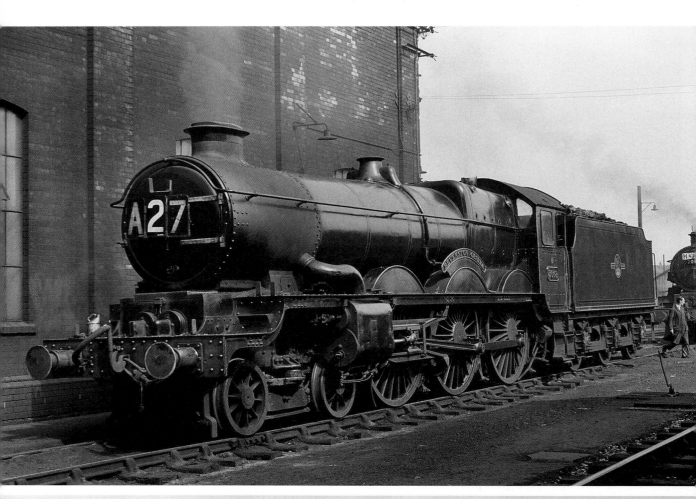

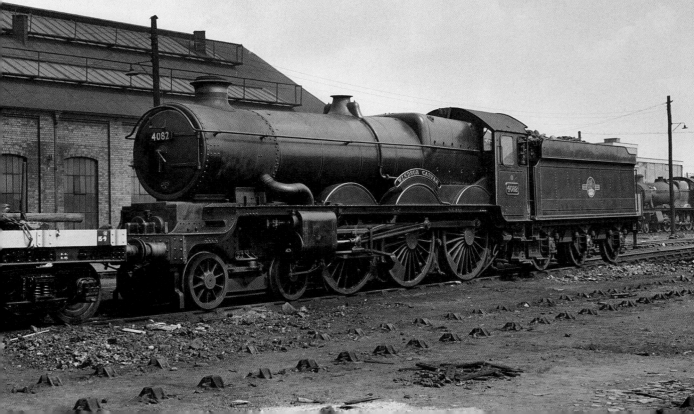

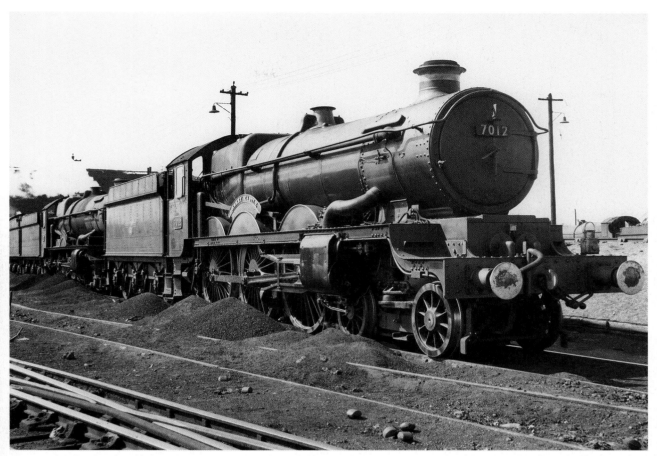

Carmarthen's 'Castle' Class No. 7012 *Barry Castle* and Plymouth Laira's 'King' Class No. 6027 *King Richard I* stood on the disposal line at Old Oak Common on 24 May 1959. Heaps of char from the smoke-boxes of serviced locomotives were piled up by the side of the line, spilling over onto the adjacent track. No. 7012 was built in June 1948 and allocated to Landore shed, Swansea. It remained a Landore engine until March 1959. Later (November 1960), it was transferred to Old Oak Common. No. 6027 was also, briefly (November 1959–January 1960), an 81A engine. *(W.A.C. Smith)*

*Opposite, top:* An exceptional portrait of 'Castle' Class No. 5068 *Beverston Castle*, was taken at Old Oak Common probably in August 1962. At the time, No. 5068 was an Oxford engine (81F from May–September 1962) although, for many years (from at least 1947 until its transfer to Oxford), it had been allocated to Swindon. The engine was carrying the train identification number A27 (probably 1A27) an express passenger train (1) with a destination (A) – the London District of the Western Region. To the rear of No. 5068 another 'Castle' Class, No. 7014 *Caerhays Castle*, was carrying the identification number (H48), indicating it would have been working train number 48 to the Gloucester/Birmingham districts (H). *(K.C. H. Fairey)*

*Opposite, bottom:* 'Castle' Class No. 4082 *Windsor Castle* was built in July 1948 as No. 7013 *Bristol Castle*. It was renamed and numbered as No. 4082 at the time of the funeral of King George VI because No. 4082 was in Swindon Works at the time. Seen here at its home shed, Old Oak Common on 24 April 1960, the locomotive is in fine condition. It was withdrawn from Gloucester in February 1965. *(K.C.H. Fairey)*

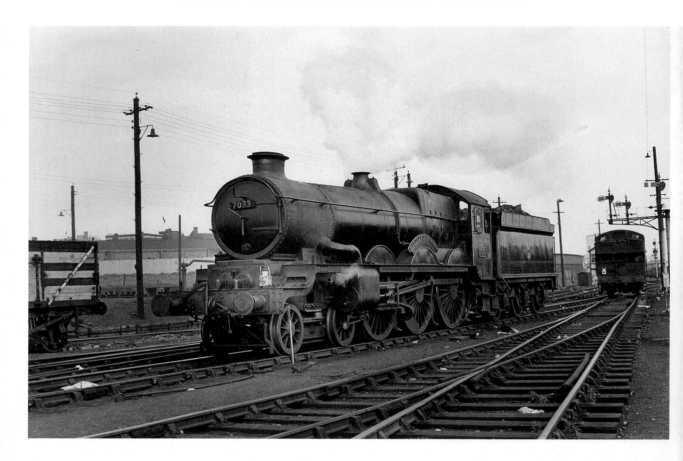

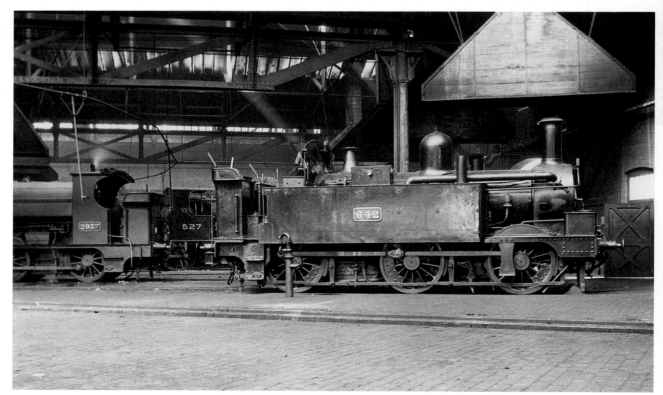

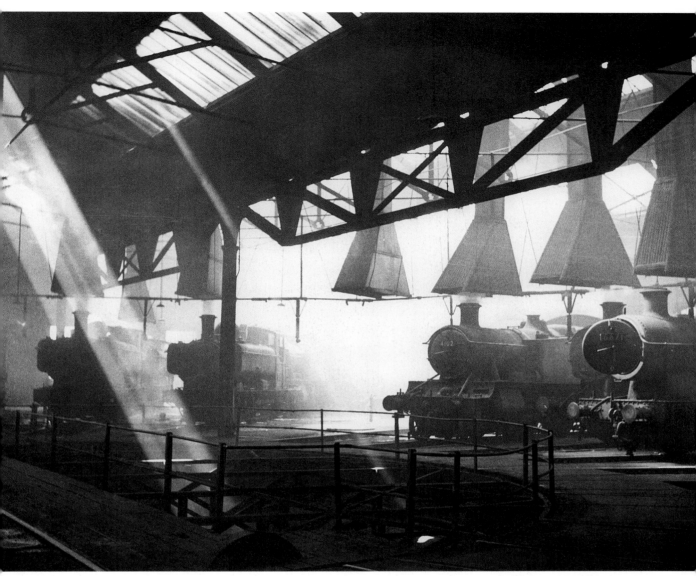

Old Oak Common shed had four turntables under one roof. It served the needs of Paddington station for express passenger locomotives but also provided freight engines, shunting engines and tank engines for suburban trains and carriage stock pilots. Here, possibly in the 'Tank Engine Shed' (the north-east turntable), in a highly atmospheric view, pannier tanks can be seen in the company of '5100' Class 2–6–2T No. 4102 (possibly a Swindon engine) and '5600' Class 0–6–2T No. 6671. *(H.G. Usmar/D.J. Hucknall Collection)*

*Opposite, top:* 'Castle' Class No. 7033 *Hartlebury Castle* is seen reversing out of Old Oak Common shed yard heading, probably, to Paddington to assume its next duty. Just visible behind the tank engine is Old Oak Common Engine Shed signal-box. The date was 20 August 1963. No. 7033 was built in 1950 and Old Oak Common was its first and last allocation. *(K.C. H. Fairey)*

*Opposite, bottom:* Inside Old Oak Common shed on 24 April 1920, Henry Casserley recorded 0–6–0T No. 642 and 0–6–0T No. 2037. No. 642 had no protection whatsoever for her crews but was fitted with equipment that allowed the engine's exhaust to be diverted via the water tanks to reduce smoke and steam emission on underground lines. *(H.C. Casserley)*

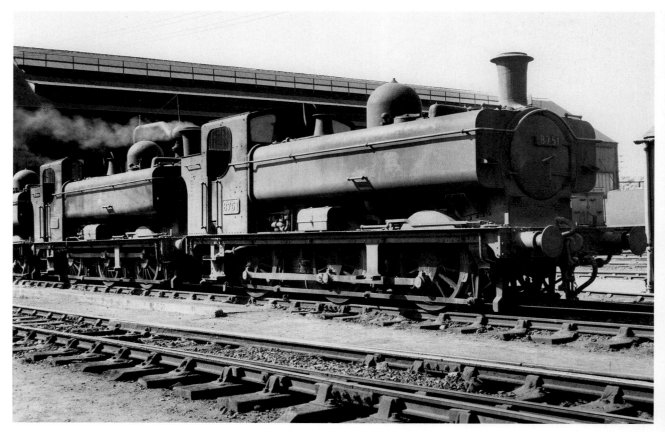

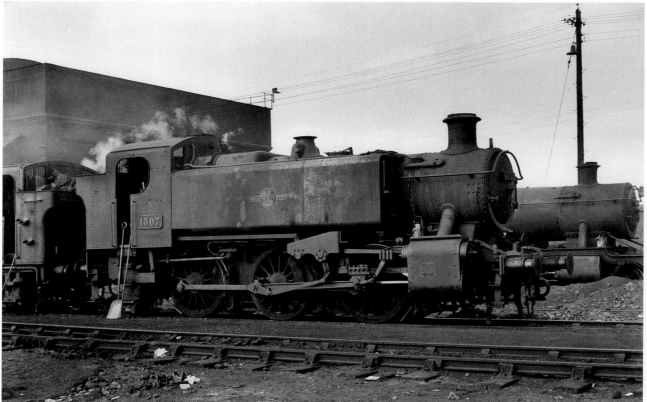

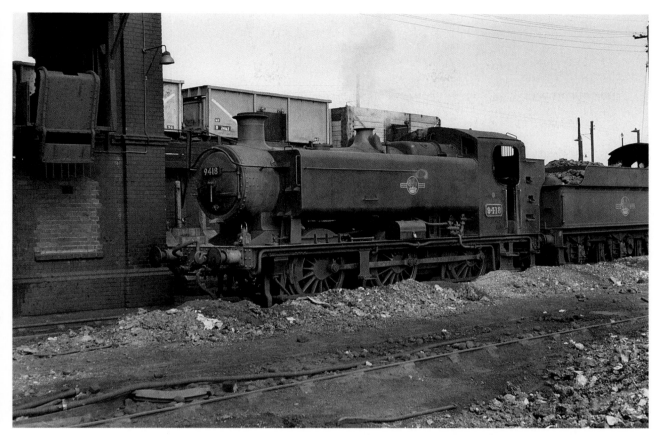

According to Russell (1978), the '9400' Class 0–6–0 PT was the tank version of the Collett '2251' Class 0–6–0 tender engine. Here, a member of the former class, No. 9418, can be seen by the coaling stage at its home shed (Old Oak Common). Significant amounts of ash and clinker lie by the side of the track, a sure indication, according to Beavor (1983), of either too few shed men or a shed management that was indifferent to the condition, or both. Although there were many examples of the class (which also included the '8400' and '3400' Classes), only ten examples were built at Swindon. No. 9418 was built by Robert Stephenson and Co. *(K.C.H. Fairey)*

*Opposite, top:* '5700' Class pannier tanks Nos 8751 and 8771 were both part of Old Oak's large allocation of tank engines when seen on 24 May 1959. Behind the engines, can be seen the large twelve-road repair shop at Old Oak Common which became known as 'The Factory'. Of the engines, both had been part of 81A's allocation in 1947. No. 8751, however, was transferred to Ebbw Junction shed, Newport, in April 1960. No. 8771 remained, however, to the end, being withdrawn in July 1962. *(W.A.C. Smith)*

*Opposite. bottom:* No. 1507, one of the capable '1500' Class 0–6–0T engines designed by Frederick Hawksworth and introduced in 1949, was seen at Old Oak Common on 20 August 1963. The shed's coaling stage was visible in the background. According to Russell (1978), most of the class's work involved carriage shunting between Paddington station and Old Oak Common yard. He also stated that they were not a particularly successful design. No. 1507 was withdrawn in December 1963. Although some 200 of the similar '9400' Class were built by contractors such as the Yorkshire Engine Co. and Robert Stephenson and Co., the construction of the '1500's was not contracted out (Russell). I am sure, however, that as a boy I saw one or two of the '1500' Class as part of a southbound freight train heading south through Parkgate and Aldwarke station. *(K.C. H. Fairey)*

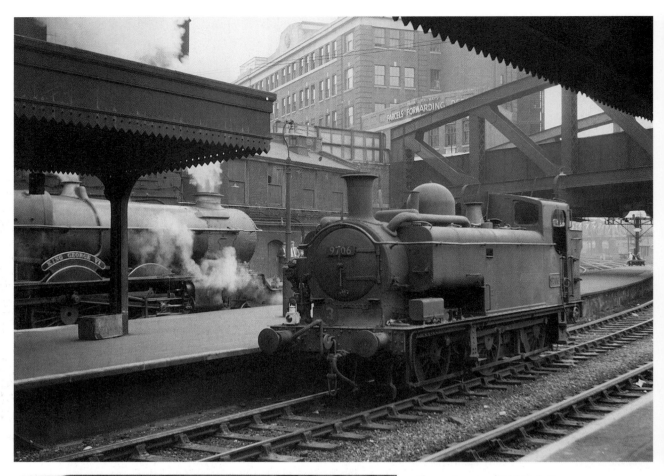

*Above:* A pair of Old Oak Common locomotives are seen going about their typical business at Paddington station in 1960. In the foreground, '5700' Class 0–6–0PT No. 9706 (one of a sub-class introduced in 1933 with significant modifications – including increased water capacity, condensing apparatus and a Weir pump for working over the LT Metropolitan Line), acting as station pilot No. 3, pauses between empty stock movements. In the background, 'King' Class No. 6028 *King George VI* (allocated to Old Oak Common when new and continuing its association with the shed almost to the end) prepares to leave the station with a South Devon express. On both platforms, trainspotters are recording the activities. *(H.G. Usmar/ D.J. Hucknall Collection)*

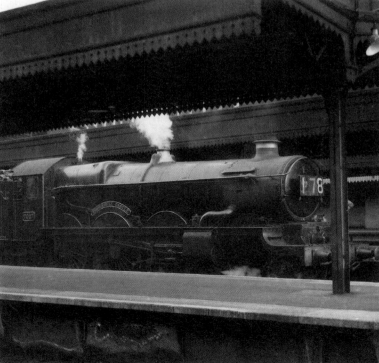

On a September day in 1957, Old Oak Common's 'Castle' Class No.7027 *Thornbury Castle* was in charge of the 6.55pm Paddington–Fishguard Harbour train (reporting Number 178). The locomotive is now owned by the Birmingham Railway Museum. *(David Hucknall)*

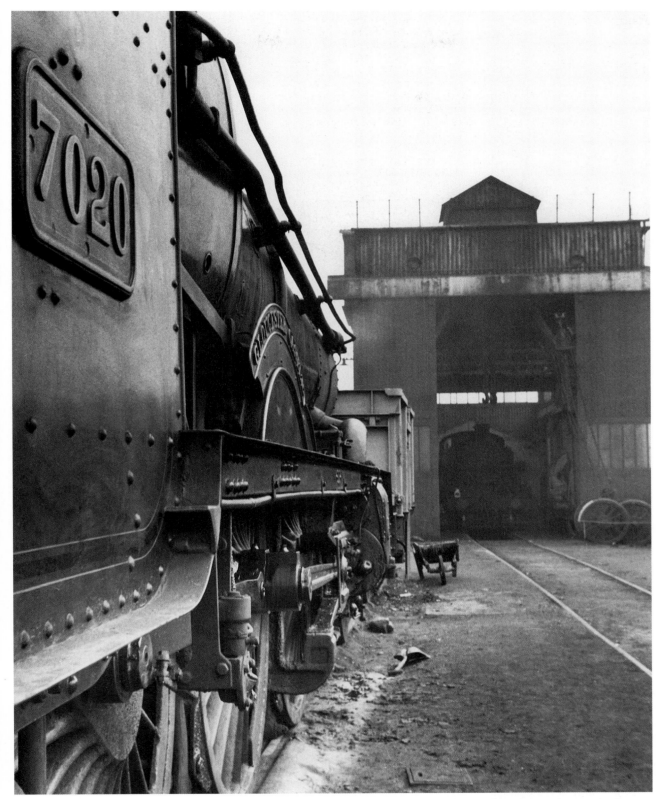

An Old Oak Common 'Castle' Class engine No. 7020 *Gloucester Castle* was seen in a siding facing the repair shop at Oxford shed. The roof had a raised section to accommodate the shear legs which were used to lift locomotives. It is possible that No. 7020 had failed while on duty and that urgent repair was called for. *(D.J. Hucknall Collection)*

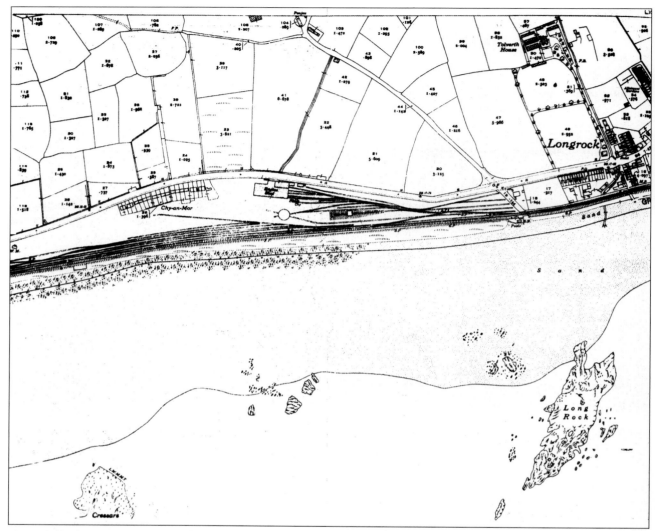

A section of a 1936 1:2500 Ordnance Survey map which shows Long Rock shed, Penzance and its surroundings. *(Crown Copyright)*

*Opposite, top:* A view of the locomotives that were in the yard at Penzance shed on 19 July 1959 shows, from left to right, 'Modified Hall' Class No. 7921 *Edstone Hall* (from Laira shed), 'Castle' Class No. 4077 *Chepstow Castle* (a Newton Abbot locomotive) and Penzance's own '5700' Class No. 9748. The shed was known locally as Longrock after a group of houses just to the east of the shed. The Long Rock is an off-shore outcrop in Mount's Bay, directly opposite the houses. *(David Hucknall)*

*Opposite, bottom:* A view from the end of the coal stage at Penzance shed on 19 July 1959 shows locomotives in the yard and the shed buildings in the background. 'Grange' Class No. 6824 *Ashley Grange* stands in the foreground, waiting to be coaled. The shed buildings can be seen in the background behind the assembled locomotives. The buildings on the left of the photograph were the shed proper (2x2 roads). The brick chimney behind No. 6824's tender was part of the sand-drier. The widest of the gable ends covered the single-track repair shop. Other identifiable structures were the shed's boiler house (with the slim chimney). The separate building was the pump house. *(David Hucknall)*

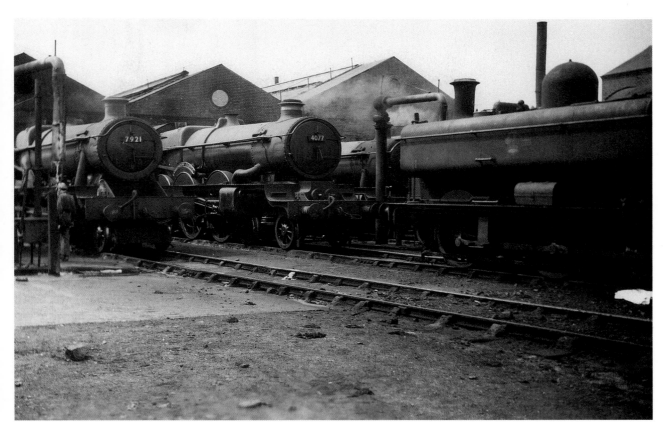

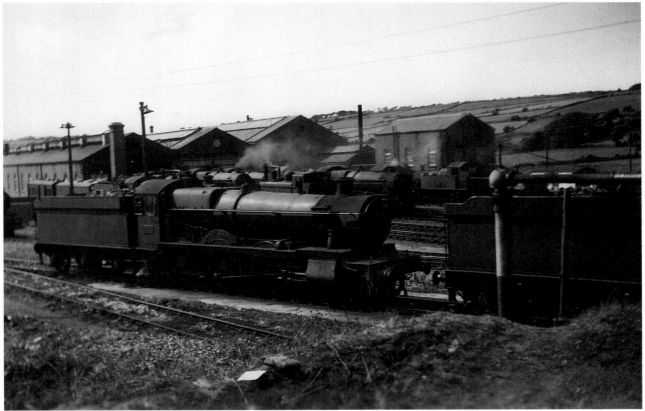

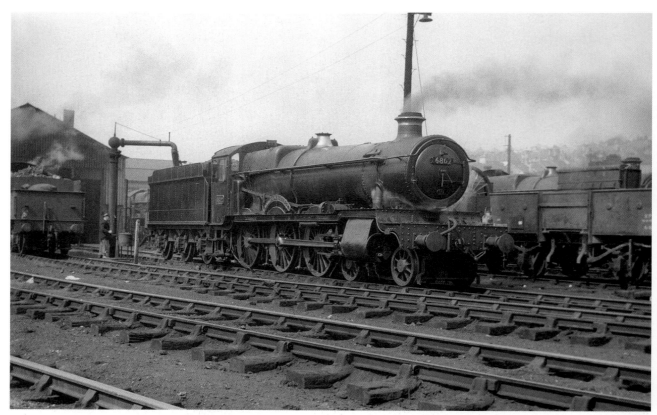

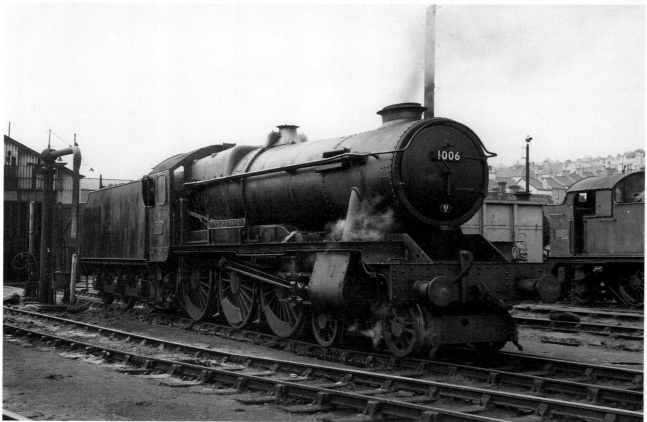

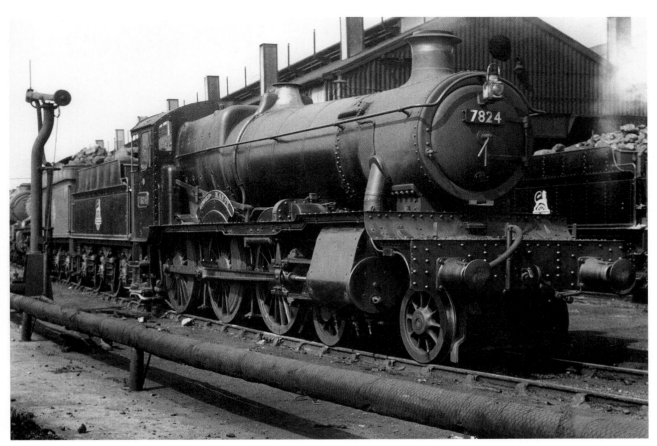

Immediately after the Second World War, there was a severe shortage of coal and the government at the time gave instructions to railway companies to convert some locomotives to oil-burning. Laira shed was involved in the experiment and, as can be seen in this photograph of 'Manor' Class No. 7824 *Iford Manor*, taken on 19 April 1954, the fuelling point outside the shed remained for some time after the conclusion of the scheme. In 1949, several 'Manors' were allocated to the westernmost sheds in the Newton Abbott division (83A, 83D,E,F and G), starting with the allocation of No. 7814 to Laira in the March. By 1952, there were eight of the type in the area. They were used for both passenger and freight work and to assist trains over the South Devon banks and the gradients in Cornwall. *(David Holmes)*

*Opposite, top:* This fine photograph of 'Grange' Class No. 6802 *Bampton Grange* was taken with the Holmes family's Kodak camera as the engine stood outside the New Shed at Plymouth Laira at 12.14 pm on 19 April 1954. No. 6802 was one of the first batch of 'Granges' to enter service. It was initially allocated to Old Oak Common in the autumn of 1936. The 'Grange' Class was introduced primarily for goods workings although, from the outset, they were used on passenger trains. By January 1947, No. 6802 had been assigned to Reading shed but before this, it may have been a Didcot locomotive and, in 1944, it worked regularly on the 8.05 pm Moreton Cutting to Feltham freight through to Feltham (Copsey, 1998). *(David Holmes)*

*Opposite, bottom:* Plymouth Laira shed's 'County' Class 4–6–0 No. 1006 *County of Cornwall* can be seen standing outside the 'New' (Long) shed at its home depot. No. 1006 became a Laira engine in 1960 but I remember it as, appropriately, a polished Penzance engine with a single chimney on a hot August day in 1957. *(H.G. Usmar/D.J. Hucknall Collection)*

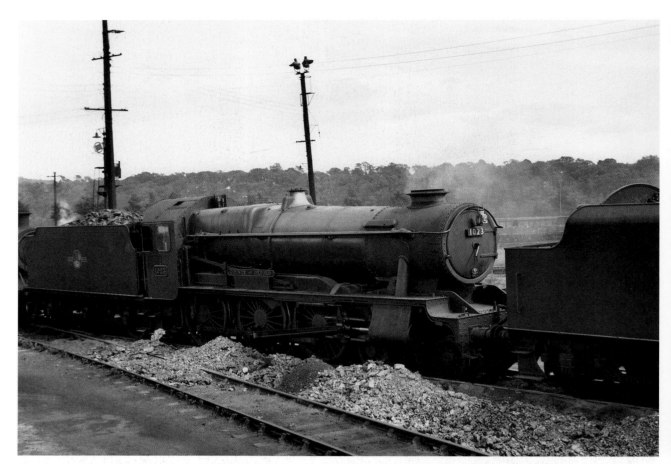

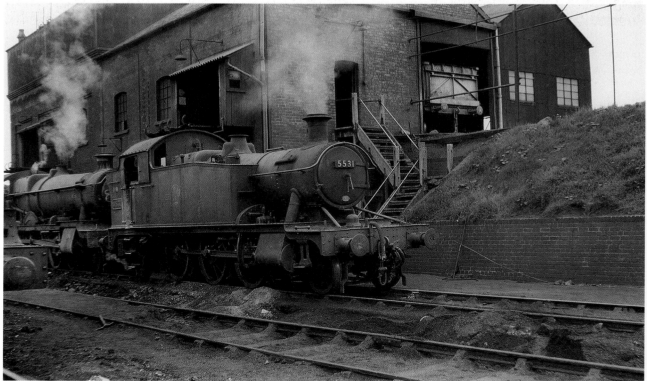

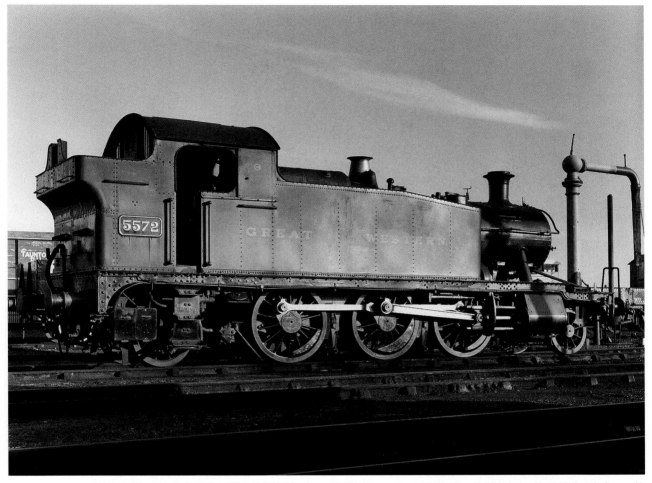

A former Laira '45XX' Class 2–6–2T No. 5572 (83D February 1957–September 1960/April 1961–April 1962 (withdrawn)) is now preserved by the Great Western Society. The engine is seen here, illuminated by the setting sun at Didcot shed on 1 January 2000). *(David Hucknall)*

*Opposite, top:* Truro shed's 'pride and joy' for several years (Gray, 1993) was 'County' Class No. 1023 *County of Oxford*. It is seen here on the coaling line at Laira shed on 18 August 1957. Hawksworth's 'Counties' represented the last passenger engine design produced by the Great Western Railway before nationalisation. *(K.C.H Fairey)*

*Opposite, bottom:* The coaling stage at Laira shed had two bays. Standing in the coaling line on 25 August 1959 are a 'Grange' Class engine and a '4500' Class 2–6–2T No. 5531. The latter was an 83D engine at the time and, apart from a short stay at St Blazey (September 1961–September 1962), remained so until the end of 1963. Judging by the piles of smokebox ash lying between the coaling line and the adjacent ash road, it had been a busy day on shed. *(K.C.H. Fairey)*

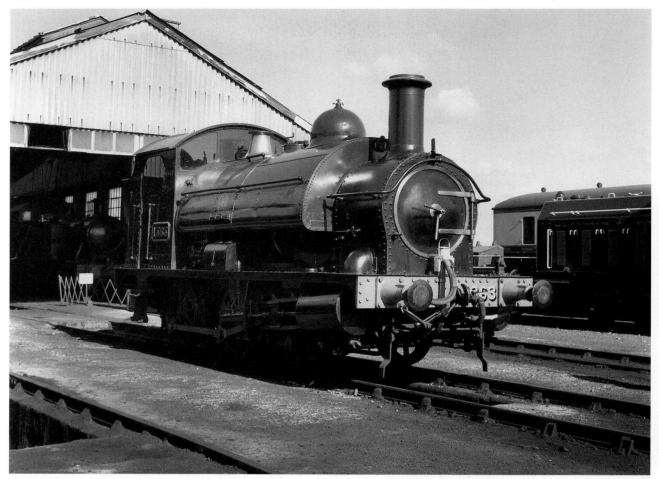

'1361' Class 0–6–0 ST No. 1363 was built in 1910 at Swindon. It was the shed pilot at Laira until it was withdrawn in December 1963. It was acquired by the Great Western Society in 1964 and, as can be seen, it has been superbly restored. It is seen here at Didcot. (*David Hucknall*)

*Opposite, top:* Swindon engine shed was opened in 1871 as a straight shed with a turntable at the rear. In 1908, a Churchward turntable unit, adjoining the original shed on the eastern side, was added (Griffiths, 1987). Taken on 17 May 1931, this photograph probably shows the inside of the 1871 building which, after the opening of the 1908 addition, was used mostly for tank engines. Around the turntable can be seen two examples, Nos 868 and 2007, of the '850' Class of small-wheeled 0–6–0 tanks built in Wolverhampton. No. 868 was one of a batch constructed in 1874/5 while No. 2007 was one of twelve engines built in 1891/2. What is so apparent from this photograph is the exemplary state of both the engines and their surroundings. (*H. C. Casserley*)

*Opposite, bottom:* Henry Casserley had visited Swindon shed on 30 April 1950. Inside the shed had been a group of tank engines, including '1400' Class 0–4–2T No. 1400 (a Swindon engine until it was withdrawn from service in June 1957), a '4500' Class No. 4538 (withdrawn from Swindon in May 1957) and a '5700' Class No. 9704 (fitted with condensing equipment). There was no reason why Swindon shed should have an engine such as No. 9704 in its allocation and it was most likely to have been a visitor from Old Oak Common to the works. (*H.C. Casserley*)

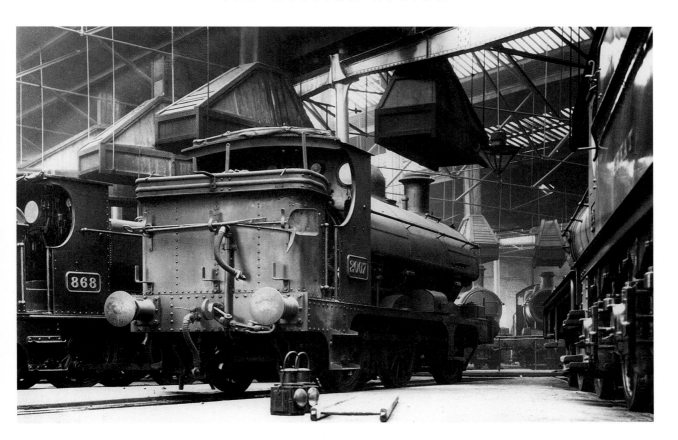

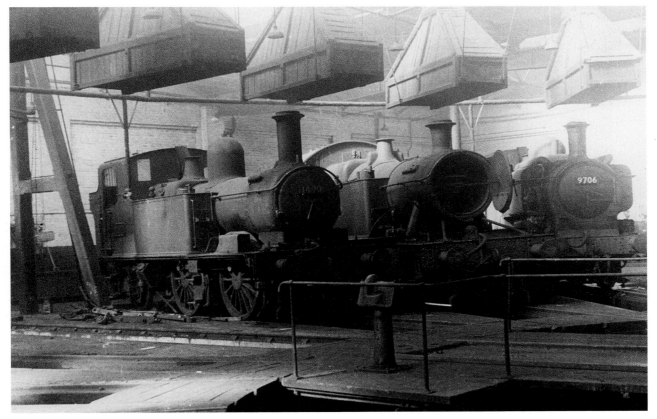

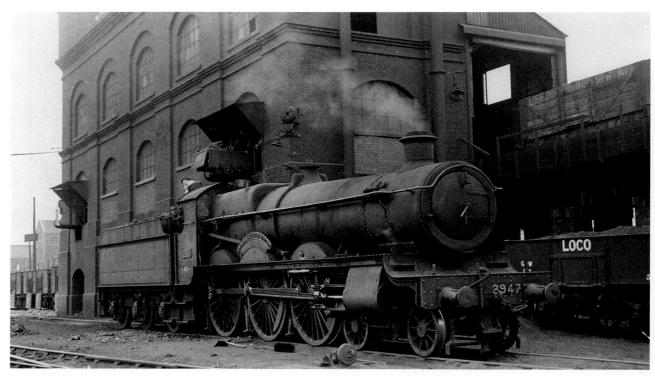

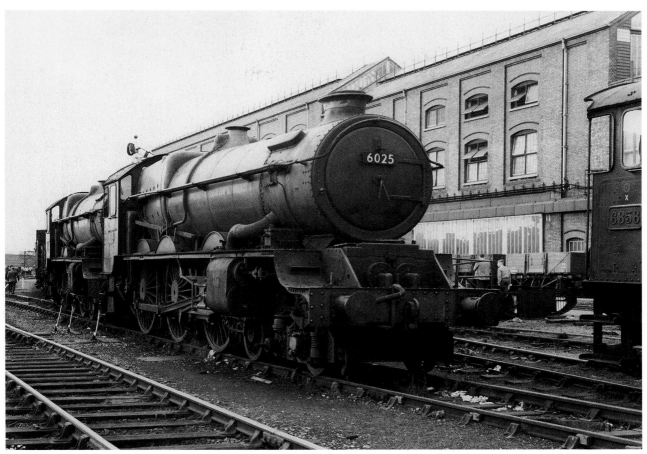

At Swindon Works, the engine numbers having been noted and the photographs taken, the trainspotters move on. In the works yard at the time, separated from their tenders before entering the erecting shop, were 'Grange' Class No. 6858 *Woolston Grange* and two 'King' Class locomotives. One of the latter was No. 6025 *King Henry III*. No. 6025 was a Laira locomotive from August 1950 until March 1959, when it was transferred to Old Oak Common. After thirty-two years of service, it was withdrawn in December 1962 and disposed of at Swindon. (*H.G. Usmar/ D.J. Hucknall Collection*)

*Opposite, top:* Swindon's 'Saint' Class 4–6–0 No. 2947 *Madresfield Court* standing at the coaling stage of its home shed on 4 July 1947. On the locomotive's tender, the coal was being trimmed before another filled tub, being held by a shedman, was added. Wagons, waiting either to be unloaded or to be returned, stand under the protective corrugated lean-to behind the unloading level. Because Welsh coal was so friable, the Great Western Railway and its successors never installed the huge mechanical coalers that dominated many sheds on other regions. (*H.C. Casserley*)

*Opposite, bottom:* 'King' Class No. 6006 *King George I* was first allocated to Stafford Road shed, Wolverhampton, in 1930. Together with that shed's five other 'Kings', it worked on the two-hour trains which ran between Paddington and Birmingham/Wolverhampton. It remained a Stafford Road engine until the last days of the class in 1962 although it was one of the first of 84A's 'Kings' to be withdrawn. Here, No. 6006 is seen at Reading General station. Partly because of its good external appearance and partly because it would not normally run via Reading, it must be assumed that it was running-in after a spell at Swindon Works. In earlier days, however, a favourite 'running-in' train was the Swindon–Bath 'stopper'. (*H.G. Usmar/D.J. Hucknall Collection*)

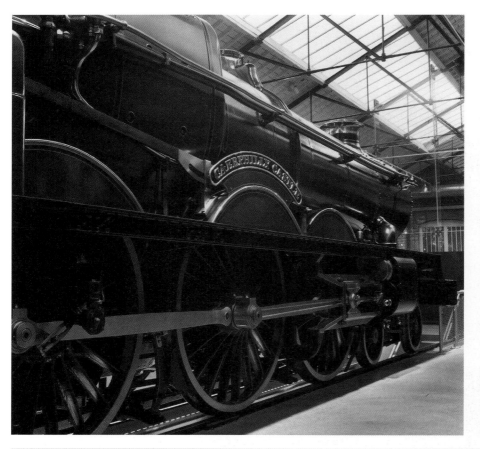

Having the look that the Great Western Railway had always tried to maintain, 'Castle' Class No. 4073 *Caerphilly Castle* is now kept at the National Railway Museum at Swindon. As seen in 2005, the locomotive carried a 1930-style headboard proclaiming, 'Cheltenham Flyer – World's Fastest Train'. No. 4073 appeared in August 1923 and, according to O.S. Nock (1975), the GWR Publicity Department described it as 'a super-locomotive' and 'the most powerful passenger train engine in the kingdom'. Nock continued, 'The validity of this claim . . . was dubious but it emerged two years later, in the locomotive exchanges with the LNER, that the claim had been nearer the mark than the authors could have supposed'. *(David Hucknall)*

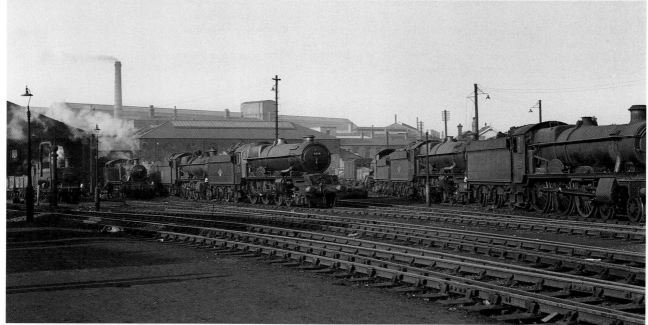

A view looking roughly north-west shows, on the left-hand side, part of No. 4 shed at Wolverhampton Stafford Road. To the right, in the background, can be seen the lifting shop associated with the old works erecting shop. The locomotive workshop was built in 1932 and sheds 4 and 5 were rebuilt as steel-framed structures at the same time. Standing outside the shed on 10 November 1959, was Wolverhampton's '5101' Class 2–6–2T No. 4108. In the centre of the photograph is 'King' Class No. 6014 *King Henry VII* and, to its right, No. 6020 *King Henry IV* behind a grimy 'Hall'. *(K.C.H. Fairey)*

A pair of Stafford Road 'Kings', No. 6014 *King Henry VII* and No. 6020 King Henry IV, were seen at their home depot on 10 November 1957. Stafford Road received its first 'Kings' (Nos 6017 and 6019) in July 1928. No. 6014 arrived in August 1930, together with Nos 6005, 6006 and 6008. In March 1935, however, No. 6014 was transferred elsewhere but returned to Wolverhampton's stock in 1954. No. 6020 was allocated to Stafford Road in January 1949. The shed's association with the 'King' Class ended in September 1962 and the shed itself closed one year later. *(K.C.H. Fairey)*

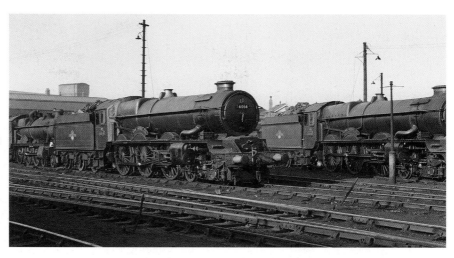

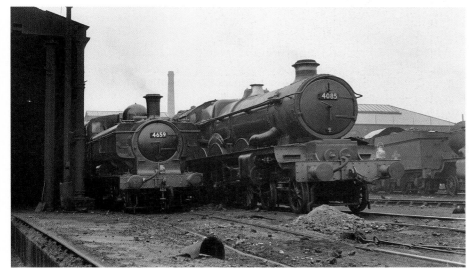

Outside No. 4 shed at Stafford Road on 27 November 1960 were Old Oak Common's 'Castle' Class No. 4085 *Berkeley Castle* and '5700' Class 0–6–0PT No. 4659 (without a shed plate but probably a Hereford engine visiting the works. No. 4085 was one of the second batch of 'Castles' to be built (see No. 4073 elsewhere), appearing in May 1925. Its first shed was Plymouth Laira. *(K.C.H. Fairey)*

In the 1920s, coal traffic in South Wales was dealt with mostly by the 0–6–2Ts of railway companies such as the Rhymney and Taff Vale Railways. When further engines were required for such work, Charles Collett introduced the '56XX' Class 0–6–2T in 1924. Seen here in fine condition, '56XX' Class No. 6648 (allocated to Treherbert shed) stands by the coaling stage at Duffryn Yard at 10.30a.m. on 14 April 1954. Duffryn Yard shed was built by the Port Talbot Railway in 1896, but in 1931 the GWR made improvements to the locomotive accommodation and servicing facilities. *(David Holmes)*

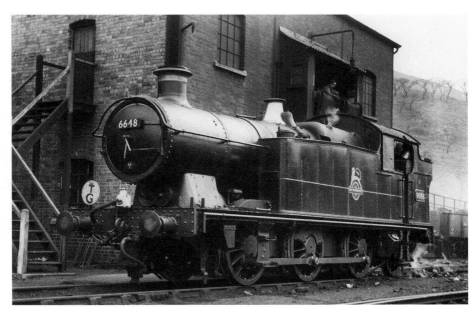

# Bibliography

*ABC of British Railways Locomotives* (Winter 1956/7 Edition), Ian Allan Ltd, London

Allen, C.J., *The Railway Magazine*, November 1938; id., ibid., August 1938; id., *Trains Illustrated*, April 1957

Anon, *The Book of the Royal Scots*, Irwell Press, Clophill, 1999

Beavor, E.S., *Steam Motive Power Depots*, Ian Allan Ltd, 1983

Copsey, *Great Western Journal*, No. 27, Wild Swan Publications Ltd., Didcot, Summer 1998; id., ibid., No. 28, Autumn 1998

Curl, B., *South Western at Nine Elms*, Kevin Robertson Books, 2004

Dart, M., *West Country Engine Sheds*, Ian Allan Publishing Ltd, Hersham, 2002

Essery, B. and Jenkinson, D., *An Illustrated History of LMS Locomotives, vol. 3 Absorbed Pre-Grouping Classes, Northern Division*, Silver Link Publishing, Wadenhoe, 1994

Griffiths, R., *GWR Sheds in Camera*, Oxford Publishing Co. (Haynes Publishing Co.), Sparkford (reprint 1988)

——, and Hooper, J., *Great Northern Railway Engine Sheds, vol. 2, Southern Area*, Irwell Press, Pinner, 1979

Haresnape, B., *Bulleid Locomotives (A Pictorial History)*, Ian Allan Publishing Ltd, Shepperton, 1977

Hawkins, C., and Reeve, G., *LMS Engine Sheds (Their History and Development), vol. 1 The London North Western Railway*, Wild Swan Publications Ltd, Didcot (reprint 1987); id., *LMS Engine Sheds (Their History and Development), vol. 2 The Midland Railway*, Wild Swan Publications Ltd, Upper Bucklebury, 1981

——, *A Historical Survey of Southern Sheds*, Oxford Publishing Co. (Ian Allan Publishing Ltd), Hersham (reprint 2001)

—— and Stevenson, J.L., *LMS Engine Sheds (Their History and Development), vol. 6 The Highland Railway*, Irwell Press, Pinner, 1989

Hooper, J., *LNER Sheds in Camera*, Guild Publishing, London, 1986

Meacher, C., *LNER Footplate Memories*, D. Bradford Barton Ltd, Truro

Nock, O. S., *British Railways in Action*, Thomas Nelson and Sons, Edinburgh, 1956

——, *Scottish Railways*, Thomas Nelson and Sons Ltd, revised edition, Edinburgh, 1961

——, *The GWR Stars, Castles and Kings; Pt. 1*, David and Charles, Newton Abbot, 3rd Impression, 1975

——, *The Railway Magazine*, p. 410, June, 1960

——, *The Railway Magazine*, November, 1964

RCTS, *Locomotives of the LNER, part 2A, Tender Engines Classes A1 to A10*, 4th Impression, RCTS, Long Stratton, 1997

——, *Locomotives of the LNER, part 2B, Tender Engines Classes B1 to B19*, RCTS, 1975

——, *Locomotives of the LNER, part 7, Tank Engines Classes A5 to H2*, RCTS, 1964

——, *Locomotives of the LNER, part 9A, Tank Engines Classes L1 to N19*, RCTS, 1977

Russell, J.H., *A Pictorial Record of Great Western Engines*, Combined Volume, Oxford Publishing Co., Oxford, 1978

Welch, M.S., *Memories of Steam from Glasgow to Aberdeen*, Runpast Publications, Cheltenham, 1993

Whitehouse, P.B., *Steam on the Shed*, Ian Allan Ltd, London, 1969

Winkworth, D.W., *Bulleid's Pacifics*, Allen and Unwin, 1974

# Index